Vito Acconci

Jerri Allyn

Luis Alonso

Emma Amos

Benny Andrews

Ida Applebroog

Tomie Arai for Political Art
Documentation/Distribution

Robert Arneson

Artists Meeting for Cultural
Change

Art Workers' Coalition

Eric Avery

Luis Cruz Azaceta

Sonia Balassanian

Rudolf Baranik

Romare Bearden

Nan Becker

Rudy Begay

Leslie Bender for Political Art
Documentation/Distribution

Black Emergency Cultural
Coalition and Artists and
Writers Protest Against
the War in Vietnam

Jonathan Borofsky

Louise Bourgeois

Vivian Browne

Chris Burden

Luis Camnitzer

Josely Carvalho

Josely Carvalho and Sabra Moore

Elizabeth Catlett

Judy Chicago

Judy Chicago and

Miriam Schapiro

Eva Cockcroft for Artists
for Nuclear Disarmament

Stencil Brigade

Sue Coe

Collaborative Projects, Inc.

Michael Corris

Carlos Cortez

Anton van Dalen

Jane Dickson

Jim Dine

James Dong

Mary Beth Edelson

Melvin Edwards

John Fekner

Mary Frank

Antonio Frasconi

Rupert Garcia

Sharon Gilbert

Mike Glier

Leon Golub

Leon Golub and Nancy Spero

Peter Gourfain

Ilona Granet

Group Material

Dolores Guerrero-Cruz

Guerrilla Art Action Group

Marina Gutiérrez

Hans Haacke

David Hammons

Keith Haring

Edgar Heap of Birds

Heresies Collective

Jenny Holzer

Rebecca Howland

Arlan Huang

Robert Indiana

Carlos Irizarry

Alfredo Jaar

Luis Jimenez

Jasper Johns

Jerry Kearns

Edward Kienholz

Janet Koenig

Margia Kramer

Barbara Kruger

Suzanne Lacy

Jean LaMarr

Jacob Lawrence

Michael Lebron

Colin Lee

Jack Levine

Les Levine

Robert Longo for Political Art
Documentation/Distribution

Paul Marcus

Marisol

Dona Ann McAdams

Yong Soon Min

Richard Mock

Sabra Moore

Robert Morris

Bruce Nauman

Joseph Nechvatal

Claes Oldenburg

Ed Paschke

Adrian Piper

Susan Pyzow

Robert Rauschenb

Faith Ringgold

Larry Rivers

Elizabeth Rodriguez

Tim Rollins + K.O.S.

Rachel Romero with
Leon Klayman for
the Wilfred Owen Brigade

James Rosenquist

Martha Rosler

Erika Rothenberg

Christy Rupp

Jos Sances for Mission Gráfica

Juan Sánchez

Peter Saul

Miriam Schapiro

Ben Shahn

Sisters of Survival

Sisters of Survival and
Marguerite Elliot

Mimi Smith

Vincent Smith

Nancy Spero

Frank Stella

May Stevens

Mark di Suvero for Artists
and Writers Protest
Against the War in Vietnam

Dennis Thomas/Day Gleeson

Francesc Torres

Andy Warhol

John Pitman Weber

he Same Boat

y

ita

Social and Political Themes
in Recent American Printed Art

COMMITTED TO PRINT

Deborah Wye

The Museum of Modern Art, New York

Published on the occasion of the exhibition *Committed to Print*
January 31 to April 19, 1988
organized by Deborah Wye, Associate Curator
Department of Prints and Illustrated Books
The Museum of Modern Art, New York

This publication has been made possible by a generous grant
from the Samuel Rubin Foundation.

The exhibition *Committed to Print* has been sponsored in part
by grants from the National Endowment for the Arts and
the New York State Council on the Arts.

Edited by Maura Walsh
Design by Barbara Balch Design, New York
Production by Susan Schoenfeld
Typeset by Trufont Typographers, Inc., Hicksville, New York
Printed by Eastern Press, New Haven, Connecticut
Bound by Sendor Bindery, Inc., New York

The Museum of Modern Art
11 West 53 Street
New York, New York 10019

Distributed outside the United States and Canada by
Thames and Hudson Ltd., London

Printed in the United States of America

In the catalogue information in this publication,
dates of publication follow names of publishers;
dates in parentheses do not appear on the works.
The dimensions given represent sheet size for prints
and page size for artists' books, height preceding
width.

Contents

Acknowledgments

In an undertaking of this scope, which focuses on the contemporary period, it is the artists themselves who play the major role. The artists represented in *Committed to Print* have been extraordinary in their responsiveness to my many queries. Discussions with them have been profoundly enlightening for me, and the exhibition is a tribute to them and to their work.

Among associates at The Museum of Modern Art my first debt of gratitude is to Riva Castleman, Deputy Director for Curatorial Affairs and Director of the Department of Prints and Illustrated Books, who encouraged me from the earliest stages of this project and lent support throughout. Also at the Museum, I have worked with two staff members whose dedication to the project has been matched only by my own. Wendy Weitman, Assistant Curator in the Department of Prints and Illustrated Books, has tirelessly devoted her considerable talents to every aspect of the exhibition and catalogue. She has shared all the exhilarations and challenges of this complex undertaking. For her keen advice throughout I will always be grateful. In the Publications Department Maura Walsh, Assistant Editor, was indispensable in bringing the catalogue to fruition. Her sensitivity to the issues at hand and her fundamental help on all levels of interpretation spurred me on. She has my warmest thanks.

There are other colleagues at the Museum who made important contributions and to whom I am indebted. Susan Schoenfeld, Assistant Production Manager, with patience and thoughtful attention to the necessary fine points guided the catalogue through production under the most pressured circumstances. The staff of the Library helped in innumerable ways. In particular, I would like to thank Clive Phillpot, Director, who shared knowledge and offered encouragement with rare generosity. Janis Ekdahl, Assistant Director, filled countless requests for acquisitions of new publications with her usual graciousness. Jerome Neuner, Exhibition Production Manager, provided imaginative solutions to many challenges of the installation. In the Department of Prints and Illustrated Books Kathleen Slavin, Curatorial Assistant, documented the large group of artists' books with care and precision; Marilu Knode, Cataloguer, was of great assistance in locating artists; Laurie Rigelhaupt, formerly Executive Secretary, did seemingly endless photocopying for the research files and also much correspondence; Charles Carrico, Preparator, handled numerous details relating directly to the art works; and Deborah Goldberg, the Department's summer intern, conducted research on various issues and events at libraries all over New York and attended to all manner of emergencies as they arose.

On behalf of the Board of Trustees of The Museum of Modern Art I would like to thank all the lenders to the exhibition, many of whom are the artists themselves. I would also like to acknowledge the National Endowment for the Arts and the New York State Council on the Arts for their support of the exhibition. The Samuel Rubin Foundation's generous assistance in the publication of this catalogue is also deeply appreciated.

Extensive research was required to document this tradition of social and political printed art, and the Archive of Political Art Documentation/Distribution proved to be an invaluable resource. The inclusion there of the papers of Dore Ashton and of Rudolf Baranik must be noted. Archive committee members Barbara Moore and Mimi Smith assisted me over a long period, and their cooperation and friendliness made my task a very pleasant one. Additional assistance was received from a wide range of individuals who suggested artists or helped locate them, who pointed to special avenues of research, or who found particular works. In this regard I would like to thank the following: the staff of Atlatl, Myrna Baez of Hermandad de Artistas Gráficos de Puerto Rico, Ken Banks of the American Indian Contemporary Arts Gallery, Robert Blackburn of the Printmaking Workshop, Andrea Callard, Fay Chiang, Kinshasha Conwill and Grace Stanislaus of The Studio Museum in Harlem, Michael Corris, Charles Dailey of the Institute of American Indian Art Museum, Terry Dintenfass of Terry Dintenfass Gallery, Cheri Gaulke of Sisters of Survival and the Woman's Building, Ben Goldstein, the staff of the Hatch-Billops Collection, Steven Heller, Watson Hines, Rebecca Howland, Arlan Huang, Jeanette Ingberman of Exit Art, Kellie Jones of the Jamaica Arts Center, Inverna Lockpez of INTAR Latin American Gallery, Margo Machida of The New Museum of Contemporary Art, Nilda Peraza of the Museum of Contemporary Hispanic Art, Howardena Pindell, Geno Rodriguez of the Alternative Museum, Kiki Smith, Seymour Tubis, John Pitman Weber, David White, and Susan Yung of Ronald Feldman Fine Arts, Inc. Special thanks for extended discussions on the subject are owed to Jon Hendricks, Jerry Kearns, and Irving Petlin.

I am also grateful for help with particular research questions from Roberta Bernstein, Patricia Caporaso and Carrie Kahn of Castelli Graphics, Paula Cooper of Paula Cooper Gallery, Joe Fawbush and Tom Jones of Fawbush Gallery, Ted Greenwald of Ted Greenwald Gallery, June Kelly of June Kelly Gallery, Robert Monk of Lorence-Monk Gallery, Alex Rosenberg of Alex Rosenberg Gallery/Transworld Art, Robert Rainwater and Roberta Waddell of The New York Public Library, and Lisa Schackner. Special thanks for the handsome design of the catalogue go to Barbara Balch, who responded to this project's complexities with imagination and good will.

Personal thanks must go to my husband, Paul Brown, and daughter, Becky Brown, who supported my efforts over such a long period. For even longer support and encouragement I would like to thank my parents, Louise and James Wye. I dedicate this catalogue to them.

D. W.

Committed to Print
Social and Political Themes in Recent American Printed Art

Approbation, inquiry, and dissent are among the functions performed by the printed works discussed here. The art works are presented in terms of these functions, with particular emphasis on their subject matter: significant issues and events of our time. In recent years many artists have made social and political concerns a focal point of their artistic activity. Yet often in the modern period art has fulfilled other, less clearly social aims, a reflection of a preoccupation with the pleasure or provocation of the eye as an end in itself and with the concept of "art for art's sake." The art studied here, by contrast, was largely created to be, as one artist put it, "a kind of instrument in the world."

The works in this study are organized by theme, rather than by style, date of execution, or artist, in order to focus on the major thrust of their imagery. They are grouped under the following headings: governments and leaders; race and culture; gender; nuclear power and ecology; war and revolution; and economics, class struggle, and the American Dream. Prints overlapping several categories or exploring universal themes are presented in an introductory section. Issues arising from the abuse of power, however, inform almost all the works under consideration, appearing so frequently as to suggest that the problem is an inescapable aspect of human experience. Many of the prints, with their images of inquiry and protest, are meant to contribute to the checks and balances necessary to remedy such abuses.

The points of view reflected in the art presented here do not represent a full spectrum of opinion. In July 1987 *The New York Times* noted that a right-wing group had issued its first political poster, on the Iran-Contra hearings. A spokesperson for the group was quoted as saying, "The left wing is generally much better at this than we are. They are more artsy." And it is the leftist or liberal point of view which dominates the works in this study. In fact, throughout the history of printed art with social and political themes, a leftist slant has predominated. As Ralph E. Shikes wrote in *The Indignant Eye* (1969), his definitive book on the history of this material, "the vast majority of art directed against the abuses of society has been drawn within a liberal or radical framework."

For some five hundred years printed works, with their inherent reproducibility, have served to disseminate beliefs and commentary to a wide audience. And the tradition of social and political printed art remains vital today, despite the fact that other mediums have long since replaced prints as major vehicles for mass communication. In the fifteenth and sixteenth centuries printed works by Hieronymus Bosch, Pieter Bruegel, Lucas Cranach, and others had powerful propaganda value, particularly on the question of church abuses. Numerous broadsides and pamphlets influenced public opinion for the cause of Luther and the Protestant Reformation. Masterpieces of printed art were created on the cruelty and suffering that war brings, in series by Jacques Callot in the seventeenth century, by Francisco Goya in the nineteenth century, and by Otto Dix, Käthe Kollwitz, and Georges Rouault in the twentieth century. Other artists, such as Honoré Daumier in the nineteenth century, did countless prints on war and peace, as well as on injustice in the legal system, government corruption, and other social inequities.

In revolutionary Mexico in the twentieth century, artists spread messages of protest against government oppression through printed broadsides. José Guadalupe Posada, who produced thousands of prints on political and religious subjects, class struggles, and Mexican history and folklore in the late nineteenth and early twentieth centuries, was an overriding influence there. In America, in the early twentieth century, realist artists such as George Bellows, Stuart Davis, and John Sloan illustrated the socialist magazine *The Masses*. And in the thirties, during the Great

Depression, a movement known as social realism gave rise to many prints on themes from breadlines and strikes to crowded city tenements. Jacob Lawrence, Jack Levine, and Ben Shahn, who are represented here, were among those whose work of the thirties embraced social commentary.

It is the contemporary aspect of this artistic tradition in America, from the sixties to the present, that is documented in this survey. The particular focus is on printed art by those working in the tradition of painting and sculpture, as opposed to those working primarily with the graphic-arts poster or with political caricature. Ephemeral printed art, such as banners, leaflets, postcards, stickers, and mailers, remains an important vehicle for social and political commentary but is beyond the scope of this exhibition.

Artists working with political and social subjects were not highly visible while Abstract Expressionism held sway in the fifties and then led to other abstract movements in the sixties. By the late sixties and early seventies, however, a pluralism began to emerge that extended to art with discernible subject matter. The feminist, ethnic, and other cultural movements reemphasized content in works of art, as did conceptual art and its offshoots. The eighties saw an increase in the prevalence of art about societal issues. Artists' groups such as Group Material and Collaborative Projects, Inc., which count among their members many who have been influential in the East Village art scene, have organized numerous exhibitions and projects on social and political themes. These groups have contributed signifi-cantly to the visual vocabulary of the period and have influenced the cultural mainstream.

Certain more established artists who were already working outside the resolutely abstract movements in the late sixties and early seventies have become more specifi-cally political in their works of recent years. These artists include Vito Acconci, Robert Arneson, Jonathan Borofsky, Chris Burden, Bruce Nauman, and William Wiley. Others, such as Robert Morris, turned from abstraction to work of profound political ramifications. And Leon Golub and Nancy Spero, who worked in these modes for years in relative isolation, were by the mid-eighties receiving widespread attention. The nature of the development traced above is reflected in the fact that, among the works

presented here, there are many more examples from the past dozen years than from the years prior.

Although the primacy of the message in the works in this study cannot be overemphasized, it is interesting to note that most of the artists communicate their concerns in the language of modernism. Collage techniques, in which otherwise familiar imagery or text is arranged in startling juxtapositions, occur frequently. Flattened surface areas that push out onto the frontal plane lend immediacy to confrontational works. Repeated modules of imagery or lines of text create minimalist, rhythmic patterns that relentlessly assert particular messages. Isolated images on stark backgrounds set up iconic figure/ground relationships that turn subjects into symbols. In addition, violent, expressionist gesture and color and distortion of the human figure often come into play in works addressing the subjects of violence and oppression.

These artistic conventions are employed in conjunction with the print mediums most appropriate for the task at hand. The flatness of silkscreen, the directness of block printing, the bite of etching, and the freedom of lithography all contribute to the power of this message-oriented art. The less traditional mediums of stencil and offset are often employed in activist art because they are easy and inexpensive. A few of the prints presented here were produced through photostat processes, and still others are monoprints. These unique works, however, are all part of large series or have compositions based on repeated images (as with stamping processes).

Prints in contemporary American art are often relegated to commodity status. Yet the variety of approaches and content explored in the work presented here evidences a vitality that is unique to the print mediums and underscores their populist origins. While the largest number of works in this study fall within the traditional domain of the limited-edition print destined to be mounted on the owner's wall, there are also many works whose purpose merges with that of graphic-arts posters. Some of these works incorporate declarative messages and were issued in quantity into the world. These prints fall roughly into two categories: conceptual and iconic.

The conceptual pieces present information in poster

format that is often ambiguous, provocative, and pointedly unusual for the sites in which they are placed. Often simply employing text, or text and imagery, such pieces have been posted in the streets, sold at newsstands, installed in restaurants, and mounted in subway stations. Yet these prints do not furnish the clear information we expect in a traditional poster.

The iconic work is closer to the traditional poster. Some pieces reproduced here, for instance, show bound figures in specific settings, yet their overall images serve to universalize the condition of victimization or oppression. Such prints were sometimes sold at benefits or given away; on occasion their imagery later became the basis for posters with texts added by the issuing organizations. Some of the stenciled images evolved within the context of artists' collectives and were sprayed on walls and sidewalks. Other prints announced specific exhibitions but contain messages of enduring relevance.

Another major area of printed works with social and political concerns is the benefit or commemorative print, issued individually or within portfolios for particular causes. Organizers of such projects usually request prints from a variety of artists, and the works contributed reflect all manner of artistic expressions. The benefit prints considered here make specific reference to the issues that inspired their making. Shahn's *Human Relations Portfolio*, for example, portrays three young civil rights workers who were killed in Mississippi in 1964; it was published in 1965 to benefit the Human Relations Council of Greater New Haven. Claes Oldenburg's *Proposal for a Monument to the Survival of the University of El Salvador: Blasted Pencil (That Still Writes)* and Leon Golub's *Merc* were both conceived to benefit Artists Call Against U.S. Intervention in Central America, a nationwide protest mounted in 1984.

During the period encompassed in this study, the United States Bicentennial elicited the most activity for portfolio prints. Marisol's *Woman's Equality* and Lawrence's *Confrontation on the Bridge* are from separate portfolios commemorating the event. Some of the most specifically political prints were created to benefit political candidates. Among the strongest prints in this category are Andy Warhol's satirical portrait of Richard M. Nixon, which was intended to advance the Presidential campaign of Senator George McGovern, and Robert Rauschenberg's contribution to Jimmy Carter's *Inaugural Portfolio*, a benefit for the Democratic National Committee.

A particularly important form of printed art, in the present context, is the artist's book. All the major themes of this exhibition are treated in a large selection of these inexpensive publications. Artists' books, which must be distinguished from deluxe *livres d'artistes*, came into prominence in the late sixties and early seventies, when there were hopes that the medium might emerge as a significant populist art form that could bypass the commercial gallery system. These goals were never fully realized, but the range of works represented here testifies to the power of the artist's book to convey social and political messages.

The 108 artists and sixteen collectives represented in this exhibition all work in America, although their art explores global concerns. For most of them, social and political themes are the major focus of their work. Others confront such subjects only occasionally, in reaction to immediate events. Among those artists who have made this material the prime concern of their art, particularly in the print mediums, are Elizabeth Catlett and Antonio Frasconi. Artists such as Peter Saul and Sue Coe have examined a range of these subjects in a figurative mode, as has Hans Haacke within a conceptual framework. Artists such as Judy Chicago and Suzanne Lacy have done pioneering feminist works, often engaging large groups of participants. As a result of its wide-ranging art "actions," the Guerrilla Art Action Group became known during its years of greatest activity as the "conscience of the art world."

Many of the artists in this exhibition are also committed activists and consider themselves cultural workers who have a mission that extends far beyond the parameters of the art world. They often organize within the community through neighborhood art and cultural centers. They combine image making with political actions in organizations such as Political Art Documentation/Distribution; they conduct oral history projects and prison art programs. Many are active participants in the community mural and poster movements. Others communicate through the press, reproduc-

ing work on the op-ed pages of *The New York Times* and other publications. And many work within the framework of collectives.

The information about individual art works presented in this study was gathered, for the most part, from the artists themselves. All questions of specific motivations and contextual information aside, however, this body of work offers important insights into the efficacy of social and political art in general. Among the achievements of these artists has been the creation of visual symbols for complex matters that are recognized and often experienced but never fully understood. The artist, in the traditional role of seer, gives us images filled with meaning that is otherwise inexpressible. Here there are powerful distillations of hope and striving, of the complexities of cultural heritage, and of the concept of the hero. We are shown emblematic images of such immediate realities as urban blight as well as portraits of more universal constructs, such as Everyman as soldier. In his eloquent work *Signs* (1970), Rauschenberg bears witness to an entire decade.

These prints can help us locate meaning in seemingly incomprehensible events of daily life by removing the actuality to a mythic plane; they can also focus communal outrage or grief. Some of the prints elicit a sense of shared pain; still others serve as vehicles for opposition and resistance. The artists portray the frailties of leaders and institutions, the fear of cultural differences, and the utter depths to which cruelty and barbarism can go. But in the final analysis it is not the specific issues or events that stand out. What we come away with is a shared sense of the human condition: rather than feeling set apart, we feel connected.

INTRODUCTION

1. David Hammons. *Pray for America*. (1969). Silkscreen and body print, printed in color, 60⅝ × 36⅝″ (154 × 93 cm). Collection A. C. Hudgins, New York

Pray for America is one of more than five hundred body prints Hammons did in the late sixties and seventies, many on social or political themes. All comprise impressions of the artist's body, and a good number incorporate the American flag. This print was done at a time of extraordinary upheaval throughout the country. Race riots were occurring in many cities, and demonstrators against the war in Vietnam were closing college campuses and organizing nationwide protests. The assassinations of Martin Luther King Jr. and Robert F. Kennedy in the preceding year were particularly bitter reminders of the violence and strife of the times. Hammons's print is an eloquent statement of foreboding and concern.

Pray for America was reproduced on the catalogue cover and poster for The Studio Museum in Harlem's exhibition *Tradition and Conflict* in 1985. The poster was seen all over New York. In discussing the image recently the artist noted, "The issues really haven't changed. The government still needs to be prayed for."

2. Louise Bourgeois. *No.* (1973). Photostat, 18 1/16 × 27 11/16″ (45.9 × 70.3 cm). Collection Inge Morath and Arthur Miller, Roxbury, Connecticut

Bourgeois's photostat derives from a ten-foot-long banner on canvas that she designed for Museum of Modern Art employees on strike in 1973. She joined the strikers and carried the long banner with the help of others. She then made a photostat edition of the design.

Bourgeois's concept of "No" as a protest cry relates to her marble sculpture of the same year, *The No March*, in which hundreds of small marble units are massed together on the floor or ground. Bourgeois sees in that piece a throng of individuals demonstrating in protest. With the repetitiveness of the small marble columns, and also of the word "No" in her banner design, she communicates the sense that the protesters will, in her words, "refuse to disappear."

1.
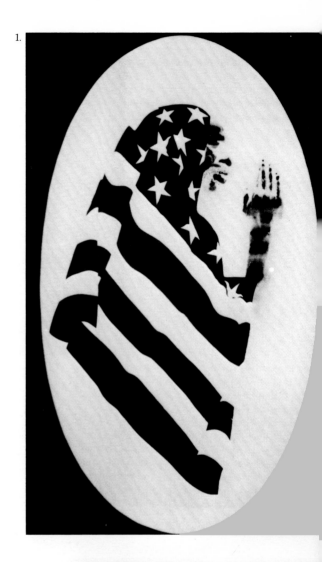

2.
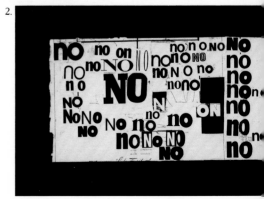

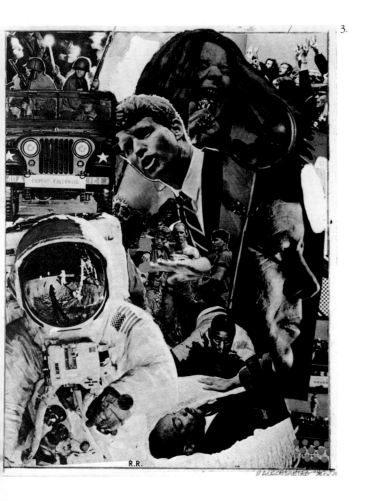

3.

3. Robert Rauschenberg. *Signs*. New York, Castelli Graphics, 1970. Silk-screen, printed in color, 43 × 34" (109.2 × 86.4 cm). Lent by the publisher, New York

Rauschenberg's silkscreen captures, precisely and vividly, all that is meant by "the sixties." With rare artistic insight Rauschenberg brings together some of the decade's most powerful images in a composition that evokes the era with startling passion. He offers us unforgettable signs of those times: John F. Kennedy, Robert F. Kennedy, and Martin Luther King Jr.; soldiers in and protesters against the Vietnam War; a fallen black man with a blood-stained shirt; the astronaut Edwin "Buzz" Aldrin standing in the Sea of Tranquillity; and the charismatic rock singer Janis Joplin, who would die from a drug overdose.

Rauschenberg originally conceived this image for a magazine cover, but it was never used for that purpose. At the time it was issued he stated that *Signs* was "conceived to remind us of the love, terror, violence of the last ten years. Danger lies in forgetting."

4. Larry Rivers. *Black Revue* from the portfolio *Boston Massacre*. New York, Marlborough Graphics, Inc., 1970. Silk-screen, printed in color, 19⅛ × 27⅜" (48.6 × 69.5 cm). Collection the artist, New York

Black Revue is one of thirteen silkscreens in a set titled *Boston Massacre*, in reference to the incident in 1770 in which British soldiers fired on Colonial American demonstrators, killing five. In 1968 Rivers had been commissioned to do a mural for a bank near the site of the massacre. His mural combines a map of Boston with images of British Red Coats and bodies strewn on the ground. The silk-screen set derives from studies for that mural.

The imagery in *Black Revue* is indicative of that throughout the portfolio in that it integrates references to the Boston Massacre with allusions to contemporary violence, such as racial conflicts and the Vietnam War. The print is dedicated to Crispus Attucks, the black Colonial American killed in the massacre. It also includes a picture of James Meredith, superimposed on a newspaper dated June 9, 1966. On that day Meredith, whose admission to the University of Mississippi in 1962 had caused violent riots, was wounded by a sniper during a voter-registration pilgrimage in Mississippi. Rivers's *Black Revue*, and indeed all of his Boston Massacre work, posits a struggle for civil liberties that did not end with the American Revolution.

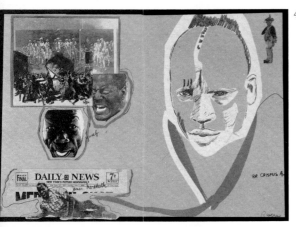

4.

5. James Rosenquist. *Cold Light*. Tampa and New York, University of South Florida Graphicstudio and Castelli Graphics, 1971. Lithograph, printed in color, 22½ × 30″ (57.2 × 76.3 cm). The Museum of Modern Art, New York. Gift of Monroe Wheeler

An artist who came of age with the Pop art movement, Rosenquist has used the imagery of American popular culture as a main ingredient in his work. During the early seventies he did a set of prints that refer to several subjects then preoccupying Americans. At the time, moon shots by Apollo astronauts were in the news, and the relationship of the moon to the earth is the underlying theme of the prints.

One of these works, *Cold Light*, stands as an eloquent "memorial" to the political situation in the world. The newspaper page included in it contains stories about the "Red Chinese," Lieutenant William L. Calley Jr., and Laos. Emotions were running high on the subject of mainland China, which would become a member of the United Nations later that year. Lieutenant Calley had recently been convicted of murder for his part in the 1968 massacre of Vietnamese civilians in the village of My Lai, and protests about his being a scapegoat for United States policy in Southeast Asia followed. Meanwhile the war continued with the invasion of Laos.

6. Faith Ringgold. *The United States of Attica*. (1971). Offset, printed in color, 21¾ × 27½″ (55.9 × 69.9 cm). Collection Artists' Poster Committee, New York

Deeply affected by the events surrounding the uprising at New York's Attica State Correctional Facility in September 1971, Ringgold conceived this "map of American violence." She did extensive research on the subject and virtually filled her map with hundreds of citations, including Bacon's Rebellion of 1676, the Omaha race riots of 1919, the political assassinations that occurred in the sixties, and casualty statistics from the Vietnam War. At the bottom of her map she instructs the viewer, "Please write in whatever you find lacking."

The poster was made to raise funds for the Judson Three (Ringgold, Jon Hendricks, and Jean Toche), who had been arrested and charged with flag desecration in connection with the *Peoples Flag Show* at New York's Judson Memorial Church in 1970. Several thousand posters were printed. In 1972 Ringgold put together a second edition of her map, adding further examples of violence in America. She had hoped to continue printing revised editions but by 1973 she found that no more citations could fit on the map.

5.
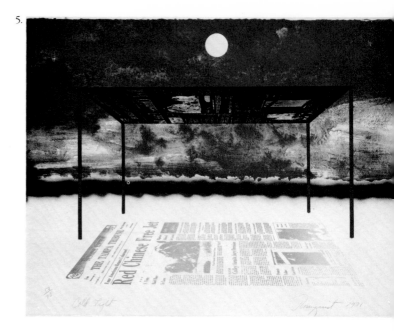

6.
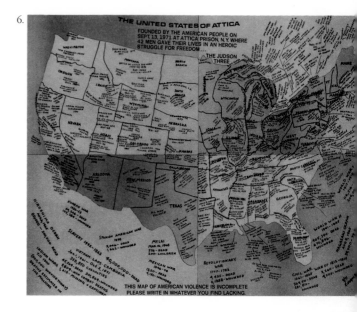

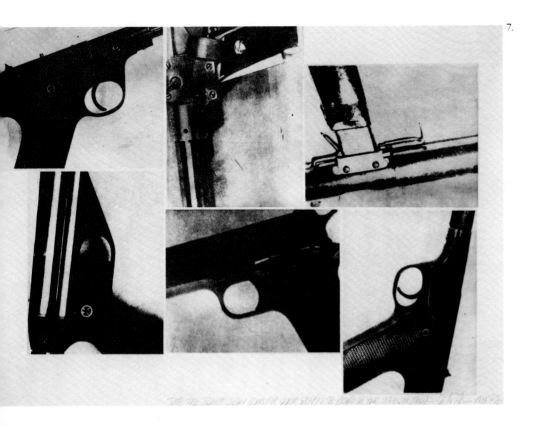

7.

descriptive photographs found in mail-order catalogues. Acconci's close-up, truncated views of the gun barrels and trigger openings also suggest phallic associations and add the subliminal message of "sex and violence." In fact the artist did a print on the theme of "sex for sale" at the same time he was working on this print. Acconci has said that he makes art as "a kind of instrument in the world"; in *Bite the Bullet* he succeeds in calling attention to an issue of critical importance through a graphic image of potential violence "to be etched on your American mind."

8. Rupert Garcia. *El grito de rebelde* (*The Cry of the Rebel*). 1975. Silkscreen, printed in color, 26 × 20″ (66 × 50.8 cm). Collection the artist, Oakland

8.

7. Vito Acconci. *Bite the Bullet: Slow Guns for Quick Sale (To Be Etched on Your American Mind)*. Oakland, Crown Point Press, 1977. Etching, 29⅜ × 41⅝″ (74.6 × 105.7 cm). Lent by the publisher, San Francisco

The grainy quality of Acconci's print enhances our sensation that we are getting a glimpse into a shadowy criminal underworld. At the same time, the multiple weapons make a chilling statement about the commonplace nature of violence in a society in which handguns are easily accessible. From this uncomfortably close vantage point we are able to distinguish the features of an array of gun types, in images that resemble the

Garcia's silkscreen stands as an archetypal characterization of an oppressed individual, although it is derived from a specific photograph of a political prisoner that was published in a 1974 brochure of the Iranian Students Association in the United States. Garcia's image was in turn published on the cover of the periodical *Toward Revolutionary Art* in 1975, and again on a Human Rights Day poster issued by Amnesty International in 1976 in a huge offset edition. His bright, flattened areas of color and abstracted composition serve to universalize his subject.

9. Adrian Piper. *Political Self-Portrait #3 (Class)*. 1980. Photostat, 36 × 24″ (91.4 × 61 cm). Collection the artist, Washington, D.C.

In this poster Piper presents an autobiographical sketch of childhood confusion. Her text elaborates on the fact that Piper lived in Harlem yet attended a fancy preparatory school with girls who lived on Park Avenue and shopped at Bonwit Teller. Caught up in Piper's intimate narrative, traced over a childhood snapshot, we become vividly aware of the societal implications of the artist's individual history. The other two *Political Self-Portraits* in Piper's series of three deal with sex and race. In all, the posters provide a grim manifestation of the notion that the personal is political: Piper's treatments of her own sex, race, and class speak to definitive issues of our time.

10. Jenny Holzer. *Truisms* (installed in New York, 1979). (1978–87). Photostat, 8′ × 40″ (243.8 × 101.6 cm). Courtesy Barbara Gladstone Gallery, New York

Holzer's *Truisms*, which in their entirety run to almost three hundred, seem to touch on every aspect of human experience. Some messages are clichéd (*A Man Can't Know What It's Like to Be a Mother*), others are philosophical (*Absolute Submission Can Be a Form of Freedom*). Still others are ironic (*Change Is Valuable Because It Lets the Oppressed Be Tyrants*) or comic (*You Get the Face You Deserve*). The variety

of viewpoints seems endless, and they provide an experience that is painful and amusing at the same time. Reading them all should give us perspective, but as much as we laugh at the preceding *Truism*, we cling to the next as truth.

Holzer began her *Truisms* in the late seventies as a street-poster campaign. They have since been presented in window installations and artists' books, as well as on handouts, billboards, T-shirts, coffee cups, and electronic signs in Times Square and Las Vegas. They also exist in Spanish, French, and German translations.

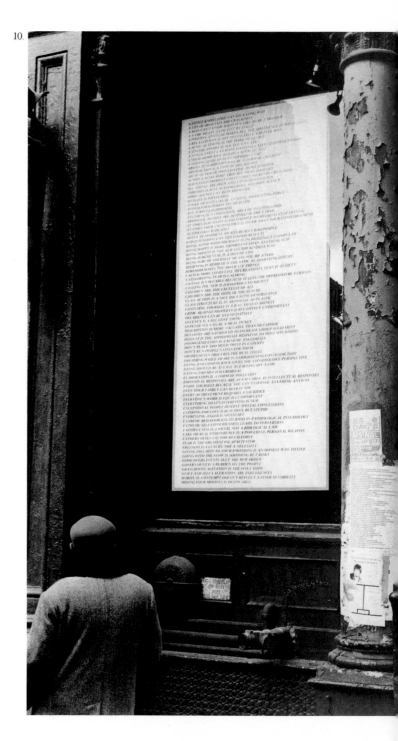

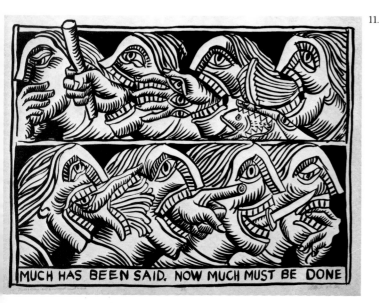

11.

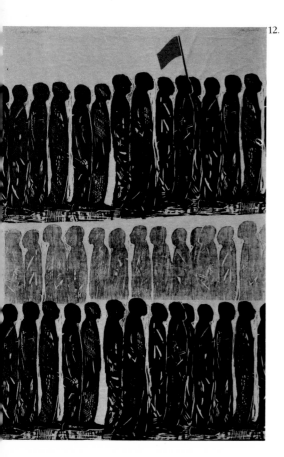

12.

11. Peter Gourfain. *Much Has Been Said. Now Much Must Be Done*. 1980. Silkscreen, 24 × 31⅛" (61 × 79 cm). Collection Lucy R. Lippard, New York

Gourfain's gargoylelike heads comment on the human condition in much the same way their Romanesque antecedents did by giving form to universal virtues and vices. Spewing forth a knife, an accusatory finger, and a club-bearing fist, among other things, they speak an incoherent language in which instinct over-rules intellect. Yet with the text "Much Has Been Said. Now Much Must Be Done," the night-marish vision becomes a call to action.

Gourfain's image has been used as a postcard and as the logo for the Alliance for Cultural Democracy, a nationwide organization of community groups dedicated to broadening the American cultural agenda. Similar heads were used on a button that Gourfain designed for the Artists Call Against U.S. Intervention in Central America events and exhibitions in 1984, and they appear elsewhere in his work on protest banners and terra-cotta urns as well as in ceramic or wood sculptures.

12. Luis Alonso. *Manifiesto V*. 1978. Woodcut, printed in color, 38⅝ × 25¼" (98.1 × 64.1 cm). Courtesy Galería Calibán, San Juan

Alonso offers in his silent marchers a representation of oppressed people united in a demonstration of protest. The marching figure has become a personal icon for the artist, and he has used it in many of his woodcuts, along with images of barbed wire, a figure crying out, and a burial, all as universal signs of besieged humanity.

Alonso's work issues from his experience of the political situation in Puerto Rico. What he describes as the repression of colonization and the struggle for Puerto Rican independence inspire his broad renderings of inhumanity and striving in the face of that inhumanity. Themes of social injustice and the abuse of power run throughout his work, yet his symbolic world view is always an eloquent visual statement of human dignity.

†

13.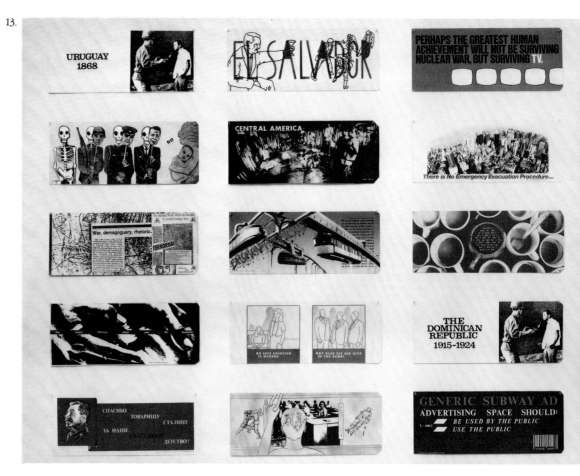

13. Group Material. Selections from the project *Subculture*.* (1983). Fifteen subway-car placards, printed in color and black, each 11 × 27⅞″ (28 × 70.9 cm). Collection Group Material, New York

Group Material is an artists' collective dedicated to "the creation, exhibition, and distribution of art that increases social awareness." After its founding in 1979 by the artists Douglas Ashford, Julie Ault, Mundy McLaughlin, and Tim Rollins, the group organized several exhibitions that became part of city life, a reflection of its belief that the context of art is an extremely important part of art's meaning. *Subculture* was one of these shows, and it was intended to "change that vacuous tableau faced by the commuter every day." It was mounted in September 1983, when the collective rented 1,400 advertising spaces on New York subway cars and installed the work of 103 artists (see †: Douglas Ashford, *El Salvador*).

*Individual artists, left to right: William Allen, Douglas Ashford, Erika Rothenberg, Marina Gutiérrez, Paul Smith, Dona Ann McAdams, Joseph Nechvatal, Day Gleeson/Dennis Thomas, Vana-lyne Green, Barbara Kruger, Ida Applebroog, William Allen, Komar and Melamid, Greg Sholette/Janet Koenig, and Lyn Hughes.

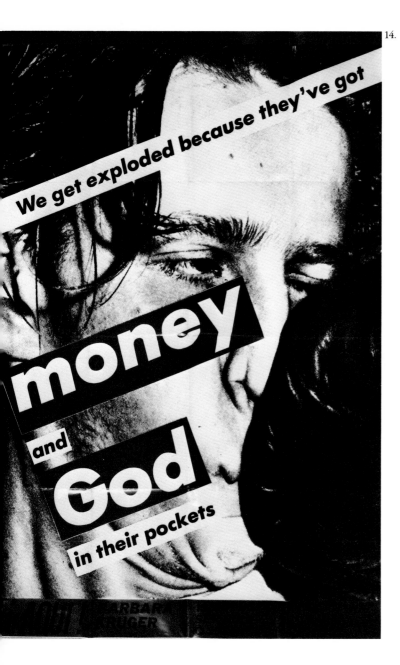

14.

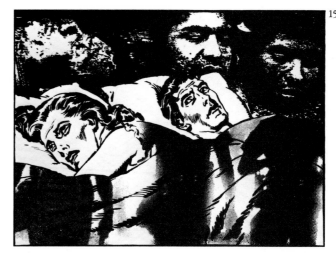

15.

14. Barbara Kruger. *We Get Exploded Because They've Got Money and God in Their Pockets*. Brooklyn, Aqui, 1984. Offset, printed in color, 69 × 44⅞″ (173.3 × 114 cm). Collection the artist, New York

Kruger's large folded poster is actually an issue of *Aqui* magazine. (The editors of the periodical ask artists to design images to be printed as posters, folded up, and sold at newsstands.) Here Kruger uses her usual format of photography and text in a layout reminiscent of advertising. The message here, as in most of her work, is suggestive rather than explicit. The word "exploded," for example, calls to mind the word "exploited" in the context of the words "money" and "God." Wealth and religion become the oppressors. The face of a boxer receiving a blow to the head dramatizes the implied act of exploitation and gives it a violent dimension. The work as a whole intimates that the success of one group is, almost by definition, at the expense of another.

15. Jerry Kearns. *Talking Heads*. 1985. Lithograph, 26¼ × 32⁹⁄₁₆″ (66.7 × 82.7 cm). The Museum of Modern Art, New York. John B. Turner Fund

Kearns's collage image depicts an uncertain situation of anxiety and fear. While the couple's expressions suggest problems of a personal nature, their dream-filled night presents an external threat well beyond their control. The couple seems haunted by the silent, masklike faces above them and terrorized by the shadows of militaristic figures below. At the top of the piece Kearns uses photographs of the heads of Salvadorans reportedly killed by death squads; at the bottom he uses silhouettes of Miami riot police quelling outbreaks among blacks. The artist has said that he sees the white male as the pivotal figure and that the images above and below are signs of racial oppression, both in the Third World and in our own cities. The title is a reference to a politicized rock-and-roll group.

16. Jos Sances for Mission Gráfica. *Dan White Released*. (1984). Silkscreen, printed in color, 35 × 23⅛″ (88.9 × 58.7 cm). Collection Mission Gráfica, San Francisco

Mission Gráfica is the graphics workshop of the Mission Cultural Center, founded in San Francisco's predominantly Hispanic Mission District in 1976. The workshop has been co-directed by Jos Sances and René Castro since 1981 and has served many community and political groups.

Sances's silkscreen was done for a San Francisco gay activist group, the Ad Hoc Committee, to be used during demonstrations protesting the parole of Dan White. A former city supervisor, White was released in January 1984 after serving just over five years in prison for the murders of Mayor George Moscone and Supervisor Harvey Milk in November 1978, inside City Hall. The figural shape wrapped in newspaper at the center of the print is a reference to a portrait bust of Moscone by Robert Arneson. That sculpture, commissioned for the Moscone Convention Center, made graphic reference to the mayor's murder and was ultimately rejected. In this print newspaper accounts of the rejection controversy form the bust's ominous shroud. The background is made up of packages of Twinkies, one of the junk foods that the defense cited in its claim that White's ability to reason had been impaired by his unnourishing diet.

16.

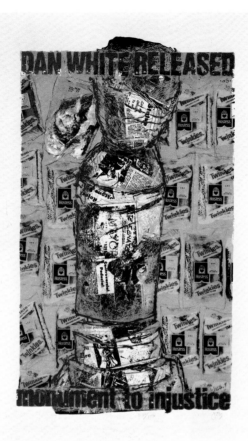

17.

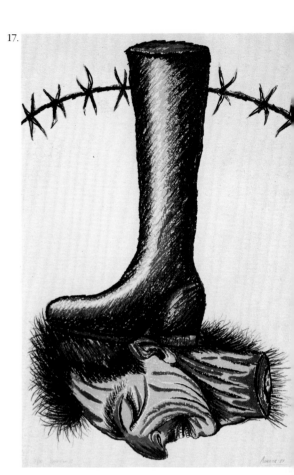

17. Luis Cruz Azaceta. *Oppression III*. 1987. Silkscreen, printed in color, 35⅛ × 23 1/16″ (89.2 × 58.5 cm). Collection the artist, New York

Azaceta's emblematic image is meant as a universal symbol of inhumanity and cruelty. The artist chooses to show the victim rather than the oppressor because he believes all regimes eventually cause suffering and social ills. "Regardless of a right- or left-wing power," he states, "the victim remains—the same dog with a different leash." Azaceta's silkscreen is the third

18.

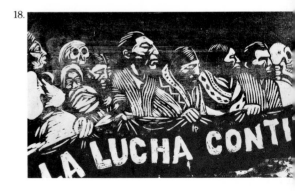

ork in a series titled *Oppres-
ion*. In all three a figure is
ned under a boot. In the first
age, a painting of 1984, the
ure crouches on all fours like
animal. In the second the
dy is severed at the waist,
th only the upper torso and
ad (a self-portrait) remaining.
Oppression III only the head
nains, again a self-portrait.
cording to the artist, "the de-
bitation illustrates not only
plence and death but also
e repressed thoughts of the
lividual."

Carlos Cortez. *La lucha continua
ve Struggle Continues*). 1986. Wood-
, printed in color, 17⅜ × 22⁹⁄₁₆″
8 × 57.3 cm). Collection the artist,
icago

lucha continua is one of
ozens of woodcuts and lino-
um cuts that Cortez has made
ce the sixties for political
uses, particularly those involv-
g the union worker and the
icano movement. Unlike
any of his prints on specific
bjects or events, *La lucha
ntinua* expresses a gener-
zed sentiment for all op-
essed people. The imagery
s drawn from a photograph of
peasant demonstration in
livia. Cortez has added skel-
on figures that derive from the
ints of the Mexican artist José
adalupe Posada (1852–1913),
orks that have always given
m inspiration. Cortez posts
me of his prints directly on
e street, while others are used
raise funds for organizations
d causes.

Artists' Books

19. Rudolf Baranik. *Dictionary from
the 24th Century* (with "Rudolf Bar-
anik: An Interview" by Jim Drobnick).
Boston, Bee Sting Press, 1987.
Offset; 9¹¹⁄₁₆ × 7⅜″ (24.6 × 18.7 cm),
20 leaves. The Museum of Modern
Art, New York

Since the early eighties Baranik
has contributed photostats of
ironic definitions from his self-
styled "Dictionary from the 24th
Century" to various exhibitions
on political themes. Although
the artist has executed about
thirty such definitions, they have
never been seen together. On
the occasion of a recent retro-
spective exhibition, however,
nine definition pieces were in-
stalled together and reproduced
in this small volume, which rep-
resents the closest approxima-
tion of an actual dictionary that
has appeared thus far. The nine
definitions included are: "monu-
ment," "armament," "1984,"
"apartheid," "earth," "post-
modernism," "world," "New
York City," and "state." Baranik, a
committed activist, distinguishes
his definition work from the
shadowy, enigmatic paintings
that comprise his main artistic
activity.

20. John Fekner. *Danger Live Artists:
Queensites*. Bjärred, Sweden,
Wedgepress & Cheese, 1982. Offset,
printed in black and color; 6⁵⁄₁₆ ×
9⁷⁄₁₆″ (16 × 24 cm), 27 leaves. The
Museum of Modern Art, New York

Fekner's artist's book documents
his outdoor stencil work from
1978 to 1982. During that time
Fekner stenciled words and
phrases on outdoor sites, calling
attention to social problems by
labeling them. Although some
of the projects were done in
Sweden and Canada, most were
executed around New York;
many of the actual works have
disappeared. The most dramatic
image in the book is a photo-
graph of Ronald Reagan, at the
time a Presidential candidate,
surrounded by reporters while
campaigning on Charlotte Street
in the South Bronx. Fekner's
stenciled word "Decay" stands
out on a crumbling building in
the background.

The projects in the book
address environmental issues,
neighborhood blight, nuclear
power, discrimination against
Native Americans, and the
power of the news media. In
describing one stencil project
executed in collaboration with
local teenagers, Fekner has ex-
plained, "We were working like
anonymous Ralph Naders."

21. Guerrilla Art Action Group. *GAAG:
The Guerrilla Art Action Group
1969–1976, A Selection*. New York,
Printed Matter, Inc., 1978. Offset; 8½ ×
5½″ (21.6 × 14 cm), 186 leaves. The
Museum of Modern Art, New York

The Guerrilla Art Action Group
(GAAG) was established in 1969
by the artists Jon Hendricks and
Jean Toche. It began as an out-
growth of the Action Committee
of the Art Workers' Coalition, a
large, New York–based associa-
tion of activist artists. GAAG
initiated dramatic protests, con-
sidered art works, in the form of
"actions," which issued from the
tradition of theater and Happen-
ings but which took place in the
real world. "Provocation, con-
frontation, and action" were the
means through which GAAG at-
tempted to accomplish its aims.

GAAG was invited by Printed
Matter, which at the time not
only distributed but also pub-
lished artists' books, to produce
in book form a compilation of
the documentation it had cre-
ated as an integral aspect of its
protest actions. The resulting
volume describes fifty-two ac-
tions undertaken by GAAG to
make known its views on artists'
rights and "classist and racist"
policies in museums; govern-
ment leaders and their policies
(particularly concerning the
Vietnam War); and such events
as the uprising at Attica State
Correctional Facility and the trial
of the black activist Angela
Davis, among other things.

22. Barbara Kruger. *No Progress in Pleasure*. Buffalo, Center for Exploratory and Perceptual Art (CEPA), 1982. Offset, printed in black and color; 11 × 8½″ (27.9 × 21.6 cm), 10 leaves. The Museum of Modern Art, New York

Kruger's artist's book reproduces as page art twelve of her photo-collage combinations of text and image. The commercial format of these works derives from her many years as an art director at *Mademoiselle* magazine. The messages in Kruger's art are always elusive, but certain undercurrents are discernible throughout. Power, for instance, is a continuing theme, particularly as experienced by the powerless (*Your Assignment Is to Divide and Conquer*). There are also many references in her work to being acted upon rather than being the initiator of action (*Your Gaze Hits the Side of My Face*). And the pictorial components of Kruger's art—razor blades, bloodied hands, or sharp spikes, for example—often have a violent aspect. Feminist concerns thread throughout her work, but Kruger's trenchant examinations challenge a broad range of social constructs.

Many of the works reproduced in this book have been made in poster form and put up in the streets; Kruger has also created many billboards. In commenting recently about her art, Kruger said, "I don't want to be correct. I want to make a difference."

23. Martha Rosler. *3 Works: I. The Restoration of High Culture in Chile; II. The Bowery in Two Inadequate Descriptive Systems; III. In, Around, and Afterthoughts (On Documentary Photography)*. Halifax, The Press of the Nova Scotia College of Art and Design, 1981. Offset; 8 × 10¾″ (20.3 × 27.3 cm), 50 leaves. The Museum of Modern Art, New York

In the first part of Rosler's *3 Works* a polite social meeting unexpectedly turns into a chilling account of the overthrow of the Chilean leader Salvador Allende in 1973. Rosler then lists information which she believes demonstrates how United States interests were served by the overthrow of the Marxist president. The piece was initially done as a handout for a memorial exhibition for Orlando Letelier, a former minister in Allende's government who was assassinated in Washington, D.C., in 1976.

The second and third parts of Rosler's book were conceived together. The Bowery piece, which has played a prominent role in critical thinking about photography, is a scathing view of the New York locale and also of the ways in which drinking and drunkenness are perceived in the general population. Rosler juxtaposes deadpan photographs of empty Bowery sidewalks and street corners with word sequences such as "squiffy, snozzled, screwed, bleary-eyed, glassy-eyed, cross-eyed, cockeyed." The third part of *3 Works* considers the purposes and effects of documentary photography in the twentieth century.

24. Erika Rothenberg. *Morally Superior Products*. New York, SZ Press, 1983. Offset; 8½ × 11″ (21.6 × 27.9 cm), 10 leaves. The Museum of Modern Art, New York

Rothenberg's artist's book at once speaks to such controversial issues as abortion, disarmament, and gun control and comments on the public's relationship to the advertising industry. The artist uses advertising strategies, particularly those associated with television, to get her messages across. In doing so she expresses her view of the cynicism of advertising that counts on the gullibility of the public. Rothenberg, who once worked as an art director in an advertising agency, believes that a direct, unambiguous art can be most meaningful.

Rothenberg's book reproduces paintings she made between 1980 and 1982 and was conceived as a vehicle to disseminate her images. She has recently used a poster format as well.

25. We're All in the Same Boat. *Calendar of Social & Political Images*. New York, We're All in the Same Boat, 198 Offset, printed in color and black; 16 × 11″ (40.6 × 27.9 cm), 18 leaves The Museum of Modern Art, New Yo

Some of the artists in the We're All in the Same Boat collective had worked together before embarking on their calendar p ect, but the group was named for this venture. The members of the collective, many of them Brooklyn neighbors, bought a printing press and in a series o meetings chose the issues that would be addressed in the illustrations for their calendar: apartheid, nuclear weaponry, oppression in Central America women's rights, the homeless, and police brutality, among others. The resulting set of woodcuts, printed on several different colored papers, was made into a portfolio, exhibite at various places, and sold. Thi offset version of the calendar, made in an edition of 1,000, wa more widely distributed.

GOVERNMENTS/ LEADERS

26. Vito Acconci. *Three Flags for One Space and Six Regions*. Oakland, Crown Point Press, 1983. Photoetching and aquatint, printed in color, 72 × 64″ (182.9 × 162.6 cm). Miriam and Ira D. Wallach Division of Art, Prints, and Photographs, The New York Public Library, Astor, Lenox, and Tilden Foundations

Acconci approached this project with the intention of making a print that would serve as a "rallying cry" in the way a poster can. He intensifies the potency of the flag motif by placing those of three powerful countries—the United States, the Soviet Union, and the People's Republic of China—in close proximity. After bringing the flags together in this uncomfortable bonding, Acconci effects a divisiveness by separating the composition into six clearly articulated parts. In so doing the artist presents a visual paradigm for superpower interaction, confrontation, and isolation. Acconci's work on this print led him to employ flags as a motif in an eight-foot-high piece in the shape of a folding house, which further explores the issue of superpower interaction.

27. Andy Warhol. Plate from the book *Flash—November 22, 1963* by Phillip Greer. Briarcliff Manor, New York, Racolin Press, 1968. Silkscreen, printed in color, 21⁷⁄₁₆ × 21¼″ (54.4 × 54 cm). The Museum of Modern Art, New York. Gift of Philip Johnson

Warhol's *Flash—November 22, 1963* may be seen as a commemorative book, in the tradition of volumes created to mark important events long before radio and television became the prime vehicles for disseminating information. Phillip Greer, a reporter, was hired to write a text in the form of news bulletins on President Kennedy's assassination. The bulletins begin with the President's arrival in Dallas and end with his funeral cortege in Washington, D.C. Warhol's images prompt the reader's memory rather than present the actual sequence of events. Renderings of Kennedy campaign posters, Kennedy's face, and Jacqueline Kennedy in her pink suit and pillbox hat stimulate a host of strong associations, as do images of the rifle used in the shooting, the window from which Lee Harvey Oswald is thought to have fired the fatal shots, and Oswald's face. A review of the text and the accompanying prints in this book leads to a vivid personal recreation of the drama and pain of those few days, days most Americans who were old enough to remember will never forget.

26.
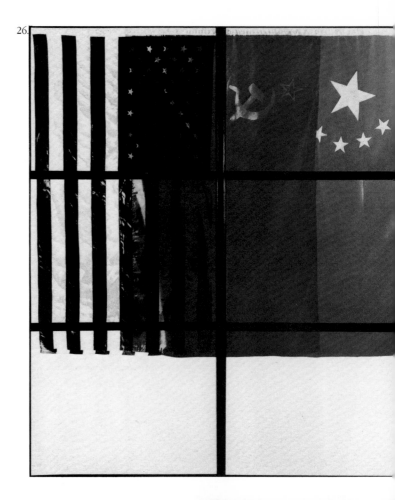

27.
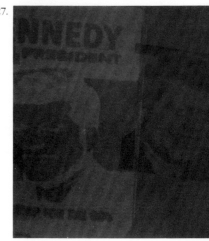

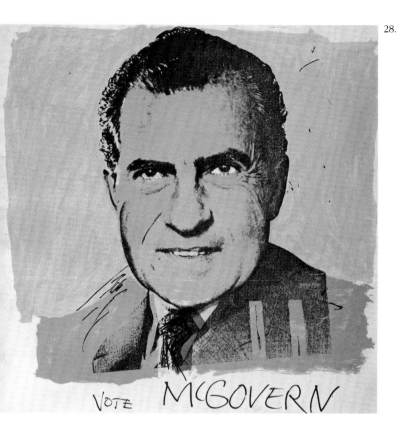

28.

28. Andy Warhol. *Vote McGovern*. Los Angeles, Gemini G.E.L., 1972. Silkscreen, printed in color, 42 × 41¹⁵⁄₁₆″ (106.7 × 106.6 cm). The Museum of Modern Art, New York. Gift of Philip Johnson

Published to raise funds for Senator George McGovern's campaign for President in 1972, Warhol's print is hilarious to those who were opposed to President Richard M. Nixon. McGovern supporters apparently believed that this unflattering portrait of the President as "tricky Dick" would encourage voters to choose their candidate. It has been noted, however, that although the poster raised $40,000 for the McGovern campaign, it actually garnered votes for both of the candidates. Warhol did posters for a variety of political candidates in his career, among them Edward Kennedy and Jimmy Carter on the national level and Carter Burden on the local level in New York.

29. Jim Dine. *Drag*. London, Editions Alecto, 1967. Lithograph, printed in color, 34¼ × 47″ (87 × 121.9 cm). The Museum of Modern Art, New York. Gift of Mr. and Mrs. John Jakobson

With a high-spiritedness that reflects the sensibility surrounding Pop art and that part of the sixties scene that created miniskirts and the "mod" fashions of Carnaby Street, Dine creates an outrageous spoof of superpower leaders. In a sociopolitical image unique in his work, Dine gives President Lyndon B. Johnson and Chairman Mao Tse-tung clownlike makeup and lipstick to produce a prettified, "drag" appearance. He takes a swipe at the powers that be in much the way graffitists do when adding details to imagery in public places, giving it a new and ridiculous meaning. During this period Johnson, with his Great Society programs as well as the burden of the Vietnam War, was at the center of the world stage. Mao, too, was the source of much attention, with his Cultural Revolution and his "Little Red Book."

29.

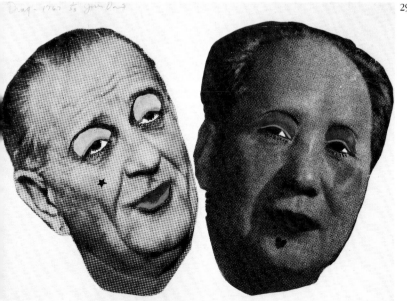

30. Robert Rauschenberg. Untitled from the *Inaugural Portfolio*. New York, Democratic National Committee, 1977. Lithograph, printed in color, 31 × 22″ (78.7 × 55.9 cm). Collection the artist, New York

Rauschenberg's print is part of a portfolio commissioned by the Presidential Inauguration Committee for Jimmy Carter in 1977. Other prints in the portfolio are by Jacob Lawrence, Roy Lichtenstein, Andy Warhol, and Jamie Wyeth. Rauschenberg frequently has done prints to benefit political candidates and organizations.

Jimmy Carter, a former governor of Georgia, was virtually unknown on a national level when he announced his candidacy early in the 1976 Presidential campaign. He was elected, in part, for his "outsider" image, when after the scandals of Watergate and the resignation of President Nixon, it was seen as an advantage to be outside the Washington system. Rauschenberg combines in this print the lofty symbols of the United States seat of government with images that evoke the "down home" qualities that contributed to Carter's appeal.

31. Anton van Dalen. *Swords into Plowshares/Buses into Bombers*. (1981). Stencil, printed in color, 10⅞ × 26⅜″ (27.6 × 67 cm). Courtesy Edward Thorp Gallery, New York

Van Dalen's stencil print was conceived for a Group Material campaign in which twenty-seven artists contributed works for display on Manhattan's Fifth Avenue bus lines. Van Dalen's image addresses the Reagan Administration's military buildup during a period of cutbacks in domestic programs such as public transportation. The work's conception and title relate to a biblical passage often cited in the cause of pacifism: "And he shall judge among the nations, and shall rebuke many people; and they shall beat their swords into plowshares, and their spears into pruning hooks; nation shall not lift up sword against nation, neither shall they learn war any more."

30.

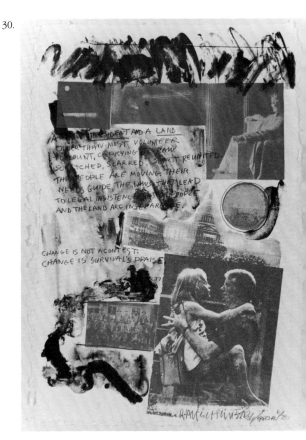

31.

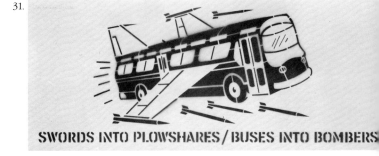

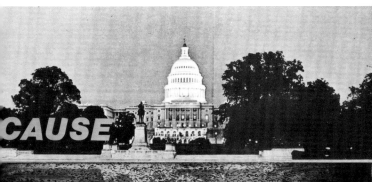

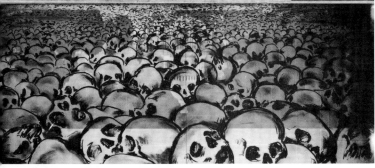

32.

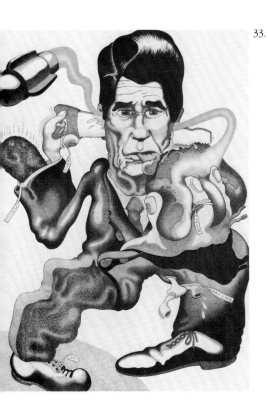

33.

32. Collaborative Projects, Inc. *Cause/
Effect* (design by Kiki Smith, Charlie
Ahearn, and Jane Dickson) from *The
Poster Project*. New York, Collaborative
Projects, Inc., 1984. Offset, printed in
color, 22¾ × 34¹⁄₁₆″ (57.8 × 86.5 cm).
Collection Andrea Callard, New York

Since its founding in 1978 the
artist's group Collaborative Proj-
ects, Inc. (Colab), has organized
a variety of experimental, collab-
orative exhibitions that bypass
the commercial gallery system.
In 1984 a group of Colab mem-
bers—John Hogan, Janet Stein,
and Darryl Turner—proposed a
street-poster project to the gen-
eral membership. The intent was
to achieve the direct impact of
traditional posters in images that
instead were intended primarily
as art. In the collective spirit of
the organization, all posters had
to result from the efforts of
more than one person, and all
the artists were required to use
the same sheet size and colors.

Cause/Effect, the result of a
collaboration among the artists
Kiki Smith, Charlie Ahearn, and
Jane Dickson, offers a grim view
of the ramifications of govern-
mental policies. The throng in
front of the United States Capitol
is not a mass of demonstrators
but a mass grave. Across the
portion of the print that depicts
the Capitol is the word "Cause";
across the sea of skulls is the
word "Effect" (regrettably
obscured in the present repro-
duction). According to one of
the collaborators the words and
image make up a kind of visual
"motto" for the continuing
effects of governmental policies.

33. Peter Saul. *Politics*. Chicago, Land-
fall Press, 1984. Lithograph, printed in
color, 32¾ × 23½″ (83.2 × 59.7 cm).
Lent by the publisher, Chicago

Throughout his career Saul has
conceived grotesque images
of injustice. In some works the
artist scrutinizes general sub-
jects, such as race, class, eco-
nomics, or government. In
others he targets specific events,
such as the Vietnam War or the
Three Mile Island nuclear acci-
dent; or specific people, such as
Bobby Seale, Angela Davis, or
Richard Nixon. Around the time
of the 1984 Presidential election
Saul again took on Ronald Rea-
gan as a subject in paintings,
drawings, and prints. (He had
dealt with him earlier, when
Reagan was Governor of Califor-
nia.) Relatively speaking, his
images of Reagan are not as
horrific as those of some of his
other targets. In *Politics* the
figure of the President becomes
a logolike sign of overwhelming
confusion. A close look at the
details reveals a grasping hand
of power and a tongue licking
at the world. Saul has described
his method of labeling body
parts as similar to the tagging
system used in morgues.

34. Guerrilla Art Action Group. *Letter Action of October 22, 1972.* 1972. Engraving, 7½ × 5½" (19 × 14 cm). Collection the Guerrilla Art Action Group, New York

The Guerrilla Art Action Group's engraved letter to President Nixon was sold on the streets of New York to raise money for the 1972 McGovern Presidential campaign. GAAG repeated in this piece a command it had issued in an earlier letter action to the President, *Eat What You Kill.* In this second work the niceties of the engraved medium contrast strikingly with the longer, even more barbarous message expressed by such words as "slaughtering," "roasting," "meat," and "rotting" used in connection with "Vietnam" and "American Dream." GAAG printed the engraving in an edition of 150 and sent the first and second numbers to President Nixon and Senator McGovern, respectively.

35. Leon Golub and Nancy Spero. *They Will Torture You, My Friend* from the portfolio *Conspiracy: The Artist as Witness.* (1971). New York and Brookline, Massachusetts, Center for Constitutional Rights and David R. Godine, 1972. Silkscreen, printed in color, 17¹¹⁄₁₆ × 23¾" (44.9 × 60.4 cm). The Museum of Modern Art, New York. Purchase

This silkscreen is one of twelve prints in the benefit portfolio *Conspiracy: The Artist as Witness*, published as a tribute to the defense in the Chicago Conspiracy Trial of 1969. (Tom Hayden, Abbie Hoffman, Jerry Rubin, Bobby Seale, and others

who had led demonstrations at the 1968 Democratic National Convention were the defendants in that controversial trial. All were found innocent of conspiracy.) Other prints in the portfolio were by Jack Beal, Alexander Calder, Sol LeWitt, Robert Morris, Claes Oldenburg, Larry Poons, Bridget Riley, Peter Saul, Raphael Soyer, and Frank Stella.

The left side of this rare collaboration between Golub and Spero shows an evocative detail from a sculpture by Golub of 1953. The clearly distinguishable chains give the ambiguous composition threatening overtones. The right side incorporates an image from Spero's involvement with the writings of Antonin Artaud. (Her *Codex Artaud* would be exhibited in 1973.) The quote about torture, the red stainlike arc, and the shadowy chains all take on special meaning in the context of the portfolio. One of the defendants in the trial, Bobby Seale, was bound and gagged by marshals during the proceedings, and the entire trial came to be seen by many as a spectacle of protest theater.

34.

35.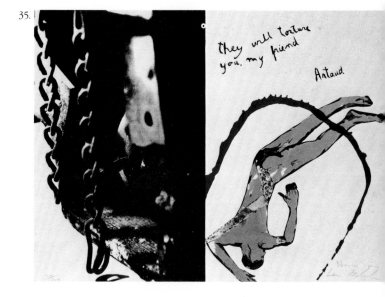

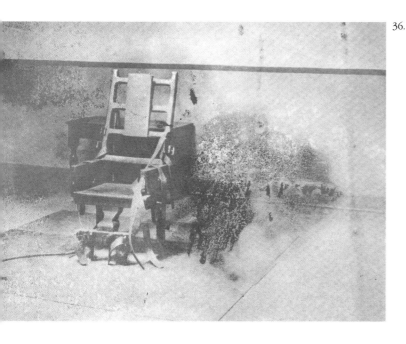

36.

37.

36. Andy Warhol. Untitled from the portfolio *Electric Chair*. Zurich, Bruno Bischofberger, 1971. Silkscreen, printed in color, 35⅞₆ × 47⅞" (90 × 121.6 cm). The Museum of Modern Art, New York. Gift of Philip Johnson

Warhol's electric chair is a morbid and fascinating icon. This work is part of a portfolio of ten identical images printed in different color combinations. In some the color and printing processes almost obliterate the chair, and only a ghostly silhouette remains. Warhol's unremitting focus on an actual device of capital punishment leaves no room for consideration of the criminal acts cited as justification for its use. The artist's coldblooded rendering of the official execution machine in contemporary America has the effect of condemning the judicial order it was invented to carry out. Some interpreters of Warhol's electric chair and of his work in general contend that no social commentary is involved. The power of this image in particular, however, calls that view into question.

37. Faith Ringgold. *Peoples Flag Show*. New York, The Independent Artists Flag Show Committee, 1970. Offset, printed in color, 18 × 24" (45.7 × 61 cm). Collection Artists' Poster Committee, New York

Ringgold, who in the late sixties incorporated the flag in several powerful painted images, designed this poster to announce the exhibition *Peoples Flag Show*. The Independent Artists Flag Show Committee sponsored this installation of works made in response to the query "Artists, workers, students, women, third world peoples . . . what does the flag mean to you?" The exhibition challenged what the poster refers to as "repressive U.S. govt. and state laws restricting our use & display of the flag." Ringgold's daughter, the writer Michele Wallace, wrote the text.

For the show, more than two hundred works were brought to New York's Judson Memorial Church and mounted by the artists. Scheduled to remain on view November 9–14, 1970, the exhibition was closed by order of the district attorney's office a day early. Ringgold, along with the artists Jon Hendricks and Jean Toche, was arrested at the church and charged with flag desecration. The Judson Three, as they became known, were found guilty in May 1971 after months of protests and demonstrations of support from the art community and civil libertarians.

38. Jack Levine. *The Daley Gesture.* Greenwich, Connecticut, Lublin Graphics, 1969. Aquatint and drypoint, 14¹⁵⁄₁₆ × 23½" (37.9 × 59.7 cm). Collection Abraham and Micheline Lublin, Key Biscayne, Florida

With *The Daley Gesture* Levine records an infamous moment at the 1968 Democratic National Convention and adds Mayor Richard J. Daley of Chicago to the cast of politicians, military men, gangsters, and tycoons that is the subject of biting commentary in much of his work. In his satiric characterization Levine fashions a stereotype from a particular person by exaggerating the corpulent body and sinister expression of his subject.

Levine was invited to the convention by *Time* magazine, and some of his renderings of the event were later reproduced as part of the weekly's coverage. The artist singles out the moment when Mayor Daley ran his finger across his throat as a signal to convention organizers to turn off the microphone of Senator Abe Ribicoff, who was protesting police treatment of demonstrators outside the convention hall.

39. Margia Kramer. *Rehnquist to Hear Black Panther Case, May 1, 1980.* (1980). Photostat on transparent film, 71 × 37½" (180.4 × 95.2 cm). Collection the artist, New York

Kramer's haunting photostat on the subject of Justice William H. Rehnquist and the Black Panther Party was made as a component of her installation work on the late Jean Seberg, which focuses on FBI surveillance of the actress. (Seberg was the target of FBI surveillance and counterintelligence activities as a result of her support of the Black Panther Party in the late sixties and early seventies.)

The present work, which originally served as contextual material within the Seberg installations, was first exhibited by itself in the *Law and Order Show* (1986), a New York benefit for the Center for Constitutional Rights. Because that exhibition coincided with hearings on Rehnquist's appointment as Chief Justice of the Supreme Court, Kramer's photostat took on new meaning within it, its emphasis shifting from the Black Panthers to Rehnquist himself. The newspaper article reproduced in the work refers to the Supreme Court, former Attorney General John Mitchell, and the Chicago police. According to the artist, these references to government branches, leaders, and departments demonstrate "the interlocking nature of the hegemony of official ideology."

38.

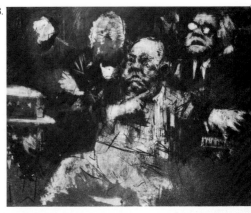

39.

40a.

40b.

40c.

40a–c. Antonio Frasconi. *Law and Order—Attica*. 1971. Woodcut, printed in color, 22⅜ × 30¹⁄₁₆″ (56.9 × 76.3 cm). *Law and Order—Kent*. 1972. Woodcut, printed in color, 22⅜ × 30¹⁄₁₆″ (56.9 × 76.3 cm). *Law and Order—The Guardian*. 1971. Woodcut, printed in color, 30¹⁄₁₆ × 22⅜″ (76.3 × 56.9 cm). All courtesy Terry Dintenfass Gallery, New York

As he does in so many works throughout his oeuvre, Frasconi brings a symbolic dimension to actual events in his woodcut series *Law and Order*. Some of the works in the series have four-part formats, which enable the artist to focus on different details at the same time. The circular, embossed signs at the centers of these works read simultaneously as targets and as abstract shapes with mythic connotations.

In *Law and Order—Attica* Frasconi incorporates newspaper photographs of a yard at New York's Attica State Correctional Facility in September 1971, when inmates seized the prison and issued demands. At the end of the four-day crisis state troopers stormed the penitentiary; several dozen inmates and hostages were shot to death in the assault. In one quadrant of his woodcut Frasconi depicts the head of a slain spokesman for the prisoners.

Law and Order—Kent addresses the violence at Kent State University in Ohio in May 1970, when National Guardsmen fired on students demonstrating against the United States invasion of Cambodia, killing four. Here Frasconi mixes newspaper photographs of fallen students with symbolic renderings.

The most brutal image in the *Law and Order* series (which also includes prints titled *Law and Order—George Jackson* and *Law and Order—Wounded Knee*) is that in *Law and Order—The Guardian*, of the National Guardsman so familiar from scenes of civil disobedience. With gas mask and tanks, he appears half man, half beast. Frasconi's series evokes, with irony, a time in our history when public officials commonly invoked the phrase "law and order" when attempting to control mass protest.

41. Frank Stella. *Attica Defense Fund*. New York, The Artist Benefit for Attica Legal Defense Fund, 1975. Offset, 29½ × 29½" (74.9 × 74.9 cm). Collection Artists' Poster Committee, New York

In 1975 the Artists' Poster Committee became aware that the lawyers for inmates involved in the 1971 Attica uprising were seeking defense funds. Since the committee was also interested in illuminating the sociopolitical issues surrounding the Attica upheaval, they organized a benefit exhibition and sale, called *A Decade of Political Posters by American Artists, 1965–1975*. Stella was asked to do a poster to raise money for the benefit. The abstract image the artist chose for his poster takes on a foreboding quality, even triggering associations with prison bars, in the context of the words "Attica Defense Fund." Stella used the same black image in his contribution to the portfolio *Conspiracy: The Artist as Witness* (1971).

42. Leon Golub. *White Squad*. New Brunswick, New Jersey, Mason Gross School of the Arts, Rutgers University, 1987. Lithograph, 29¾ × 41⅞" (75.6 × 106.4 cm). Courtesy Barbara Gladstone Gallery, New York

Golub's White Squads represent police, as opposed to mercenary soldiers or interrogators, other major protagonists in the artist's work. In these works the police—civil agents of the state— are seen in acts of flagrant abuse of power. Details from two of the artist's *White Squad* paintings

make up the encounter depicted here. (The head on the left is from *White Squad (El Salvador) IV* [1983], the title of which gives a specific reference to place that is unusual in this series.)

By including only the heads and a weapon, the artist intensifies the psychological interaction of the moment. The villain's sadistic expression and the victim's utter vulnerability contribute to the atmosphere of terror. Golub photographed the face on the left (taken from his painting) from an acute angle, giving it an even more sinister cast. He then photocopied the composition to heighten the contrasts and roughen the texture before proceeding with the print. The resulting lithograph has the immediacy of a broadside, which is particularly appropriate for the subject at hand.

43. Antonio Frasconi. *Los desaparecidos VI (The Disappeared VI)*. 1986. Woodcut, 41⅝ × 29⁹⁄₁₆" (105.7 × 75.1 cm). Courtesy Terry Dintenfass Gallery, New York

Frasconi's harrowing image of a hooded figure, a visual encapsulation of repression, is part of his ongoing series on "the disappeared" in Latin America. "The disappeared" are those citizens who "vanished" during government campaigns against internal resistance; Amnesty International has termed the phenomenon "an especially abhorrent method of government repression." Survivors of "disappearances" in Argentina have described the military govern-

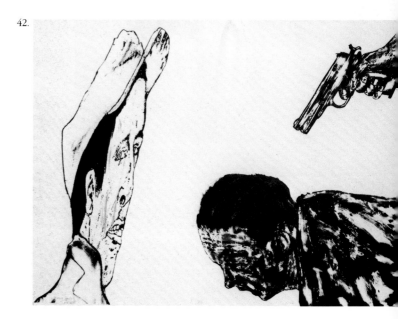

41.

42.

43.

FREEDOM FOR
POLITICAL PRISONERS

45.

KAMOOK BANKS GARY TYLER EDGARDO ENRIQUEZ DENNIS BANKS

REGINA MARCONDES KIM CHI HA LOLITA LEBRON MARTIN SOSTRE

44.

Her Fragrance Lingered on

45. Rachel Romero with Leon Klayman for the Wilfred Owen Brigade. *Freedom for Political Prisoners*. 1976. Linoleum cut with collage, 23½ × 34½″ (59.7 × 87.7 cm). Collection the artists, New York

Romero and Klayman founded the political-poster group the Wilfred Owen Brigade (later known as the San Francisco Poster Brigade) in 1975. This linoleum cut was commissioned for the cover of the catalogue for a Bicentennial event at the San Francisco Art Institute. A festival of Third World dance, film, performance, and visual art, the event was titled *Other Sources: An American Essay*. Romero and Klayman took the opportunity to introduce political concerns into this forum on cultural activities. Their image is comprised of portraits of political prisoners whose fates the brigade was following. The heads in the upper right and left symbolize Chile and Argentina, countries in which imprisonment for political reasons was widespread at the time. The prisoners' names were added before the offset-poster version of the linoleum cut was made. The brigade mounted the poster around San Francisco at the time of the event to make more widely known its view that Third World culture and Third World politics are inextricably linked.

44. Luis Camnitzer. *Her Fragrance Lingered On* from the series *Uruguayan Torture*. 1983. Photoetching, printed in color, 29½ × 21⅞″ (74.9 × 55.6 cm). Collection the artist, Great Neck, New York

Camnitzer's *Uruguayan Torture* series is made up of thirty-five prints that evoke the daily existence of a torture victim. The repetitiveness of the format and the warm, veiled tones created by the etching process mesmerize us and pull us into intimate contact with the events described. We become closely involved in a narrative that makes us recoil in horror.

A Uruguayan citizen, Camnitzer did research for this series by talking with friends who had been imprisoned and by studying Amnesty International documentation on torture in Uruguay and in Latin America in general. According to the artist, the text "Her Fragrance Lingered On" refers to the one documented female torturer in Latin America.

ment's widespread practice of abduction, torture, and murder for political reasons in the book *Nunca Más* (*Never Again*; 1985), prepared by the Argentine National Commission on the Disappeared. Frasconi has focused on the phenomenon as it relates to Argentina, Brazil, Chile, and Uruguay, where he grew up. The subject has preoccupied the artist for the last five years and has been the basis of an extensive series of woodcuts, some conceived as single images and others executed for a bound set.

Artists' Books

46. Black Emergency Cultural Coalition and Artists and Writers Protest Against the War in Vietnam. *Attica Book*, edited by Benny Andrews and Rudolf Baranik. New York, Black Emergency Cultural Coalition and Artists and Writers Protest Against the War in Vietnam, 1972. Offset; 10¹⁵⁄₁₆ × 14″ (27.8 × 35.5 cm), 57 leaves. The Museum of Modern Art, New York

Two activist-artist groups of the late sixties and early seventies joined forces to publish this compendium of art in response to the 1971 Attica uprising. The book reproduces paintings, drawings, collages, prints, and sculptures by forty-eight concerned artists. Some works refer to actual events at Attica; others are abstract and in this context take on a symbolic character. The book also includes a selection of poems by four Attica inmates. Proceeds from the sale of the book went toward the distribution of free copies within the prison system. In the preface the artists/editors Benny Andrews and Rudolf Baranik make the following statement: "Attica—one year old—is no longer a locality upstate New York. This three-syllable word is a battle cry and lament—the *Guernica* of America's dispossessed."

47. Guerrilla Art Action Group. *November 19, 1971: Contribution to the 8th N.Y. Avant Garde Festival of the 26th Armory of New York—Description of Action, Receipt from the Fortune Society and a Statement of Fact on the Attica Massacre*. 1971. Photocopy on five sheets, each 11¹⁄₁₆ × 8½″ (28.1 × 21.6 cm). Collection the Guerrilla Art Action Group, New York

The Guerrilla Art Action Group designed this action regarding the inmate uprising at Attica for the eighth New York Avant Garde Festival, which took place just two months after the tragedy occurred. GAAG's aims were threefold: "to raise some amount of money" for the families of those who died at Attica; to draw attention to the festival's setting (a barracks for the National Guard); and to "refuse the censorship" of the festival organizers, who had specified "no politics." As part of the action GAAG members mounted a large printed list of the names of those who died at Attica and passed a collection box. The documentation of the action includes photocopies of this list and of the donation receipt from the Fortune Society, which had established an Attica fund for burial expenses. GAAG views such documentation, including written communiqués sent through the mails, as an integral part of its actions. *November 19, 1971* was mailed to 150 people soon after the festival component of the action took place.

48. Margia Kramer. *Essential Documents: The FBI File on Jean Seberg*, Parts I and II. New York, 1979 and 1980. Offsets; each 8½ × 5½″ (21.6 × 14 cm), 20 and 22 leaves respectively. The Museum of Modern Art, New York

Kramer's two small-format books were produced as guides to and mementos of installations derived from FBI documents on the late actress Jean Seberg, material obtained through the Freedom of Information Act. Kramer speculates in the foreword to Part I of *Essential Documents* that FBI surveillance and counterintelligence activities from 1969 into the seventies, undertaken as a result of Seberg's financial support of the Black Panther Party, "contributed to Seberg's distress, emotional breakdown and suicide."

Early in her career Seberg had been touted by Hollywood image makers as the perfect, all-American girl. Few people who remember the fifties can forget the extraordinary hype surrounding the talent search that turned the unknown Iowa seventeen-year-old into a star. The FBI memoranda reproduced in Kramer's books, scarred by deletions, indicate how the abuse of a governmental agency's power contributed to the decline of a woman whose public persona had been created through the power of Hollywood and the media.

49. Les Levine. *Watergate Fashions*. New York, Museum of Mott Art, Inc. 1973. Offset; 11 × 8½″ (27.9 × 21.6 8 leaves. The Museum of Modern Art New York

In 1972, at the Watergate apart ment complex in Washington, D.C., employees of the Nixon reelection campaign were arrested while burglarizing the offices of the Democratic National Committee. The subs quent investigations eventually led to the resignation of President Nixon. Levine's text docu ments the audio component o his slide performance *Waterga Fashions*, a series of shots of a television screen on which the 1973 Watergate hearings were being aired. In his text Levine espouses no political views bu simply names the senators and witnesses and the days on whi they spoke, adding descriptior of their clothes. This catalogue of the suits, shirts, and ties of such senators as Howard Bake Sam Ervin, Daniel Inouye, and Lowell Weicker, and of such witnesses as John Dean, John Ehrlichman, and Jeb Magruder gradually takes on an absurd humor. The monotonous ward robe listing undercuts the profundity of the historical drama so many were viewing and stresses one of the few areas o commonality among the witnesses, senators, and members of the television audience.

RACE/CULTURE

50. Ben Shahn. *The Human Relations Portfolio*. New Haven, Human Relations Council of Greater New Haven, 1965. Three silkscreen facsimiles of drawings, printed in color, each 22 × 16⅞" (55.9 × 42.9 cm). Courtesy Terry Dintenfass Gallery, New York

In the summer of 1964 the young civil rights workers James Chaney, Andrew Goodman, and Michael Schwerner were found murdered in Mississippi. They had been the subject of a long and widely publicized search, in which the FBI and ultimately even President Johnson played a part. Seven white men were eventually convicted of conspiracy in the workers' deaths.

Shahn memorializes the young men with eloquent renderings that achieve an iconic dimension in their simplicity. They also reveal something of the individual personalities of the three victims. We are struck, first, by the youthful idealism in their faces. Chaney was from Mississippi, and met Schwerner at a voter-registration training session. He worked at the community center in Mississippi set up by Schwerner and his wife. Goodman, a junior at Queens College in New York, also worked at the Schwerners' community center. Schwerner had been a social worker on New York's Lower East Side before he began his work in Mississippi.

50.

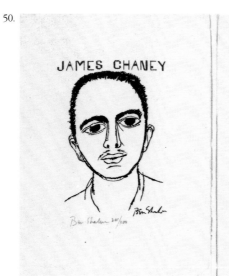
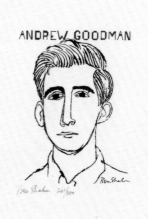
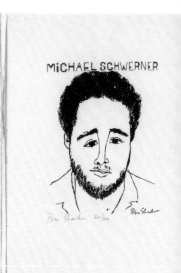

51. Benny Andrews. *Right On!* 1972. Etching, 29⅞₁₆ × 20⅞" (74.8 × 53 cm). Collection the artist, New York

Andrews's *Right On!* is from a group of etchings done in the early seventies on social and political themes. (Other works in the group include *Pusher, Strung Out,* and *Sexism,* all from 1972.) Andrews has said that *Right On!* was inspired by the Attica uprising in 1971; it stands as a symbolic rendering of the concept of defiance. He has explained further that he wanted to evoke an idea that goes "beyond violence" and "encompasses dignity." The raised, clenched fist became a familiar expression of black solidarity in the late sixties and early seventies, as did the exclamation "Right on!" An abbreviation of the expression "right on time," the phrase derives from black culture and conveys approval and encouragement.

51.

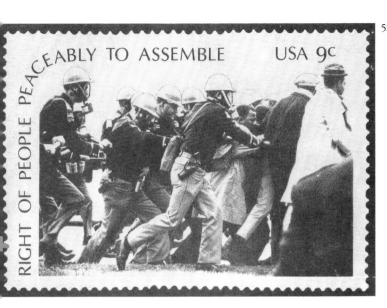

52.

53.

52. Janet Koenig. *Right of People Peaceably to Assemble*. 1982. Silkscreen, printed in color, 23¾ × 30″ (60.3 × 76.1 cm). Collection the artist, New York

Koenig's silkscreen is based on an actual postage-stamp design of the mid-seventies. The artist preserves the original's text but substitutes a different image and gives the stamp a horizontal format. (The original stamp depicted the dome of the United States Capitol.) Koenig's image is derived from a photograph of the Alabama state police charging civil rights activists in a protest march from Selma to Montgomery, in 1965. She chose a civil rights subject because she originally conceived her work for an exhibition protesting the infamous *Nigger Drawings* show of abstract works at Artists Space in New York in 1979.

Koenig has done a number of variations on postage-stamp designs. In explaining her decision to base her work on such models the artist has said, "As advertisements for the state, postage stamps encourage patriotism and project an idealized national history in which social contradictions vanish and democracy triumphs. To question what is represented on postage stamps is to begin to imagine the history that has been left out."

53. Melvin Edwards. *Night Chain*. 1973. Etching and aquatint, 30¾ × 22⅜″ (78.1 × 56.8 cm). Courtesy the Printmaking Workshop, New York

In this powerful and provocative work Edwards arranges clearly distinguishable chains in a mesmerizing minimalist format. An all-over composition brings the chains right to the surface of the paper, leaving no area free of them. The associative power of the image stimulates an intensely imagined fear of potential or past pain. But because the print is about the anticipation or memory of violence rather than an actual event, we are not afforded the release of an ending: the threat evoked in Edwards's image is constant.

Edwards began incorporating chains in his sculpture in the potent *Lynch Fragments* series, initiated in 1963, a time of intense civil rights struggles in America. In the early seventies he employed barbed wire and hooks in conjunction with chains and locks in minimalist sculptures with overtones of violence and anger. He also made many works on paper, similar to this print, which were created through the use of these objects in a stencil/watercolor technique. A composition related to that in *Night Chain* was included in *Attica Book* (1972).

54, 55. Vincent Smith. *First Day of School* and *Mississippi Incident*. 1965. Etchings, 14¾ × 20⁹⁄₁₆″ (37.5 × 52.2 cm) and 21¹⁵⁄₁₆ × 14⅞″ (55.9 × 37.8 cm). Collection the artist, New York

54.

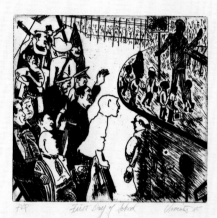

55.

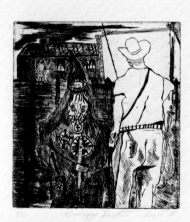

Smith's etchings depict scenes from the American South of the mid-sixties. His scratchy, etched lines communicate the "bite of the print" so often referred to in social and political printed art. *First Day of School* records a symbolic confrontation in the days of the most bitter conflicts over school desegregation. A sheriff, a Klansman, and various armed men agitate on the left side of the print. Their jeering, taunting mass contrasts starkly with the group of small children carrying lunchboxes and books at the right. The paunchy figure of a Southern politician stands ineffectually between the two.

In *Mississippi Incident* Smith constructs a scene reminiscent of the nightmarish world found in the prints of James Ensor. Here Smith's Klansman stands as a monster with hairs sprouting from his face. The Klansman and the sheriff loom large behind a fence, while two figures walk unaware in the background. Smith's prints were done during the height of civil rights demonstrations and racially motivated violence in the South.

56.

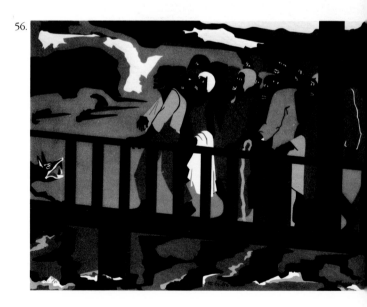

57.

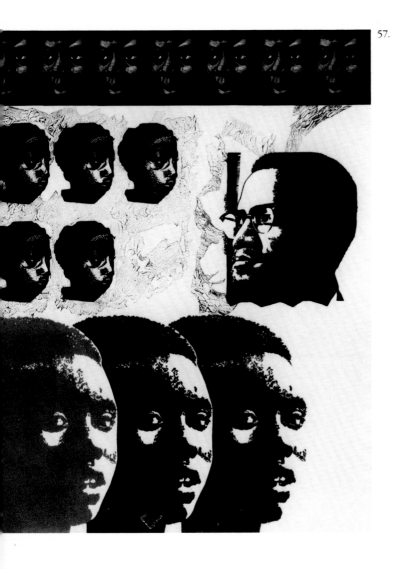

56. Jacob Lawrence. *Confrontation on the Bridge* from the portfolio *An American Portrait 1776–1976*. 1975. New York, Transworld Art, 1976. Silkscreen, printed in color, 19½ × 25⅞" (49.3 × 65.8 cm). Courtesy Terry Dintenfass Gallery, New York

57. Elizabeth Catlett. *Malcolm X Speaks for Us*. 1969. Linoleum cut, printed in color, 37⅞ × 27⁹⁄₁₆" (94.9 × 70 cm). Collection the artist, Cuernavaca, Mexico

The jagged lines in Lawrence's silkscreen create a threatening environment in which the sky and the water echo the fierce jaw of the howling dog at the left. The moment depicted in this print occurred on a bridge in Birmingham, Alabama, in 1963, when a civil rights march led by Martin Luther King Jr. was blocked by T. Eugene "Bull" Connor, the city's police commissioner and a vehement adherent of segregation. The atmosphere in the print seems to reflect more than a particular moment, however; rather, it captures the mood that made Birmingham the focal point of the drive against racial segregation throughout the South at that time. Lawrence's print was commissioned for a Bicentennial portfolio that included the work of thirty-three other artists, as well as fiction and historical writings.

Although she was living in Mexico during Malcolm X's strongest years of influence, Catlett was deeply moved by the Muslim leader's powerful messages. Born Malcolm Little in Omaha, Nebraska, in 1925, the militant activist preached black nationalism. He was shot and killed in New York in 1965.

Here, using the linoleum cut technique she has employed since the forties, when she began working at the Taller de Gráfica Popular in Mexico City, Catlett creates an arresting visual statement concerning the impact of the charismatic leader. She knew of the sentiment that Malcolm X had given black men their manhood back. Catlett has said that she wanted to show in this work that black women, too, were being given back their pride. All of the faces surrounding Malcolm X in the print are female. As the print's title makes plain, they are asserting "Malcolm X speaks for us."

58. Tim Rollins + K.O.S. *By Any Means Necessary*. New York, Fashion Moda, 1986. Silkscreen on book page, 10³⁄₁₆ × 6¹⁵⁄₁₆″ (25.9 × 17.6 cm). Lent anonymously

Tim Rollins, an artist and teacher in the South Bronx, created *By Any Means Necessary* in collaboration with Kids of Survival (K.O.S.), participants in his after-school program for teenagers there. In accordance with its usual art-making process, the group based a visual art work on its understanding of a literary work, in this case *The Autobiography of Malcolm X*. The silkscreen was printed on a page from the book, and its title refers to a well-known rallying cry of the black leader. The emblematic configuration superimposed on the page incorporates the initials "M" and "X" and was derived from African decoration. It has the impact of a logo whose abstract shape comes from the tradition of modernist art.

It was Franklin Darnell Smith, a K.O.S. participant, who initiated the project on Malcolm X. This work evolved through group discussions and art-making activities that continued for more than a year. The black configuration was first used in several larger works that incorporated series of the book's pages as grounds. This silkscreen was published to benefit Fashion Moda, an alternative-arts collective in the South Bronx. *The Autobiography of Malcolm X* is the most overtly political literary work explored by Tim Rollins + K.O.S. to date.

58.

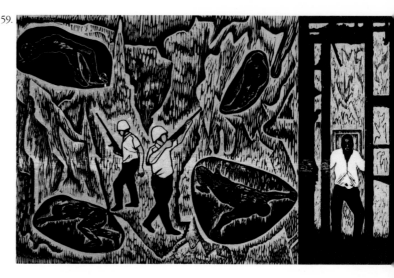

59.

59. Elizabeth Catlett. *Watts, Detroit, Washington, Newark*. 1970. Linoleum cut, printed in color, 23¼ × 35¾″ (59 × 90.8 cm). Collection Samella Lewis, Los Angeles

Catlett's linoleum cut is one of several from the late sixties and early seventies that demonstrate her close connection to the black liberation movement in the United States, although she was living in Mexico at the time. (Other such prints include *Homage to the Panthers* and *Black Is Beautiful*, also from 1970.) When she heard accounts of the chaos in so many American cities, she remembers thinking back to a Harlem riot in the forties that was "a collective emotional eruption." In this print she portrays black people fallen at the hands of white police, suspended in what she refers to as "womblike" enclosures. A frightened survivor hovers nearby in a burned-out building. During this period

60.

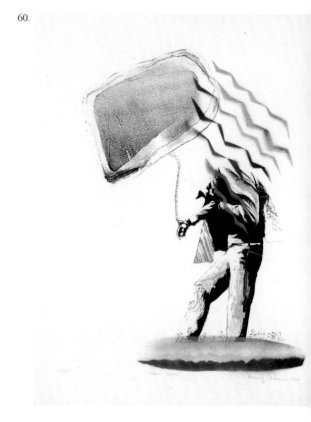

61.

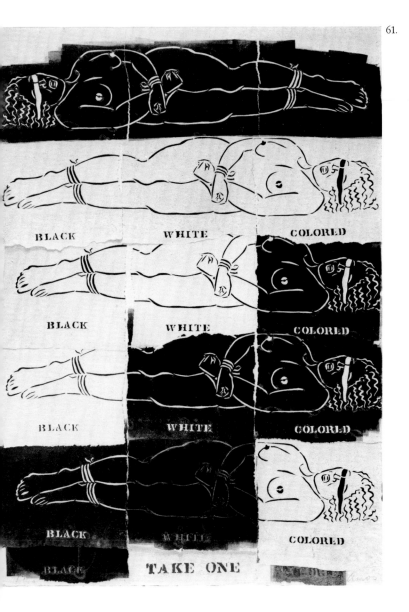

Catlett stated, "I have gradually reached the conclusion that art is important only to the extent that it helps in the liberation of our people. It is necessary only at this moment as an aid to our survival."

60. Benny Andrews. *From Home*. 1975. Photocopy and stencil, printed in color, 29¹⁵⁄₁₆ × 22⅜" (76.2 × 56.8 cm). Collection the artist, New York

For Andrews the title *From Home* signifies being "away" in an inhospitable place and far from home. He interprets the individual depicted as someone caught in a situation beyond his control, bound by unsolvable problems.

Andrews's concept derives from the situation of a specific person, George Jackson, whose influential collection of prison letters, *Soledad Brother*, was published in 1970. Jackson's killing in a disputed escape attempt at San Quentin Prison in 1971 prompted a major outcry from black activists. Andrews has said that he chose the subject of Jackson, whose fate was seemingly out of his own control, to symbolize circumstances of contemporary life in which many continue to find themselves. As he does in much of his realist-based art, Andrews here attempts to explore a universal concept through a specific event.

61. Emma Amos. *Take One*. 1985–87. Stencil, printed in color, 41½ × 29¼" (105.4 × 74.3 cm). Collection the artist, New York

Take One was originally conceived for an exhibition sponsored by Art Against Apartheid, an organization made up of artists from many fields which since 1984 has sponsored a variety of cultural events aimed at focusing attention on the racial policies of South Africa. In this brutal portrait Amos gives the reality of apartheid human form. As she states it, the repeated image is "of a bound and helpless human, torn in black, white, and colored pieces by the absurd racism of apartheid." Her composition highlights the aggressive pulling apart of people and the reconstruction of those people according to a perverse standard. *Take One* is a profound expression of the helplessness of the victims of apartheid, and of their state of being acted upon, in effect, of being defined by something or somebody outside themselves. Through a grotesque metaphor Amos's print portrays an inhuman system.

62. Vivian Browne. *Amistad I*. 1970. Etching and aquatint, 15⁵⁄₁₆ × 22³⁄₁₆″ (38.9 × 56.4 cm). Collection the artist, New York

In 1839 the Africans aboard the slave ship *Amistad* mutinied. The ship was later seized off the coast of Long Island and they were brought to trial. The case received widespread attention, with many abolitionists raising funds for the defense of the Africans. Former President John Quincy Adams successfully defended the Africans before the Supreme Court, and they were finally freed. The incident has inspired work by many artists and writers.

Vivian Browne learned about the *Amistad* incident during the late sixties, when she became involved in black rights issues. With this newly discovered knowledge she created the imagery in *Amistad I*. Using the working method she still employs today, Browne brought forward her subject from the suggestions of her random markings on the plate. The result is a symbolic statement on freedom and slavery. She interprets the image on the right as a gesture of flight and escape, and that on the left as a suggestion of cotton bales and burlap, which evokes the lives of those left behind.

63. Romare Bearden. *Roots Odyssey*. (1976). Offset, printed in color, 28¹⁵⁄₁₆ × 21″ (68.4 × 53.4 cm). Collection Ben and Beatrice Goldstein, New York

Bearden's collage design on the subject of Alex Haley's book *Roots* (1976) was produced in conjunction with the television miniseries that aired in January 1977. The epic tale of Afro-American heritage captured the popular imagination, and the miniseries was hailed as the most-watched program in television history. Bearden's collage was the basis for this promotional offset print and was also pictured on the cover of *TV Guide*. The artist has said that he decided to add the hope for freedom, even in the context of a slave ship, in depictions of white birds and the rising sun. He has also said that his project led to his *Odysseus* series of the next few years. He realized that the long and troubled journey described in Homer's *Odyssey* was especially relevant to the Afro-American experience.

62.

63.

64.

65.

PARTHEID (obsolete) a Dutch-Afrikaans term for separation of
he races (archaic) used in the territory of what is now Azania.

PARTHEID (historic) an extreme form of intra-species segrega-
ion and oppression used in the Republic of South Africa—Unie
an Suid Afrika, in the last stages of the primitive era and ended
n the first quarter of the 21st Century. The system of apartheid
esembled the customs of forest animals who mark their terri-
ories and attempt to exclude creatures recognized as other by
cent and sight. Human territorial marking and segregation was
ased on sight determination of skin pigmentation, head struc-
ure and the form of hair.

Vritten codification of the system shows that the people of the
white race (archaic) of South Africa held full sway over the people
f the black race (archaic) and two other groups, known as
oloured and Indian. However remaining archaic documentation
n photography (archaic), video (obsolete), laser-prints (archaic)
nd diapositives (obsolete) show that in real color terms the
kin of the white race people was pink, the skin of the black race
eople was brown and the skin of people described as brown
as light beige. The pink South Africans, who arrived from North-
estern Europe in the 17th and 18th Century, though always
minority, lived a largely parasitic life, forcing the brown and
eige members of the species to do most of the physical work,
while at the same time restricting their places of domicile and
epriving them of all power.

n the second half of the 20th Century the most retarded segment
f the pink South Africans, known as Nationalists (archaic) came
power and this led to an intensified struggle against apartheid
y the majority. Near the end of the century civil dislocation and
total refusal to work for the pinks paralyzed the country and
oppled the apartheid rule. South Africa was renamed Azania-
antu Afrika and proclaimed the equality of all citizens. Some
nglish-speaking pink South Africans migrated to England and
ome Afrikaans-speaking pinks attempted to go to Holland, but
ere refused entry as non-productive and backward. By the end
f the 21st Century color of skin ceased to be an issue and the
roups started to merge. Zulu and other Bantu languages started
dominate Uhuru (formerly Johannesburg) and Biko (formerly
apetown) as well as the countryside of Azania-Bantu Afrika. A
escendent of the pink Afrikaaners, Jan Kinabetabele Smutdaal,
merged as a leading novelist in the Zulu language. The Bantu
ulture of the region now predominates but also incorporates
ome Afrikaans and English traditions.

ICTIONARY OF THE ENGLISH LANGUAGE, 24TH CENTURY EXCERPTED BY RUDOLF BARANIK

64. David Hammons. *Free Nelson Mandela*. (1987). Stencil, printed in color, cut from outdoor posted site, 28¹³⁄₁₆ × 28¹¹⁄₁₆″ (73.2 × 72.5 cm). Collection the artist, New York

Hammons's street stencil is the second print he has done on the subject of Nelson Mandela. (He has also executed a public sculpture on the subject, which was commissioned by the city of Atlanta.) When Hammons's stenciled portrait is posted, his Nelson Mandela takes on the aspect of a vigilant being, present in spirit if not in body to watch over events. Indeed, that is precisely the position the imprisoned leader occupies in the minds of many of his fellow black South Africans. Although he has been since 1964 serving a life sentence for subversive activity, Mandela remains a powerful figure in the resistance to apartheid, as does his wife, Winnie Mandela. As the black South African bishop and Nobel Peace Prize winner, Desmond Tutu, has stated it, Winnie and Nelson Mandela "have become a symbolic couple with their incredible strength and refusal to be broken."

Born in 1918, Nelson Mandela practiced law before his imprisonment. He was a leader of the outlawed African National Congress and later advocated taking up arms against South Africa's system of apartheid. A recent poll indicates that seventy percent of that country's blacks regard him as their leader.

65. Rudolf Baranik. *Apartheid*, excerpted from *Dictionary of the English Language, 24th Century*. (1984). Photostat, 25 × 19″ (63.5 × 48.3 cm). Collection the artist, New York

Baranik's seemingly official dictionary definition is actually from the artist's self-styled "Dictionary of the English Language, 24th Century." His view of apartheid from the almost vertiginous perspective of several centuries in the future distances us from the events occurring in our time. From the vantage point of the twenty-fourth century, the absurdity rather than the cruelty of our "primitive era" is felt. In his hopeful view from the future Baranik describes apartheid as "an extreme form of intra-species segregation and oppression" which has long since "ended."

Baranik has conceived numerous definitions for use as broadsides in exhibitions on political themes. *Apartheid* was done for an Art Against Apartheid show in the fall of 1984; it has also taken the form of page art in periodicals.

66. John Woo. *Make Choices*. (1981). Silkscreen, printed in color on two sheets, each 22¹⁵⁄₁₆ × 30¹⁄₁₆″ (56.7 × 76.4 cm). Collection the artist, New York

With the command "Make Choices," Woo voices what he terms "a positive call" to action. Woo, who has designed many community posters and broadsides for the Basement Workshop arts center in New York's Chinatown, contrasts this affirmative command with many slogans of what he calls "movement art." He believes that much protest rhetoric is based on lamenting a situation rather than on formulating action.

Although the figures in Woo's print are actors from one of the many propaganda plays performed in China during the time of Chairman Mao's Cultural Revolution, he has said that the image is about being a Chinese-American and living in America. Woo chose the scene primarily for its bold impact and show of firm resolve.

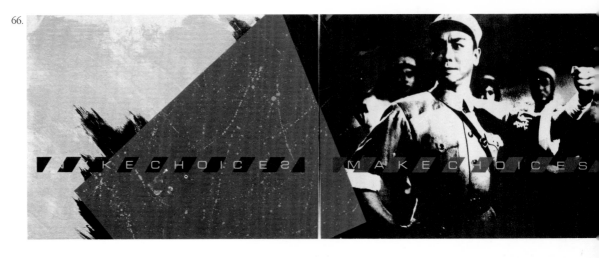

66.

67. Qris Yamashita. *Redress/Reparations Now!/Little Tokyo*. Los Angeles, the Woman's Building, 1983. Silkscreen, printed in color, 30⅛ × 22¾″ (76.5 × 57.8 cm). Collection the Woman's Building, Los Angeles

Yamashita's silkscreen confronts us with evidence of the United States' discriminatory treatment of a group of its citizens during World War II. She reproduces a document that was posted in Los Angeles neighborhoods on May 3, 1942, instructing people of Japanese ancestry to evacuate the area by May 9. It calls on Japanese-Americans to "report to the Civil Control Station" and to "carry with them on departure" such things as "Bedding," "Toilet articles," "Extra clothing," and "Sufficient knives, forks, [and] spoons . . . for each member of the family." The document is surrounded by memorabilia of the period: family snapshots, newspaper clippings reflecting anti-Japanese sentiment, and scenes of the internment camps.

Yamashita's print was done for *Public Announcements/Private Conversations*, a program sponsored by the Woman's Building of Los Angeles. As part of the project Yamashita posted her print in the same neighborhood in Little Tokyo where the government document had been in the forties. Part of the edition was given to the National Coalition for Redress and Reparation for fundraising efforts.

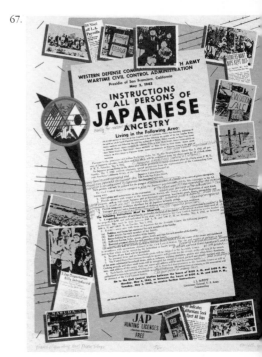

67.

68.

69.

68. Colin Lee. *Angel Island Smuggler's Story*. 1979. Etching and aquatint, 23½ × 34¹⁵⁄₁₆″ (59.7 × 88.7 cm). Collection Kiyo Matsumoto, New York

Angel Island, located in San Francisco Bay, was the port of entry for the majority of Chinese immigrants to California between 1910 and 1940. Lee's print, based on family stories about Angel Island, is one in a series of works, including a performance/installation, that the artist has done on this subject.

Lee explains that during the early years of this century exclusionary policies prevented Asian women from entering the United States; Asian men, on the other hand, were sought for the labor force. By prohibiting women from entering, these policies encouraged Chinese men to be sojourners rather than settlers in America. Lee's print is based on stories of women being smuggled in by boat: if the smuggler in Lee's etching were about to be caught, the story goes, he would throw the women overboard to drown.

Many painful tales about the treatment of immigrants on Angel Island still circulate in the Bay Area Asian-American community. It was only after a fire partially destroyed the building there in 1940 that the port-of-entry station was abandoned. The site is now a state park.

69. Arlan Huang. *Sugar People— Part I*. 1982. Charcoal stencil with varnish, 26⅛ × 34⅛″ (66.4 × 86.7 cm). Collection George T. Chew and Marilynn K. Yee, New York

Huang's stencil is one in a series of works on early Chinese immigrants in America. "Sugar people" is the English translation of a term older Chinese immigrants often use in reference to fellow Chinese-Americans. Huang's figures are adapted from photographs taken at the turn of the century in San Francisco's Chinatown. The photograph of the man was titled *Cigar Maker*, and the one of the woman was called *Slave Girl*.

Huang grew up in San Francisco's Chinatown and views this series as an exploration of his own heritage. Born in America, Huang is particularly curious about Chinese-Americans who arrived as immigrants. Huang is of Cantonese descent, and the major Cantonese immigration to America occurred in the nineteenth century. The men came to America to be part of the labor force, but women and children were in effect excluded. Many of the very few women who did gain entry were brought in as prostitutes, Huang explains, or "slave girls."

70. Jean LaMarr. *Now and Then in Nixon, Nevada*. 1983. Etching and aquatint, printed in color with collage, 20¾ × 21¹³⁄₁₆″ (52.7 × 55.4 cm). Collection the artist, Susanville, California

LaMarr's print contrasts the old with the new: an old photograph of tribal elders is juxtaposed with a recent photograph of young men from the Pyramid Lake Reservation near Nixon, Nevada. The elders are seen in traditional garb, whereas the young men wear typical clothing of American youth. In her parallel groupings of different generations LaMarr compares the near mythic concept of the Indian that is fixed in the popular imagination with the reality of the contemporary Indian, whose very existence comes as a surprise to many.

Further, LaMarr contrasts what she views as the current disregard for land in Nevada with the reverence for it that informed traditional Native American life. She places an eagle, an Indian symbol of spiritual power, in opposition to a collaged element in the shape of an MX missile, for her a symbol of death. The missile shape is a reminder that Native American land in Nevada is currently being used for the testing of MX missiles. The young men pictured in LaMarr's print protest this testing: one holds up a clenched fist, another raises a drumstick as a sign of dissent.

71. Edgar Heap of Birds. *We Don't Want Indians*. 1983. Photostat, 17 × 11″ (43.2 × 27.9 cm). Collection the artist, Geary, Oklahoma

Heap of Birds's poster proclaims one of his "insurgent messages for America." He has chosen language, as disseminated through a variety of forms, as the major vehicle of his art because he believes that his messages are "present day combative tactics" comparable to the "sharp rocks" used as arrowheads in earlier times. *We Don't Want Indians* has taken several forms. It began as a centerfold/poster for an Oklahoma arts newsletter. It was also made into a die-cut word installation now permanently on view at The State Museum of Oklahoma in Oklahoma City. In 1984 an offset-poster version was mounted in a four-part arrangement on abandoned buildings on New York's Lower East Side, as part of the *Not for Sale* anti-gentrification project organized by Political Art Documentation/Distribution.

In discussing his message Heap of Birds has referred to the "dominant culture's strange custom" of giving things Indian names. He goes on to say that this practice is "particularly insulting when one considers the great lack of attention that is given to real Indian concerns," referring to education, job skills, medical treatment, and proper housing.

70.

71.

JAЯUTAИ

WE DON'T WANT INDIANS
JUST THEIR NAMES
MASCOTS
MACHINES
CITIES
PRODUCTS
BUILDINGS

LIVING PEOPLE

72.

IN SUEÑO LIBRE ¡Aleluya! Cuando se diga "Patria y Justicia y sea verdad Cuando se vela pasear por las calles llenas de Sol Noche y Dia Cuando las manos del pueblo ya no Jíbaro/aino se una en un gran poder Bello y Revolucionario Cuando Todo Ser humano Tenga pan Tierra, Salud y la bendición de vivir de un poema del corazón Cuando nuestra liberación llegue los espíritus libres de nuestros niños se vestirán florecido de oro

73.

72. Rudy Begay. Untitled. (1972–73). X ray, drypoint, and collograph, printed in color, 17⅞ × 13⅛″ (45.4 × 33.4 cm). Collection Seymour Tubis, Denver

Begay's macabre apparition juxtaposed with the American flag suggests the deaths of Native Americans at the hands of the United States government. It also evokes a deathlike spirit that will not disappear and continues to observe the situation. Begay has said that the subject matter of this print is in keeping with the concerns of the artists at the Institute of American Indian Art in Santa Fe in the early seventies, when he studied there. At that time there was a great deal of support for protest activities of the American Indian Movement in particular and for social and political activism in general. Imagery such as that in Begay's print was not unusual in that context.

74.

73. Juan Sánchez. *Un sueño libre (A Dream for All Our Children)* from the portfolio *Guariquen: Images and Words Rican/Structed.* New York, Exit Art, 1986. Lithograph, printed in color with collage and hand additions, 22 × 30″ (55.9 × 76.2 cm). Lent by the publisher, New York

Sánchez's lithograph is part of a portfolio of five prints which, in his words, "is a realization of images embracing the aspirations, needs, and movements of my people." The portfolio as a whole has something of the quality of a scrapbook: photographs, texts, and mementos are incorporated. In *Un sueño libre*

Sánchez uses photographs he took in Brooklyn neighborhoods and a poem about his hopes for the future. The last print in a suite that deals with many of the hard realities of Puerto Rican life, it is an attempt, the artist has said, to end on a positive note. The poem in this print is in Spanish, as is much of the text throughout the set. It refers to a time when "Motherland and Justice is a said truth," to "revolutionary power" and "liberation," and to children who will dress in "flowered gold." The Puerto Rican flags in the print are based on photographs of those painted on walls in New York's Puerto Rican neighborhoods. Sánchez has noted that when the flags are painted over by city workers, they mysteriously reappear within hours.

74. Dolores Guerrero-Cruz. *Peacemakers.* Los Angeles, Self-Help Graphics and Art, Inc., 1985. Silkscreen, printed in color, 22⅝ × 27¹¹⁄₁₆″ (57.5 × 70.3 cm). Collection Elizabeth Rodriguez, Hoboken, New Jersey

Peacemakers focuses on children as future citizens and, it is hoped, contributors to world peace. In this print Guerrero-Cruz juxtaposes portraits of Mexican-American children from her own family with images of heroes of American popular culture. She has said that she is concerned about the ways in which the values of her Mexican heritage conflict with those reinforced by American television and comics. She donated

this silkscreen to her children's school and led a class discussion there in an effort to broaden the students' notions about who can be a hero, and why.

Peacemakers was made at Self-Help Graphics and Art in East Los Angeles, an arts center for the predominantly Chicano community. The Atelier Program there gives silkscreen instruction to an invited group of emerging artists, who work on individual projects and take part in group discussions. Some sixty editions of printed art, *Peacemakers* among them, have been issued through the Atelier Program since its founding in 1983.

Artists' Books

75. Sue Coe. *How to Commit Suicide in South Africa* by Holly Metz. New York, Raw Books and Graphics, 1983. Offset, printed in color and black; 14⅛ × 10½″ (35.9 × 26.6 cm), 22 leaves. The Museum of Modern Art, New York

How to Commit Suicide in South Africa is first and foremost an educational resource, filled with facts, footnotes, and bibliography. It differs from conventional reference books, however, in that it brings an artistic sensibility to bear on its subject.

The artist Sue Coe and the author Holly Metz were both deeply affected by the death in 1977 of the Black Consciousness leader Steve Biko, a political detainee in South Africa. This book is the result of their research on the political situation there. Coe's black, white, and red illustrations evoke a terrifying nighttime atmosphere in which episodes of chaotic violence recur. But the surreality of Coe's depictions is charged with the reality of Metz's overlay of factual information. Certain words and phrases jump out at the reader—"homelands," "pass laws," "Sharpeville Massacre," "Soweto 1976"—but the main text systematically presents chronologies, descriptions of working and living conditions, lists of political prisoners who died in custody, and statistics on foreign investments in South Africa. *How to Commit Suicide in South Africa* is a call to activism.

76. Sue Coe. *X*. New York, the artist and Raw Books, 1986. Offset, printed in color and black; 8¹⁵⁄₁₆ × 6″ (22.7 × 15.2 cm), 20 leaves. The Museum of Modern Art, New York

Coe's *X* is a general indictment of American society, with Malcolm X as the symbolic spokesperson. Texts on Malcolm X's life are interspersed with illustrations that attack racism, sexism, organized religion, governmental abuses, and economic exploitation. Financial gain is the leitmotiv. On the cover the "Almighty Dollar" is personified, with all manner of beings bowing down to it and unsightly horrors seemingly issuing from it. The back cover includes the following dedication: "This book is for Malcolm X and all those who have been Xed out by the American Dream—a nightmare where profit is valued more than human life."

Amid nightmarish, often allegorical scenes is a chronology of events from 1955 to 1965, the year of Malcolm X's murder. The final text ends with the black leader's ominous phrase "by any means necessary."

77. Edgar Heap of Birds. *Sharp Rock[s]*. Buffalo, Center for Experimental an[d] Perceptual Art (CEPA), 1986. Offset, printed in black and color; 16¾ × 10¹⁵⁄₁₆″ (42.6 × 27.6 cm), 19 leaves. The Museum of Modern Art, New Y[ork]

Heap of Birds's book, a collection of his posters, document[s] his mission to "maintain and strengthen indigenous rights and beliefs" of Native America[n] people. He chose not to bind *Sharp Rocks* because he think[s] of it as a "living" book and hopes the individual pages w[ill] be mounted as broadsides. Th[e] title *Sharp Rocks* refers to the arrowheads once used for hu[nt]ing and defense; the artist con[n]siders his posters a defensive weapon against the contempo[ra]rary threat of the influence of the dominant culture. "Oh!/ Those South/African/Homelands," one poster goes, "You/ Impose/U.S./Indian/Reservations." Heap of Birds thus expresses his belief that the Uni[ted] States invented the concept of the "homelands" in South Afr[ica] when they put Native America[ns] on reservations.

GENDER

78. Mary Beth Edelson. *Some Living American Women Artists/Last Supper*. 1972. Offset, 25 1/16 × 38" (63.6 × 96.5 cm). Collection the artist, New York

Edelson's offset poster overturns the patriarchal organization depicted in Leonardo's *Last Supper*. The artist devised this image as part of a larger, conceptually based piece for which other people were asked to suggest art works. One suggestion involved negating an aspect of organized religion, and Edelson's solution was this feminized image of *The Last Supper*. By choosing an artistic and religious masterpiece and inhabiting it with women artists, Edelson makes a statement about the male-dominated systems of art history and organized religion.

　　The image immediately struck a responsive chord, and the poster was reproduced in magazines and widely distributed, particularly at women's conferences. It also led, in 1976, to three other posters in which the heads of contemporary women are superimposed on figures in famous paintings. Edelson has explained, "The purpose in each of the posters was to address the moral and physical (ecological) decay of the patriarchal system, whether religious or secular, and to indicate by using women as activators that the need to re-integrate the feminine is paramount to a new paradigm to replace the outlived patriarchy."

78.

SOME LIVING AMERICAN WOMEN ARTISTS

80.

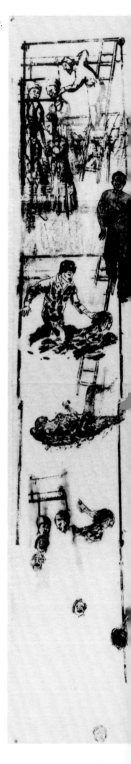

79.

79. Susan Pyzow. *Biological Timeclock*. New York, Pycus Studio, 1987. Lithograph, 22 × 16" (55.8 × 40.7 cm). Courtesy P.P.O.W., New York

Pyzow's lithograph is one in a recent series of works the artist has done on feminist issues, and it is striking in its graphic focus on what is usually a matter of private concern and even torment for women of a certain age. The artist has chosen a silhouette format in order to give the subject universality. She has said that her art is concerned with the notion that "everyone must fit a role so that our mechanisms can keep working." In another print Pyzow depicts a woman weighing herself and imagining her figure to be a shrunken ideal of the actuality.

81.

80. Nancy Spero. *Hanging Totem II*. 1986. Zinc-cut stamps and zinc-cut stamp collage, printed in color, 9′ × 20½″ (274.3 × 52.1 cm). Courtesy Josh Baer Gallery, New York

Violence toward women reverberates throughout this vertical-format piece, which is the second of two works focusing attention on the hanging of witches. Spero has made stamps of motifs from a variety of historical and contemporary sources, and impressions from them figure prominently in this work. A sixteenth-century English print documenting the trial of a witch is the basis of one of the stamps used repeatedly here.

The scene of a man dragging a woman by the hair is from the Vietnam War. Spero has also used this stamped rendering as the sole image in several small compositions. The woman fleeing with a child in her arms is also a Vietnam image. According to the artist, this piece comments on state-endorsed violence perpetrated by men against women, such as that which has occurred in times of war or in witch hunts.

81. May Stevens. *Rosa Luxemburg*. (1977–80). Photostat, 50½ × 33½″ (128.3 × 85.1 cm). Collection the artist, New York

Stevens's photostat is part of a long series of paintings, drawings, and prints derived from photocollages on the subject of Rosa Luxemburg, pictured alone and with the artist's mother. The present photostat deals only with Luxemburg, who has preoccupied Stevens since the late seventies.

A Polish-German Marxist revolutionary, Luxemburg (1871–1919) was imprisoned for long periods during World War I as a result of her antimilitarism. She was murdered in Berlin along with a socialist colleague, Karl Liebknecht, in the civil strife that followed the end of the war. Stevens's image combines photographs of Luxemburg, her prison cell, and a group of men which included her murderer. Stevens also incorporates the text from a handwritten letter by Luxemburg.

The artist first used the image in this photostat as page art in the inaugural issue of the feminist publication *Heresies*, in 1977. The collage was part of a double-page spread, the right side of which is titled *Two Women* and combines photographs of Luxemburg and the artist's mother.

82.

82. Jerri Allyn. *Apron: A Covering Worn in Front to Protect*. 1981. Diazo print (blueprint, printed in red) on two sheets, each 25 × 42⁵⁄₁₆″ (63.5 × 107.5 cm). Collection the artist, New York

One in a series of three posters Allyn designed for installation in Los Angeles restaurants, *Apron*, intended for a cappuccino bar, focuses on what, for a waitress, "the right amount of attention is." The text discusses sexual harassment, as well as such protective coverings as aprons, the psychological coverups of dreams, and chastity belts. The other two posters in the series were mounted in a cafeteria (a print on women and service) and a sushi restaurant (a work on the role of the geisha).

This series was cosponsored by The Waitresses, a Los Angeles feminist performance group. It was part of a larger project organized by the Woman's Building, *Public Announcements/Private Conversations*, in which women brought the personal voice to the pubic domain through poster works. One of Allyn's current projects involves audio works (designed for jukeboxes) and placemats for use in diners.

83. Elizabeth Rodriguez. Untitled. Los Angeles, Self-Help Graphics and Art, Inc., 1986. Silkscreen, printed in color, 23¼ × 35½″ (59.1 × 90.2 cm). Collection the artist, Hoboken, New Jersey

Contemporary relationships between men and women underlie much of Rodriguez's work. In this silkscreen the artist combines images from magazines and other publications to arrive at what seems to be a dreamlike vision of the thoughts preoccupying a glamorous young woman: an archetypal bride treads upon a weapon-bearing man as a strangely hermaphroditic figure lingers nearby. Rodriguez believes that her use of imagery appropriated from the media lends credence to her

84.

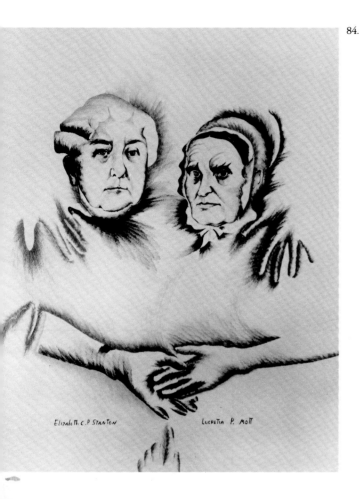

85.

art's commentary on various socially reinforced belief systems. She made her silkscreen as part of the Atelier Program of Self-Help Graphics and Art, which is situated in the largely Chicano East Los Angeles neighborhood where she grew up.

84. Marisol. *Women's Equality* from the *Kent Bicentennial Portfolio: Spirit of Independence*. New York, Lorillard, A Division of Loews Theatres, Inc., 1975. Lithograph, printed in color, 41⅞ × 29½″ (106.3 × 74.9 cm). The Museum of Modern Art, New York. Gift of Lorillard, A Division of Loews Theatres, Inc.

Marisol selected two important nineteenth-century figures in the women's movement as her subjects for a Bicentennial portfolio. "I chose to portray Lucretia Mott and Elizabeth Cady Stanton," she has stated, "because of their leadership in the struggle for women's rights, and because I like their faces—strong, determined, with very intense eyes."

In 1848 in Seneca Falls, New York, Mott and Stanton organized the first American convention on the status of women. After a discussion on the social, civil, and religious rights of women, "A Declaration of Sentiments" was issued, which stated that "all men and women are created equal." Both Mott and Stanton went on to write and lecture on women's issues extensively. Stanton eventually worked with Susan B. Anthony in the cause of woman suffrage.

85. Miriam Schapiro. *Homage*. Halifax, Lithography Workshop, Nova Scotia College of Art and Design, 1975. Lithograph, printed in color, 20⅛ × 20″ (51.1 × 50.8 cm). Lent by the publisher, Halifax

Schapiro's lithograph is one of two made while the artist was teaching a feminist art course at the Nova Scotia College of Art and Design. Both prints are concerned with the place of women artists in history. (The companion piece to this print urges a rewriting of art history to include sixty women artists, from Sofonisba Anguissola of the sixteenth century to Marguerite Zorach of the twentieth century.)

In *Homage* Schapiro incorporates qualities of embroidery and quilting patterns as well as decorative coloring. Her practice of linking traditional women's art forms to her own abstract art had begun a few years earlier, after an immersion in the feminist art movement. *Homage* pays tribute not only to the relatively well known Sonia Delaunay and Georgia O'Keeffe but also to the visionary painter Emily Carr (1871–1945), who remains virtually unknown outside her native Canada.

86. Jonathan Borofsky. *Male Aggression*. Los Angeles, Gemini G.E.L., 1986. Silkscreen, printed in color, 42½ × 46″ (108 × 116.9 cm). The Museum of Modern Art, New York. Purchase

Borofsky's concept of *Male Aggression* goes back to the early eighties, when the artist used the image for a poster that was mounted on buildings throughout New York. The artist has also used the image in a ten-foot-high painting, in several large wall paintings, and in leaflets that have been strewn on the floor in his installations.

Borofsky has said that he believes that male aggression is among the most powerful negative forces in society. He portrays it as an age-old problem, symbolized in weaponry that goes in stages from a caveman's club to an MX missile. The artist characterizes this subject as one of his "outer concerns," in contrast to the inner visions that fill so much of his work. This silkscreen was printed in red, pink, and black versions.

87. May Stevens. *Big Daddy with Hats*. (1971). Silkscreen, printed in color, 23 × 24¼″ (58.4 × 61.6 cm). Collection the artist, New York

Stevens's Big Daddy became an icon of the late sixties and early seventies, although it started out in her work as a reference to her own father, whom the artist associated with negative "male" values and dominance. The image first occurred in Stevens's paintings, and it preoccupied her for several years. She gradually began presenting the figure with the American flag, sometimes entirely draped in it. In this silkscreen the flag becomes the costume of the pet bulldog. The "paper doll" accoutrements are a further elaboration of Stevens's theme, enabling the hero to assume many roles. The present Big Daddy, for example, comes equipped with military, police, Klansman, and hangman hats. Stevens has done variations of the image in several other silkscreens, and executed a Big Daddy poster for an international women's art exhibition in the early seventies.

86.

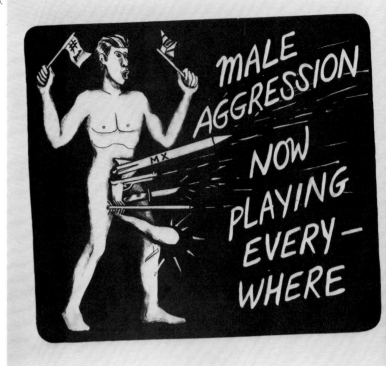

87.

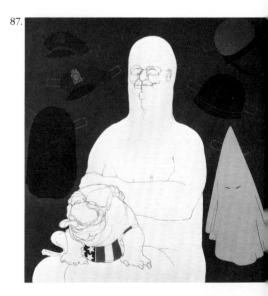

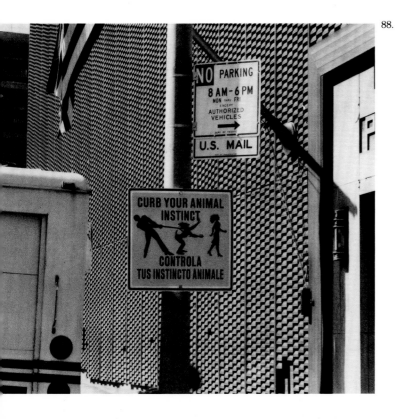

88.

89.

88. Ilona Granet. *Curb Your Animal Instinct* from the *Emily Post Series* (installed in New York, 1986). New York, Exit Art, 1986. Silkscreen on steel, printed in color, 24 × 26″ (61 × 66 cm). Courtesy P.P.O.W., New York

Granet's silkscreen is part of the artist's ongoing *Emily Post Series*. All the pieces are done on metal so they can be placed outside and assume the official status of a street sign. All involve the behavior of men toward women, in particular anonymous and aggressive catcalling. Some of Granet's signs announce that those in violation must pay fines or go to jail. Her experience as a sign painter enables Granet to give the images an unmistakable authenticity. Although the signs have a somewhat humorous aspect, they derive from a series of performances Granet did on the subject of rape.

89. Ida Applebroog. *American Medical Association*. New York, Strother/Elwood Art Editions, 1985. Linoleum cut, printed in color on two sheets, each 29⁷⁄₁₆ × 21³⁄₁₆″ (74.8 × 53.8 cm). The Museum of Modern Art, New York. John B. Turner Fund

Applebroog's linoleum cut takes the all-too-familiar, semiprivate indignity of the medical examination into the public sphere of art in an indictment of sexism and impersonality in the medical establishment. At the same time, the artist subverts the common response to the female nude as an artistic motif by focusing on the nakedness and vulnerability of her subject: the viewer's position becomes one of complicity with the three-man board seemingly sitting in judgment. The male figure on the right adds an ambiguous and vaguely sinister element to the composition. This work reached a wide audience as a three-page project for *Artforum International* magazine in April 1985.

Artists' Books

90. Jerri Allyn. *Role Confusion*. Los Angeles, 1977. Offset, printed in color; 7⅜ × 5½″ (18.7 × 14 cm), 2 leaves (folded cover and accordion-fold sheet). The Museum of Modern Art, New York

Allyn's postcard-set-style folding book uses a storyline technique to confront the issue of role confusion. She makes use of her own experiences as subject matter, combining family and other personal snapshots with a text comprised of statements she has heard during her life. The role confusion in Allyn's story derives from the fact that she was named in tribute to a male friend of her father. The artist depicts herself growing up and questioning not only her name but also the validity of male and female stereotypes. She produced this book while she was a student at the Feminist Studio Workshop at the Woman's Building in Los Angeles. Allyn's interest in women's roles also informs much of her later work in a variety of mediums.

91. Sonia Balassanian. *Portraits*. New York, 1983. Offset; 10⅞ × 8⅜″ (27.6 × 21.3 cm), 14 leaves. The Museum of Modern Art, New York

Balassanian's *Portraits* extends imagery from an installation mounted at New York's Franklin Furnace in late 1982. A prominent element in that piece was the solemn-faced head of a woman whose hair was covered by a *chador*, the traditional scarf worn in Iran. For her book Balassanian fractures that face, using a collage technique, and adds calligraphic writing, fingerprints, and the typewritten words "stoning" and "raping" over and over again. She thus underscores the pain and resignation that comes from being endlessly acted upon in a violent and chaotic manner.

Balassanian, a native Iranian who left Teheran in 1978, has treated various aspects of the political upheaval there in her work since 1980. The diminished liberties of Iranian women inspired *Portraits*, but the artist has also executed pieces on the subject of the Americans held hostage at the United States embassy in Teheran in 1979–80.

92. Nan Becker. *Sterilization/Elimination*. New York, 1980. Offset; 8 × 8″ (20.3 × 20.3 cm), 10 leaves. The Museum of Modern Art, New York

In this harrowing combination of word and image Becker decries the use of sterilization as a quick and cheap solution to the immense and complicated problem of poverty, tracing the history of its use to the interest in eugenics in the twenties. The artist focuses particularly on the practice of sterilization in Puerto Rico. Her English and Spanish text is integrated with illustrations of traffic-signal-style symbols with such warnings as "No Turning Back," "Do Not Enter," and "Caution."

In a smaller version of this book Becker investigates sterilization in the United States, particularly among welfare recipients. This smaller volume was included as part of a *Wedge* magazine issue that was comprised of several artists' books on political subjects. She has also done window installations and posted broadsides on the street to bring attention to the problem.

93. Josely Carvalho and Sabra Moor *150 Artists Book* for *Connections P ect/Conexus*. New York, 1987. Nine booklets with offset, housed in env lope with silkscreen, printed in col 8¼ × 5⅜″ (20.9 × 13.6 cm), each booklet 10 to 24 leaves. The Museu of Modern Art, New York

This collaborative artists' bool was one part of *Connections Project/Conexus*, organized b the Brazilian-born artist Josely Carvalho and the American ar Sabra Moore in 1987. The larg project involved an exhibition and extensive letter-writing ar information-sharing actions among women artists of Brazi and the United States. The int was to explore the artistic, so cial, and political connections among women artists in the t cultures. The project eventuall resembled a chain letter, with the circle of artists widening through mailed invitations to participate. Sixteen pairs of ar ists took part in the exhibition whereas 150 artists were invite to contribute to the book. Carvalho and Moore have said that in organizing *150 Artists Book* they "acted on the basis the social intimacy women ha always shared privately." The re sult is a set of small booklets c page art based on themes of birth, food, body, shelter, en vironment, race, spirit, and wa death.

95. Judy Chicago. *The Dinner Party: A Symbol of Our Heritage* and *Embroidering Our Heritage: The Dinner Party Needlework*. New York, Anchor Press/Doubleday, 1979 and 1980. Offsets, printed in black and color; 7⅞ × 8⁵⁄₁₆″ (27.6 × 21.1 cm) and × 8³⁄₁₆″ (28 × 20.8 cm), 152 and 8 leaves. The Museum of Modern Art, New York

An extraordinary sculptural environment, *The Dinner Party* was conceived by Chicago and created by a group of more than four hundred volunteers, most of them women. The result of a five-year involvement on Chicago's part, it was first exhibited at the San Francisco Museum of Modern Art in 1979, and has since been seen in thirteen cities, with the most recent showing being in Frankfurt, in 1987.

The Dinner Party is a monument to the history of women, from the dawn of time to the twentieth century. It consists of a triangular table fifty feet long on each side, with place settings for thirty-nine women (ranging from a primordial goddess to Georgia O'Keeffe). A tile floor incorporates the names of 999 additional women who have made significant contributions to history but who remain virtually unknown to the general population. A ceramic plate and goblet and an embroidered runner make up each place setting. Chicago has said, "From my studies of women's art and literature and my research into women's lives—undertaken as part of my search for my own tradition as a woman and an artist—I had concluded that the general lack of knowledge of our heritage as women was pivotal in our continued oppression."

The two books cited document the entire project of *The Dinner Party*, in a format that relates to illuminated manuscripts. They were conceived as a means to send *The Dinner Party* message to the widest possible audience. Both volumes were written and illustrated by Chicago and designed by Sheila Levrant de Bretteville. The first volume, *The Dinner Party*, is a comprehensive history of the women who are honored in the installation. Brief biographies are interspersed with designs used in the project. In addition, Chicago includes a diarylike commentary that describes the extraordinary collaborative effort through which the piece was made. The second volume, *Embroidering Our Heritage*, with needlework background by Susan Hill, features arresting embroidery-work details throughout and documents each runner in *The Dinner Party*. The book adds to our knowledge of the thirty-nine celebrated women and also serves as a history of the art of needlework.

96. Judy Chicago and Miriam Schapiro. *Womanhouse*. Valencia, California Institute of the Arts, 1972. Offset; 8½ × 8½″ (21.5 × 21.5 cm) (irreg.), 16 leaves. The Museum of Modern Art, New York

Womanhouse documents a project of the Feminist Art Program at the California Institute of the Arts, which Chicago and Schapiro directed in the early seventies. Students in the program renovated a deserted house in a run-down section of Hollywood for the purpose of creating an environmental art work. Then, individually and in groups, they re-created each room using their experiences as women as the raw material of their art. As the introduction to this small book states: "The age-old female activity of homemaking was taken to fantasy proportions. *Womanhouse* became the repository of the daydreams women have as they wash, bake, cook, sew, clean and iron their lives away." This house-shaped book, designed by Sheila Levrant de Bretteville, captures the *Womanhouse* rooms with pictures and texts by the artists.

97. Mike Glier. *White Male Power: Senators, Game Show Hosts, National Monuments, Clergy, Etc.* New York, 1981. Offset, printed in black and color; 16½ × 11¼″ (41.9 × 28.5 cm), 14 leaves. The Museum of Modern Art, New York

Glier works predominantly in black and white, partly because such work reproduces well and can therefore reach a wider audience. It was with dissemination of images in mind that he compiled *White Male Power*. The portfolio/book is the summation of a theme that absorbed the artist for several years, and its publication coincided with a related exhibition at a New York gallery. *White Male Power*'s subtitle, which lists "Senators" next to "Game Show Hosts," sets the tone for the work's raucous depictions of men with power in American society. Glier offers us immediately recognizable characterizations, in which the ridiculous aspects of each subject appear to predominate. *White Male Power* later reached a still wider audience in the form of page art; *The Paris Review* featured a series of Glier's images in a 1982 issue.

98. Heresies Collective. *The Women's Pages*. New York, Heresies: A Feminist Publication on Art and Politics (vol. 4, no. 2), 1982. The Museum of Modern Art, New York

The Heresies Collective is a feminist policy-making and publishing group whose membership has varied since its founding in 1975. Each issue of *Heresies* has its own editorial board. Lyn Blumenthal, Cynthia Carr, Sandy De Sando, Sue Heinemann, Elizabeth Hess, Alesia Kunz, and Lucy R. Lippard served as editors of *The Women's Pages*.

Although all the issues of *Heresies* combine texts and reproductions of art works, this is the first issue devoted entirely to the medium of page art. Thirty-nine artists contributed. In an introductory statement the editorial board describes page art as an inherently political art form: "It shares much of its outreach energy with its sister, the street poster . . . continuing a time-honored tradition of public speaking by artists through broadsides, leaflets, graffiti and 'democracy walls.'" Although *Heresies* issues are usually devoted to specific themes, the art in *The Women's Pages* deals with a variety of topics, such as abortion, sexism, racism, and unemployment, as well as more allegorical subject matter. The issue also includes a blank page, for the reader to add an art work of his or her own.

99. Suzanne Lacy. *Rape Is*. Los Angeles, Women's Graphic Center, 1972. Offset; 5⅝ × 5¾" (14.3 × 14.6 cm), 26 leaves. The Museum of Modern Art, New York

With brief, clear descriptions, Lacy gives twenty-one examples of what rape is. Many of the situations commence with degrading actions or statements recognizable to most women, such as the "pinched ass," or the overly familiar "Hi Sweetie!" from strangers. Other graphic examples describe events far more damaging to body and spirit. As a whole, the book serves as a grim commentary on women being acted upon and on the societal structures that lead to these acts so destructive to women.

This small-format book was made while Lacy was involved in feminist art studies at the California Institute of the Arts in Valencia. At the conclusion of her studies there Lacy continued to probe the issue of violence against women in performance art. She designed huge-scale events, often involving many participants and incorporating the news media.

100. May Stevens. *Ordinary. Extraordinary*. New York, 1980. Offset; 11 × 8½" (27.9 × 21.6 cm), 18 leaves. The Museum of Modern Art, New York

Stevens's artist's book came about after she had made a whole series of photocollages on the subjects of her mother, Alice Stevens, and the Marxist leader Rosa Luxemburg. After studying the works in the series in various sequences, Stevens decided to put them in the form of a book with a text including statements by each of the women. The result is a collection of Stevens's personal perceptions of the two women, rather than an entirely factual accounting of their lives. Stevens describes Luxemburg as "Polish/German revolutionary leader and theoretician, murder victim," and Alice Stevens as "housewife, mother, washer and ironer, inmate of hospitals and nursing homes." She goes on to sum up this volume as "an artist's book examining and documenting the mark of a political woman and marking the life of a woman whose life would otherwise be unmarked. Ordinary. Extraordinary."

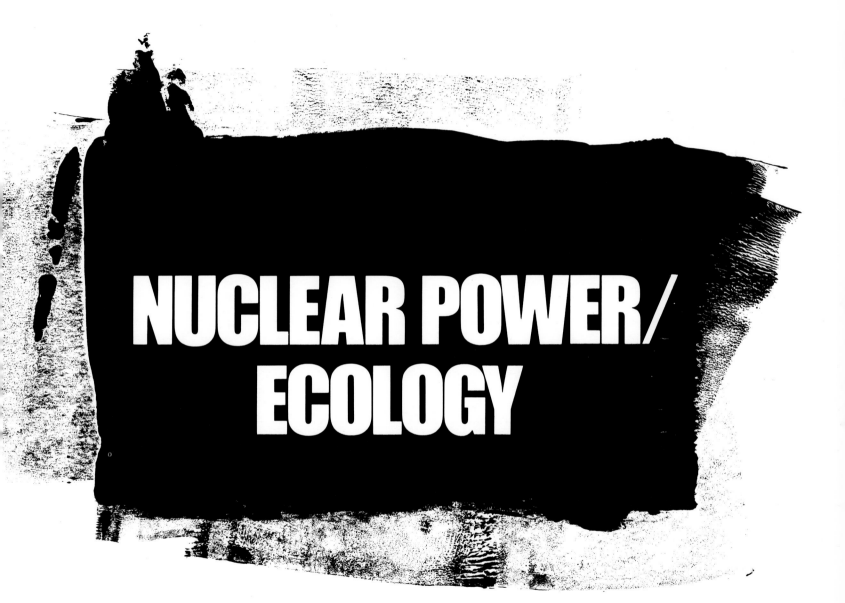

101. Chris Burden. *The Atomic Alphabet*. Oakland, Crown Point Press, 1980. Etching, printed in color, 57½ × 39″ (146.1 × 97.1 cm). The Museum of Modern Art, New York. Gift of Crown Point Press in celebration of its 25th anniversary

Burden's large-scale print is based on a performance he did in several locations in 1979–80. The piece lasted only thirty seconds, and in it Burden quickly and aggressively shouted out this list of letters and words. The performance was done in Japan, among other places, and at that event leaflets were handed out giving the translations of all Burden's words. He incorporates the translations in this print, calling attention to the fact that atomic bombs were dropped on Japan. Burden's print has all the clarity, simplicity, and appeal of a grade-school primer, yet the content of the work is certainly complex and disturbing. His list of words is a strangely rhythmic whole, with expected words such as "Bomb," "Nuclear," and "War" punctuated by surprising words such as "Dumb" and "Yeller." In June 1982 Burden's print took the form of page art in a full-page contribution to a *Village Voice* special issue on nuclear disarmament.

102. Keith Haring. Untitled. 1982. Offset, 24 × 18″ (61 × 45.7 cm). Collection the artist, New York

In 1982 Haring printed twenty thousand copies of this offset poster for the huge June 12 antinuclear rally in New York, which coincided with a United Nations conference on nuclear disarmament. After a march from the United Nations, hundreds of thousands of demonstrators converged in Central Park to hear speakers and listen to benefit concerts. Haring and several friends stood in the park and gave away posters as fast as they could. About fourteen thousand were distributed there and the rest were given away later.

Haring's image contains his signature crawling baby, which, after the artist began adding radiating lines, came to be referred to as the "radiant child." The present radiant child seems suspended in the air on a mushroom-shaped cloud and is surrounded by figures resembling angels. Down below, factions battle over an ominous molecular symbol.

Haring has been preoccupied with placing his art in worldly contexts and with the broad dissemination of his images since he emerged as the premier subway graffiti artist in the late seventies and early eighties. Social and political issues always figure, however obliquely, in the artist's imagery.

101.

THE ATOMIC ALPHABET

A for ATOMIC 原子
B for BOMB 爆弾
C for COMBAT 戦闘
D for DUMB 馬鹿
E for ENERGY 原動力
F for FALLOUT 原子灰
G for GUERRILLA 奇襲隊
H for HOLOCAUST 大焼尽
I for IGNITE 発火
J for JUNGLE 密林地帯
K for KILL 殺害
L for LIFE 生命
M for MUTANT 突然変異体
N for NUCLEAR 原子核
O for OBLITERATE 抹殺
P for PANIC 恐慌
Q for QUAKE 地震
R for RUBBLE 粉砕
S for STRIKE 奇襲
T for TARGET 標的
U for URANIUM 重金属元素
V for VICTORY 勝利
W for WAR 戦争
X for RAY 照射線
Y for YELLER 腰抜け
Z for ZERO 零

102.

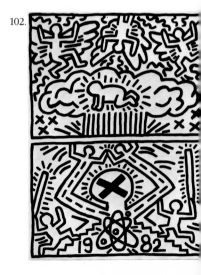

103.

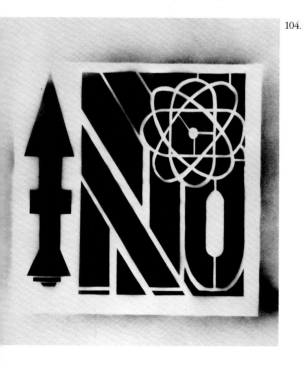

104.

print derives from a drawing titled *Nagasaki Red* (1983). He has given other works on these ·themes such titles as *Just a Test*, *General Nuke*, and *Hiroshima Bomb*. Arneson has said that he realized that an artist's treatment of a sociopolitical issue could have a serious impact after his commissioned ceramic bust of the late Mayor George Moscone of San Francisco was rejected by city officials in 1981 and the controversy preoccupied the media for days. (The pedestal of that work made graphic reference to Moscone's and Supervisor Harvey Milk's murders in 1978.)

104. Eva Cockcroft for Artists for Nuclear Disarmament Stencil Brigade. *Logo*. (1982). Stencil, printed in color, 34⅛ × 28 1⁄16″ (86.7 × 71.3 cm). Collection the artist, New York

Cockcroft's *Logo* was one of several stencils designed for the antinuclear protest held in New York on June 12, 1982. Artists for Nuclear Disarmament (AND) organized a number of antinuclear actions for that event. Cockcroft directed AND's Stencil Brigade, whose core members included John Friedman and Camille Perrottet, but which comprised as many as twelve members at any one time. In the months preceding the protest rally stencil workshops were held and images of skulls, bomb explosions, President Reagan, and others evolved. They were later sprayed on sidewalks and walls throughout New York, most often in clusters that resembled stenciled murals.

103. Robert Arneson. *A Nuclear War Head*. San Francisco, Experimental Workshop, 1983. Woodcut, printed in color, 42 × 57″ (106.7 × 144.8 cm). Courtesy Allan Frumkin Gallery, New York

Arneson's woodcut presents a savage image of a deformed head turned slightly toward us in what appears to be an attempt to make eye contact. The potency of the image and its dramatic size and coloring combine to give *A Nuclear War Head* a startling impact.

Arneson has worked extensively with the imagery of nuclear issues in sculpture, paintings, drawings, and prints throughout the eighties. This

105. William Wiley. *Three Mile Island, Three Years Later*. Chicago, Landfall Press, 1984. Lithograph, printed in color, 38¼ × 27" (97.1 × 68.6 cm). Lent by the publisher, Chicago

In 1980 Wiley made a print on the subject of the 1979 accident at the Three Mile Island nuclear plant near Harrisburg, Pennsylvania. In it he depicted a worn fragment that he labeled a "relic" of the incident. Three years later he executed this related lithograph, which symbolically charts the effects of time passing. Using his customary mysterious iconography, Wiley creates an image of a mutant beast with the legs and arms of an animal and a fan-shaped head containing nuclear reactors and a cyclopean eye. In an obscure but mesmerizing vision, Wiley gives form to an unspeakable fear.

Wiley is particularly sensitive to nuclear issues because he grew up in Washington state, near the Hanford plutonium-processing plant. Family members and neighbors worked at the plant, and he remembers hearing about incidents of contamination.

106. Joseph Nechvatal. *Diabolos Incarnatus*. New York, Studio Heinrici Ltd., 1984. Silkscreen, printed in color, 20 × 18⁷⁄₁₆" (50.8 × 46.9 cm). The Museum of Modern Art, New York. John R. Jakobson Foundation Fund

Nechvatal's title comes from the occult and refers to an embodiment of the devil. In this print the artist locates the Satanic force in nuclear devastation: a claustrophobic web of lines entangles two very healthy-looking babies with skulls, skeletons, missiles, and monsters. This eerie representation of the nuclear threat is made even more lurid through the use of yellow paper.

Nuclear proliferation has long been a major theme in Nechvatal's art. He has done several photocopy handouts of weblike drawings that address the subjects of nuclear missile buildups and superpower brinksmanship. His *20-Megaton Blast* (1980) describes nuclear destruction at various distances from ground zero. It was part of a street campaign in New York.

105.

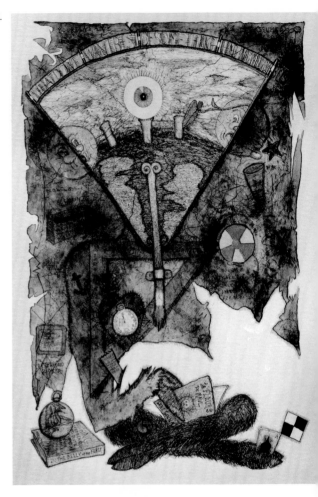

106.

107.

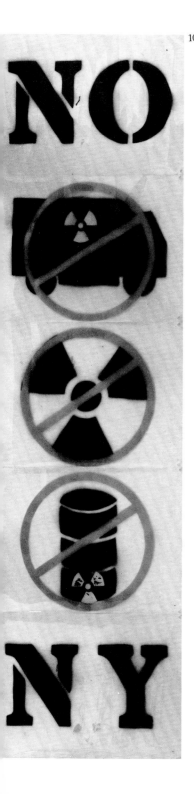

108.

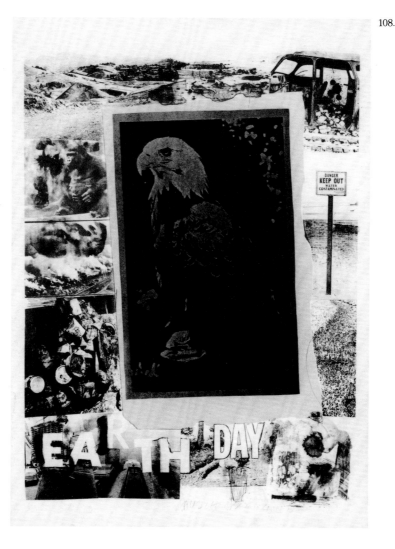

removing such waste from the Shoreham nuclear power plant and Brookhaven Laboratories on Long Island. Fekner stenciled signs along the highways and created huge murals on overpasses in an effort to dramatize the threat of the proposed plan. The artist was not alone in his opposition: in a landmark ruling in February 1982 the courts prohibited the trucking of nuclear wastes through New York City suburbs on grounds that an accident would expose many millions of people to harmful radiation.

108. Robert Rauschenberg. *Earth Day*. Los Angeles, Gemini G.E.L., 1970. Lithograph, printed in color, with collage, 52½ × 37½" (133.4 × 95.3 cm). Collection the artist, New York

Rauschenberg's lithograph is a large-scale version of a poster he did for Earth Day in 1970, to benefit the American Environment Foundation. In that year on April 22, millions of Americans participated in antipollution demonstrations. Volunteers cleaned up littered urban areas and organized parades featuring mock funerals of car engines and marchers wearing gas masks. Public officials joined the demonstrations. A few months earlier President Nixon had called for a stepped-up fight against pollution in his State of the Union address. *Earth Day* reflects both the increased respect for the environment and the heightened awareness of the power of collective action that characterized that time.

107. John Fekner. *No Transportation of Nuclear Waste in NY*. (1981–82). Stencil, printed in color on five acetate sheets, each 18⁹⁄₁₆ × 24½" (47.2 × 62.3 cm). Courtesy Anders Tornberg Gallery, Lund, Sweden

Fekner's stencils on acetate, incorporating symbols for radioactive waste, document a project on the Long Island Expressway and on Grand Central Parkway, parts of a proposed route for

109. Rebecca Howland. *Toxicological Tablecloth*. New York, Fabric Workshop, 1985. Silkscreen, printed on linen with hand additions, 7'9⁹⁄₁₆" × 7'1⁵⁄₁₆" (214.9 × 215.6 cm). Collection the artist, New York

Howland had been making plaster and ceramic dishes for sale at the A. More Store, an artist-organized gallery/store initiated by Collaborative Projects, Inc., in 1980. This involvement led to an invitation by the Fabric Workshop to print table linens. Howland's *Toxicological Tablecloth*, produced at the workshop, deals with strip mining, pollution from industrial smokestacks, acid rain, and the improper disposal of toxic waste. It presents an image of an industrialized civilization destroying itself with its own by-products. Designed for use in the context of dining, the tablecloth has a particularly outrageous effect. But while there is a certain absurd humor to the overall conception of the work, Howland's message is deadly serious.

109.

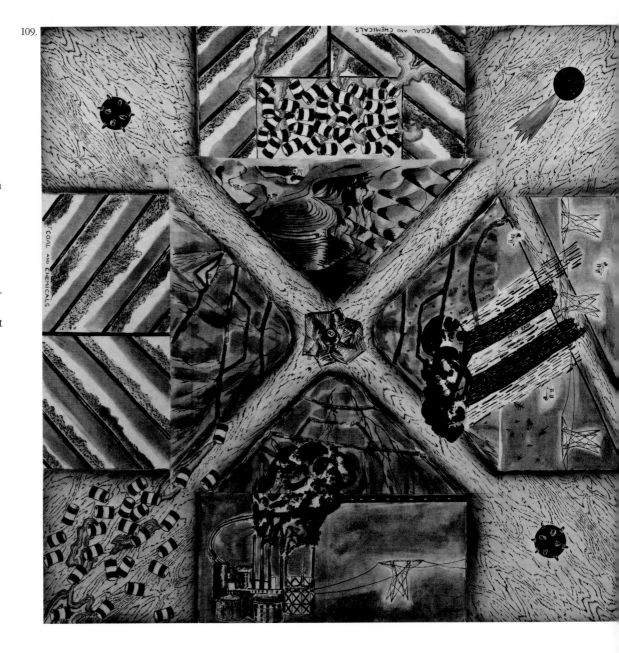

Artists' Books

110. Sharon Gilbert. *A Nuclear Atlas*. Rosendale, New York, The Women's Studio Workshop, 1982. Offset; 11⁵⁄₁₆ × 9½" (28.7 × 24.1 cm), 17 leaves. The Museum of Modern Art, New York

Through its depiction of maps, its symbols of nuclear sites, its statistics, and its reproductions of newspaper clippings, Gilbert's book gives the impression of a world given over to the nuclear power phenomenon. In scanning Gilbert's text our eyes fall upon words that have taken on new meaning in our nuclear age: "inspections," "evacuations," "shutdowns," "accidents," "exposure," "contamination," "dosage," "waste," "leaks," "dumps," and "meltdowns." "Chernobyl," at the time of Gilbert's writing merely one of hundreds of place names for nuclear power plants, is perhaps now the most changed word of all.

A Nuclear Atlas is part of a series of works Gilbert did on the subject of nuclear power after the Three Mile Island nuclear accident in 1979. She did extensive research for this work through the United Nations, the Atomic Energy Commission, and special investigatory commissions set up by the government after the accident.

111. Dona Ann McAdams. *The Nuclear Survival Kit*. New York, 1981. Offset; 5¼ × 7¾" (13.3 × 19.7 cm), 27 leaves. The Museum of Modern Art, New York

McAdams's postcard book is part of a multimedia antinuclear campaign the artist began after the Three Mile Island accident in 1979. As part of her work the artist traveled across the United States photographing nuclear facilities. She used the resulting photographs in her *Nuclear Survival Kit* and in more than five thousand photocopy posters. These were mounted all over America, as well as in Australia, England, Sweden, and Germany. She also did related juggling performances on street corners, in exhibition spaces, and in clubs. With monologues on human error and nuclear-accident statistics, McAdams's performances enhanced the meaning of the first postcard in her artist's book: *They're Juggling Our Genes!*

112. Bruce Nauman. *LA Air*. New York, Multiples, Inc., 1970. Offset, printed in color; 12 × 12" (30.5 × 30.5 cm), 8 leaves. The Museum of Modern Art, New York

While living in San Francisco in the mid-sixties Nauman made an artist's book called *Clear Sky*. It was based on the artist's perception of the sky around San Francisco, and the pages were sheets of radiant blues. After he later moved to Los Angeles Nauman decided to do another book, in the same size and on the same principle. The result was *LA Air*, a work with pages colored in various browns, musty yellows, and blacks, reflecting the notoriously bad air quality around Los Angeles. The humor is evident as we leaf through the pages, but there is irony as well; the twelve-inch-square fields of color are luxurious in their own right, no matter how unhealthy their implication.

113. Christy Rupp. *Acid Rain*. New York, 1982. Photocopy, printed in color; 8½ × 11" (21.6 × 27.9 cm), 9 leaves. The Museum of Modern Art, New York

During the early eighties Rupp did several works based on the effects of acid rain. She did research on the subject by working in the Adirondacks with a naturalist from the New York State Department of Environmental Conservation. There she learned about the special vulnerability of high-altitude ecosystems to high concentrations of toxic materials in the rain. The underlying issue in this work is not the environment per se, however, but, according to the artist, "man's attitude toward the environment and how that attitude is affected by economics."

The photocopy process was used because the textures created resemble particles in the air. The book was meant to be made and remade according to demand and was originally sold at the A. More Store.

114. Sisters of Survival (Anne Gauldin, Cheri Gaulke, and Sue Maberry). *Sisters of Survival's Memento Mori*. Los Angeles, Sisters of Survival at the Woman's Building, 1984. Letterpress and photographs, printed in color; 8 × 6″ (20.3 × 15.2 cm), 15 leaves. The Museum of Modern Art, New York

A memento mori is a symbol, such as a skull, meant to be a reminder of death. The term can also be used to refer to an entire work of art in which these reminders figure prominently. *Sisters of Survival's Memento Mori* employs photographs of group members and a skeleton figure taking an allegorical journey through the desert environment of Joshua Tree National Monument in California. The pilgrims are finally seen in a peace march in Los Angeles. The Sisters of Survival view this artist's book as a contemporary illuminated manuscript, and it is rich with religious overtones, although the texts fall squarely in the secular realm. Brief quotes from Jonathan Schell's *The Fate of the Earth* (1982) and Joanna Macy's *Evolutionary Blues* (1983) and texts by William Lynch and John Mack refer to mass destruction, extinction, and despair in the nuclear age.

115. Sisters of Survival (Jerri Allyn, Nancy Angelo, Anne Gauldin, Cheri Gaulke, Sue Maberry) and Marguerite Elliot. *Shovel Defense*. Los Angeles, Sisters of Survival at the Woman's Building, 1982. Offset and photocopy, printed in color; 11 × 8½″ (27.9 × 21.6 cm), 63 leaves. The Museum of Modern Art, New York

This compendium documents an installation/performance presented at five public sites in Southern California, on the subject of civil defense plans in the event of nuclear war. It was prompted by a statement made by an undersecretary of defense in the Reagan Administration, paraphrased in *Shovel Defense* as follows: "All the United States needs to survive a nuclear war is enough shovels to go around. Each person would dig a three-foot trench; get in it; . . . and emerge unscathed two weeks later." Marguerite Elliot was inspired in her installation design by a political cartoon of a shovel graveyard. The Sisters of Survival, wearing multicolored habits of nuns, collaborated with her on the performance. *Shovel Defense* was created in conjunction with Target L.A.: The Art of Survival, a series of antinuclear-art activities sponsored by L.A. Artists for Survival, a chapter of the Southern California Alliance for Survival.

116. Mimi Smith. *This Is a Test*. Rochester, Visual Studies Workshop, 1983. Offset; 8⅛ × 10¾″ (20.6 × 27.3 cm), 21 leaves. The Museum of Modern Art, New York

This Is a Test deals with two subjects that have preoccupied Smith for several years: television news and nuclear annihilation. Smith began with drawings, one-of-a-kind books, and performances in which she would reiterate information she had heard in news broadcasts. She believes that world news has become trivialized, as people watch or listen to televised accounts as a background to their lives. After one of Smith's performances a viewer approached her and said she had not realized how horrible the news really is. In *This Is a Test*, with its serial format and its relentless repetition of sentences such as "It's a warning," "It could happen," and "Now here's the news," Smith gradually transcends the numbing familiarity of news-speak. The announcements that Washington, D.C.; Peking; Paris; Moscow; and Tripoli have been destroyed by nuclear bombs have a real impact. Smith ends with the familiar words "This was only a test. Had it been an actual emergency . . ."

WAR/REVOLUTION

117. Art Workers' Coalition. *Q. And Babies? A. And Babies*. New York, Art Workers' Coalition, 1970. Offset, printed in color, 25⅛ × 38″ (63.8 × 96.5 cm). The Museum of Modern Art, New York. Gift of the Benefit for the Attica Defense Fund

The fall of 1969 brought the disclosure that scores of civilians had been massacred by American soldiers in the Vietnamese hamlet of My Lai in 1968. The Art Workers' Coalition, a large association of activist artists founded in New York in 1969, issued this poster to express its outrage at the massacre. The design was the collaborative effort of members of the group's poster committee: Frazer Dougherty, Jon Hendricks, and Irving Petlin. It incorporates a photograph taken by the Army combat photographer R. L. Haeberle, which had been published in *Life* magazine. Superimposed on that photograph are two lines of text from an interview the reporter Mike Wallace had with a Vietnam veteran regarding the events of My Lai. In questioning about which villagers were shot in the incident, Wallace asked the former soldier, "And babies?" "And babies," the veteran replied.

The background of this poster's publication shows something of the confrontational relationship between the Art Workers' Coalition and The Museum of Modern Art in the late sixties and early seventies. During a meeting of artists and Museum officials Petlin had suggested that a poster on the My Lai massacre be issued, and that the Museum join the Art Workers' Coalition in publishing it.

After much discussion and during the final phases of planning, the Museum refused to participate, citing an unwillingness to commit itself to "any position on any matter not directly related to a specific function of the Museum." Arguments against Museum participation centered on the belief that an organization "comprised of individuals with diverse points of view" could be effective only if it confined itself "to questions related to [its] immediate subject."

118. James Dong. *Vietnam Scoreboard*. 1969. Etching and aquatint, printed in color, 20⅝ × 27½″ (52.4 × 69.9 cm). Art Department Print Collection, San Francisco State University

The ace pilot in Dong's etching keeps track of the times he hits his target by adding markings to the side of his plane; the markings, however, are not the typical small emblems of aircraft. The "scoreboard" here is comprised of silhouettes of a family grouping, the same grouping that is seen at the left. Dong incorporates an old family photograph for the portrait. In this context, juxtaposed to the cocky pilot so familiar from war movies, the family appears both innocent and vulnerable. Although the members of Dong's family are in fact Chinese, the artist identifies them in a more general way as Asian victims. He has said that he made this print in an attempt to emphasize and specify the human toll of the war, to counteract the dehumanizing statistics of daily Pentagon casualty reports.

117.

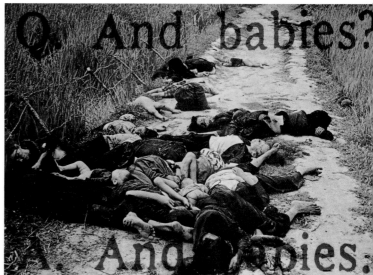

118.

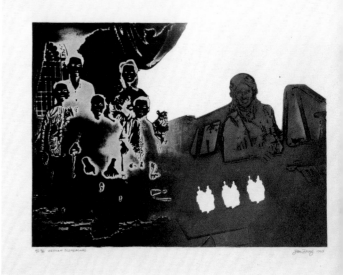

119.

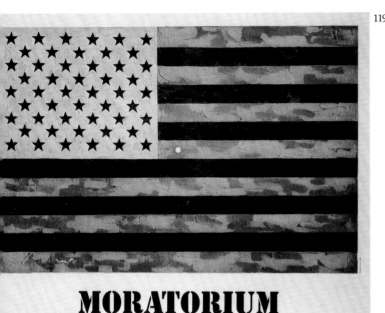

MORATORIUM

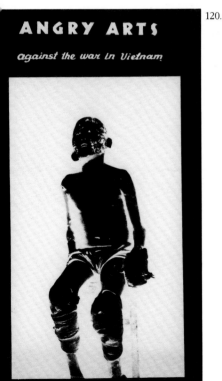

120.

119. Jasper Johns. *Moratorium*. New York, Leo Castelli Gallery, 1969. Offset, printed in color, 22½ × 28¾″ (57.1 × 75.6 cm). The Museum of Modern Art, New York. Gift of the artist

Although depictions of the flag recur throughout American protest art of the late sixties and early seventies, Johns's use of it has not been for political purposes. On one occasion, however, the artist contributed a green, orange, and black version of his signature flag to a protest effort against the Vietnam War, the first national Moratorium Day, in 1969.

On October 15 of that year, businesses closed and mass demonstrations took place, among them many candlelight processions. The Art Workers' Coalition contributed to the art world's participation. Moratorium signs were printed and placed in the windows of galleries, and some galleries held shows dedicated to the protest. Johns was asked to make this poster for a related benefit exhibition at Leo Castelli Gallery. He added stenciled lettering as he had done many times before, but this time the letters spelled out a plea for an end to the war in Vietnam. In this context, Johns's color combination seems macabre; some even interpret his customary central dot (a residue of an optical game in paintings of two flags) as a bullet hole. The poster was distributed widely and became one of the most well known images of the period. A signed edition of about one hundred was sold for the benefit of protest activities.

120. Rudolf Baranik. *Angry Arts*. New York, Angry Arts Against the War in Vietnam Committee, 1967. Photostat, 24⅛ × 14¹⁄₁₆″ (61.3 × 35.7 cm). Collection the artist, New York

Baranik's image of a young person burned by napalm remains a deeply affecting symbol of human pain. Centrally placed against a stark background, the figure is transformed from an actual person into an iconic presence representing all wars, all suffering. The photograph Baranik used in this poster inspired the artist's haunting series of paintings *Napalm Elegies* (1968–75). Baranik has said that during the late sixties and early seventies the very word "napalm" was "an outcry-symbol, a signifier of the anguish we felt about the war."

Angry Arts was made in conjunction with the Week of the Angry Arts Against the War in Vietnam, a series of protest events by artists in all fields, held in New York in early 1967. Hundreds of copies of the poster in various sizes were posted around the city to call attention to the week of events. Much of the printing for versions of this and other posters was done by a group of students at the School of Visual Arts who had set up an Angry Arts graphics workshop.

121. Antonio Frasconi. *The Involvement II*. 1967. Woodcut, printed in color, 24⅛ × 19⁷⁄₁₆″ (61.3 × 49.4 cm). Courtesy Terry Dintenfass Gallery, New York

Frasconi's bright red woodcut presents a nightmarish vision of the war in Vietnam. The artist combines a photographed image of a B52 bomber with a seemingly maimed head of a Vietnamese victim; bombs appear to be splitting the figure in two. Frasconi uses this double image to underscore the intensity of the pain inflicted. In discussing the print the artist refers to the American practice of "carpet" or "saturation" bombing in Vietnam, massive raids in which military and civilian targets were bombed indiscriminately. His choice of title also comes from the vocabulary surrounding the Vietnam experience. Government reference was made always to "our military involvement"; there was an avoidance of the term "war." Frasconi's woodcut relates to a bound set of prints he did in the same year called *Viet-Nam!* Images of bombers figure throughout that set, as do double-image faces of war-torn Vietnamese people.

121.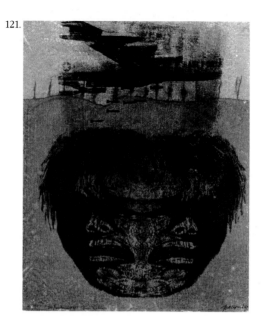

122. Marina Gutiérrez. *Soldiers and Civilians*. 1980. Etching, printed in color on three sheets, each 22⁰⁄₁₆ × 29⅞″ (56 × 75.9 cm). Collection the artist, New York

Gutiérrez's print is based on scenes from photographs taken during the war in Vietnam. An experienced printmaker, the artist made separate metal plates based on individuals in the photographs; she then arranged the plates to create her own scenario. The result is a cinematic enactment of violence against a Third World woman: a soldier with his gun drawn comes closer and closer to a walking civilian, until he is poised to fire at her head at point blank range. The other figures are repositioned accordingly, with the civilians on the left appearing to scatter as the soldiers move aggressively closer. The tiny figures' balletic movements on the

122.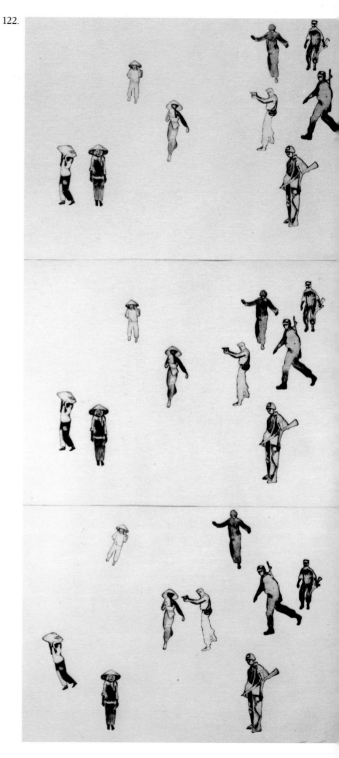

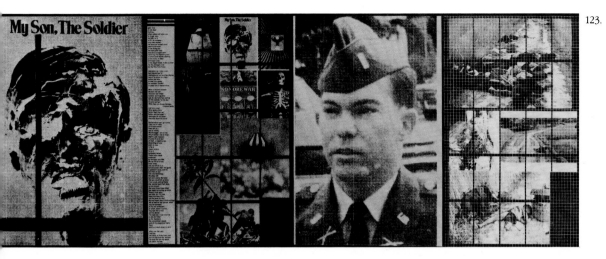

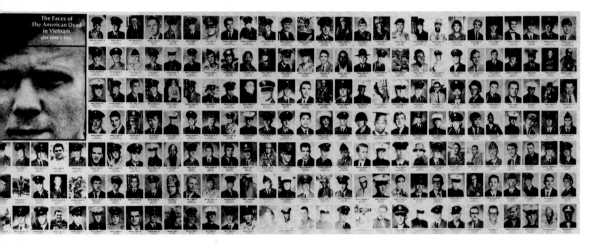

123.

123. Carlos Irizarry. *My Son, The Soldier*, Parts I–II. 1970. Silkscreen, printed in color on two sheets, each 25⅛ × 62³⁄₁₆″ (63.8 × 158 cm). The Museum of Modern Art, New York. Gift of the San Juan Racing Association

Irizarry's powerful antiwar silkscreen focuses on the human toll of the Vietnam War, particularly as it related to the young men evoked by the work's title. Using pictures that had appeared in *Life* magazine, Irizarry shows row upon row of young faces, one week's worth of American casualties. The listing of the dead soldiers' names, ages, and hometowns, from Kearns, Utah, to Chicago, Illinois, restores their individual identities and heightens awareness of the ordinary lives cut short by the extraordinary, obliterating force of the war. Lieutenant William L. Calley Jr., the young man who would be convicted of murder in 1971 for his part in the 1968 My Lai massacre, is pictured next to an image of the dead at My Lai, a graphic reminder of Vietnamese suffering. A ghostly face disfigured by napalm serves as a counterpoint to the image of Lieutenant Calley. Amid these painful elements is a long, thin column of text, a poem on the senselessness of war by Senator Eugene McCarthy, who had been the peace candidate for President in 1968.

luxurious expanse of white create a lyric effect very much at odds with the brutality of the narrative. Gutiérrez succeeds in making a riveting generalized statement on human violence using specific imagery of the Vietnam War. It is interesting to note that the war continued to draw an artistic response in 1980, but Gutiérrez's *Soldiers and Civilians* clearly has ongoing relevance.

124.

124. Nancy Spero. *Search and Destroy*. 1974. Woodcut and zinc-cut stamps and zinc-cut stamp collage, printed in color, with paint additions, 17½″ × 13′7″ (44.5 × 414.1 cm). Courtesy Josh Baer Gallery, New York

Spero first addressed United States "search and destroy" missions in Vietnam—in which soldiers searched villages and hamlets and destroyed those judged Viet Cong combatants and their arms caches—in her *War Series* of 1966–70. The phrase is scratched on a *War Series* image of a helicopter in the midst of a strafing mission.

In the present work Spero uses the scroll format she initiated in her *Codex Artaud* series of 1970–71. The cryptic words "Licit Exp" at right relate to a medieval text on the Apocalypse and have been used repeatedly, as a kind of personal code, elsewhere in Spero's work. In 1986 she made another version of this scroll, adding the words "Pacification" and "Body Count," more terms from the vocabulary of the Vietnam War. This print and other recent works by Spero demonstrate a continuing search for meaning in this subject, long after the war's end.

125.

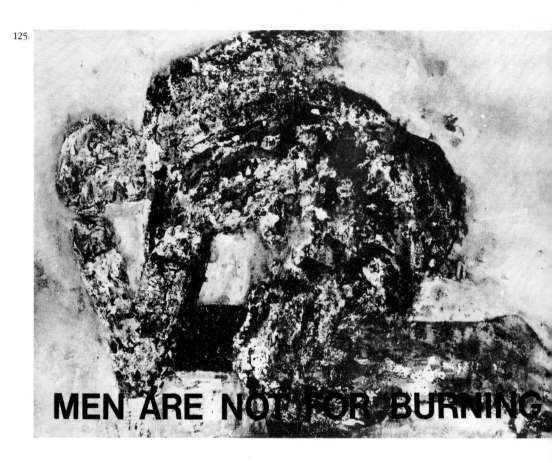

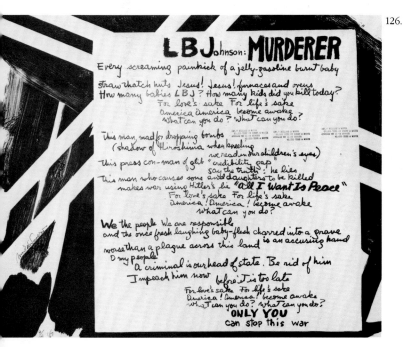

125. Leon Golub. *The Burnt Man*.
(1970). Silkscreen, printed in color,
38¼ × 50⅛″ (97.2 × 127.3 cm).
Courtesy Barbara Gladstone Gallery,
New York

The Burnt Man figure first ap-
peared in Golub's painting as
early as 1954, but the 1967 paint-
ing *Burnt Man IV* is the specific
reference in this silkscreen. The
crouching figure here, as in
many other Burnt Man works, is
derived from Greek and Roman
sculpture. Until the late sixties
Golub rendered these figures in
a generalized way, suppressing
details that would locate them in
any single time or place. Then
Golub began making his work
more specific in reference. In
1969 he did his first painting on
the theme of napalm. The pres-
ent work, on which the text
"Men Are Not for Burning" has
been printed, directly addresses
the Vietnam War. Golub contrib-
uted examples of it to benefit
many antiwar groups during the
early seventies. For the protest
mural *Collage of Indignation*,
exhibited as part of the Week of
the Angry Arts Against the War in
Vietnam in 1967, Golub had
used photostat versions of a
similarly posed figure with the
text "Burnt Man" printed across
the bottom.

126. Mark di Suvero for Artists and
Writers Protest Against the War in
Vietnam. Untitled from the portfolio
*Artists and Writers Protest Against the
War in Viet Nam*. New York, Artists and
Writers Protest, Inc., 1967. Lithograph,
printed in color, 21¹⁄₁₆ × 25¹³⁄₁₆″ (53.5 ×
65.5 cm). The Museum of Modern Art,
New York. John B. Turner Fund

Di Suvero was one of sixteen
visual artists and eighteen poets
associated with the group Artists
and Writers Protest Against the
War in Vietnam who contributed
work to the above-mentioned
portfolio. Rudolf Baranik, Paul
Burlin, Charles Cajori, CPLY
(Charles Nelson Copley), Allan
D'Arcangelo, Leon Golub,
Charles Hinman, Louise Nevel-
son, Irving Petlin, Ad Reinhardt,
Jack Sonenberg, George Sugar-
man, Carol Summers, David
Weinrib, and Adja Yunkers also
contributed prints. As the critic
Max Kozloff states in the intro-
duction, "these visual and verbal
images are meant to testify to
their authors' deep alarm over a
violence which . . . has been
impossible for them to ignore."

Di Suvero's contribution to
the portfolio combines poetry
and printmaking. The artist fills
a broadsidelike square, which
resembles a "Wanted" poster
slapped on a wall, with an ac-
cusatory outcry. Under the head-
ing "LBJohnson: Murderer," di
Suvero calls for a stop to the war
with language and imagery that
echoes its violence. The vig-
orous slashes around the bor-
ders of the print call to mind the
artist's expressionist sculpture.

127. Robert Morris. *Crater with Smoke* from the series *Five War Memorials*. New York, Castelli Graphics and Hollanders Workshop, 1970. Lithograph, 24¹⁄₁₆ × 42½″ (61.1 × 108 cm). Collection Artists' Poster Committee, New York

Morris's *Crater with Smoke* is one in a series of five proposals for a war memorial he formulated at the height of the Vietnam War, when he was deeply involved with protest activities. All the images incorporate aspects of the visual languages of minimalism and of earthworks, a reflection of Morris's major artistic interests during the late sixties, and all include an expressionist rendering of a threatening sky. In this print, with its gaping crater in a desolate landscape, Morris eloquently emphasizes the emptiness that remains after the terrible losses incurred in war. In 1982 the Vietnam Veterans Memorial was dedicated in Washington, D.C. Its elemental presence bears resemblance to the early proposals put forward in Morris's *Five War Memorials*.

128. John Pitman Weber. *Nguyen Van Troi*. 1970 (dated 1969). Silkscreen, printed in color, 22⁷⁄₁₆ × 17½″ (57 × 44.4 cm). Collection the artist, Chicago

Weber's silkscreen was created at the studios of the School of the Chicago Art Institute, where extensive antiwar printmaking took place following the United States invasion of Cambodia. It was sold at antiwar benefits and also given away. With its flattened areas of shading brought about by the silkscreen technique, and the central placement of the figure, Weber's scene can be given a broad, symbolic interpretation even as it evokes a specific time and place.

The print is derived from a photograph of Nguyen Van Troi, a South Vietnamese, taken right before his execution in 1964 for his part in an attempt to murder Secretary of Defense Robert S. McNamara in Saigon. Among Nguyen's last words was a denouncement of the American presence in Vietnam: "It is the Americans who have committed aggression on our country, it is they who have been killing our people with planes and bombs. . . . I have never acted against the will of my people." Nguyen became a symbolic figure for many opposed to the United States involvement in Vietnam.

127.

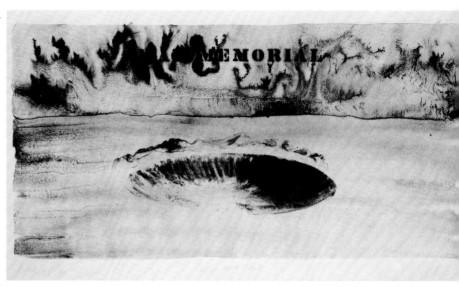

128.

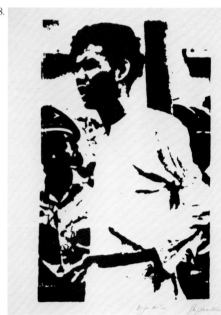

129.

130.

129. Bruce Nauman. *Raw-War*. New York and Los Angeles, Castelli Graphics and Nicholas Wilder Gallery, 1971. Lithograph, printed in color, 22⅜ × 28¼″ (56.8 × 71.8 cm). The Museum of Modern Art, New York. John B. Turner Fund

Nauman's scratched words "Raw" and "War" instill a sensation of unsettling ambiguity. This print is derived from a neon sculpture done in an edition of six, one of several conceptually inspired word pieces Nauman created during the early seventies. *Raw-War* alone of this early work makes specific reference to an actual event, the Vietnam War, and yet the piece has a more generalized meaning as well. Nauman has said, ironically, that he wanted the neon version turned on whenever a war was being waged. Since wars are being fought constantly in one part of the world or another, the implication was, Nauman's *Raw-War* would function as a kind of ghastly "eternal flame," casting its neon glow in perpetuity.

130. Edward Kienholz. *The Portable War Memorial 1968*. Düsseldorf, Kunsthalle Düsseldorf, 1970. Silkscreen on tin with hand additions, 22¹⁄₁₆ × 33¼″ (57 × 84.5 cm). Collection the artist, Hope, Idaho

Kienholz's silkscreen is a further, even-more-portable evolution of his tableau sculpture of 1968, *The Portable War Memorial*. Printed on tin in the manner of a commemorative plaque, Kienholz's silkscreen, like the sculpture that inspired it, stands as an indictment of the Vietnam War and of all wars. Although the tableau depicted includes American elements, such as a picture of Uncle Sam and a rendering of Marines raising the flag at Iwo Jima, it also incorporates a blackboard with the names of hundreds of countries that no longer exist because of wars and boundary changes throughout history. Kienholz leaves blank spaces where places and dates of new wars can be added. In discussing the piece recently he has said that he continues to be enraged by war, and particularly by the stupidity of "always killing off our youngest and best, who kill off others' young and best."

131. Les Levine. *Block God* (installed in London, 1985). London, Institute of Contemporary Arts and The Artangel Trust, and Derry, Orchard Gallery, 1985. Silkscreen, printed in color, 9′7″ × 21′9″ (287.5 × 652.5 cm). Collection the artist, New York

This billboard is one of twenty Levine placed around London, Derry, and Dublin as part of his *Blame God* exhibition in 1985–86. The images are derived from photographs taken by the artist in Northern Ireland and they deal with the civil strife in that country. All the billboards incorporate two-word phrases, the second word of which is always "God." Some of the other words paired with "God" are "Protest," "Create," "Attack," "Kill," "Torture," and "Starve." Levine has stated that he did this billboard project "to point out how ridiculous it is to assume that acts of violence can occur in the name of God." His hope was "to create the possibility of public discussion and new thinking on the subject." Levine, who was born in Dublin, had done a series of works on the subject of Northern Ireland's civil strife in 1973, *The Troubles: An Artist's Document of Ulster*, a set of photoetchings.

131.

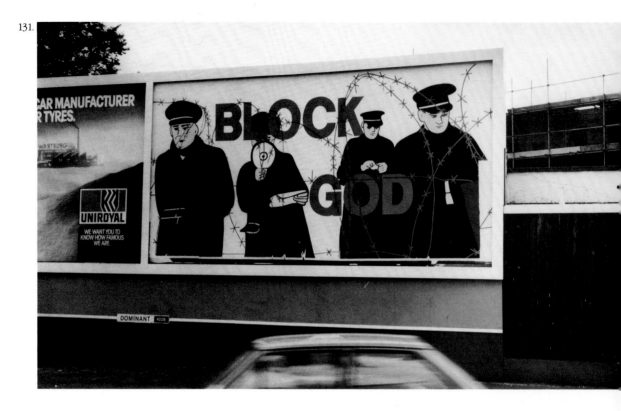

132. Francesc Torres. *Not Difficult to Piece Together*. New York, Pelavin Editions, 1986. Engraving, printed in color, 29⅞ × 22¼″ (75.8 × 56.4 cm). Lent by the publisher, New York

With *Not Difficult to Piece Together* Torres presents a haunting, ghostlike image of a soldier, derived from a World War II photograph. In its anonymity the profile becomes that of every soldier in every war. The surrounding details of a village, a church, and two fighter planes are likewise generalized.

The work as a whole resonates with a certain elegiac recognition, which supports the idea that Torres's fragmentary composition is indeed not difficult to piece together. The

132.

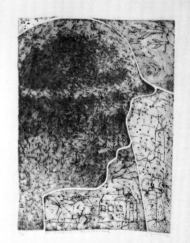

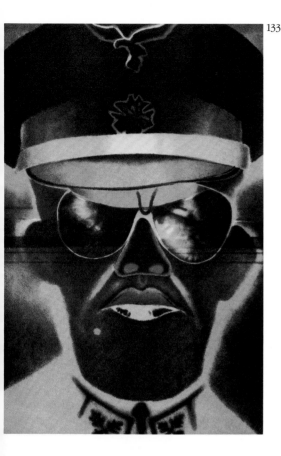

133.

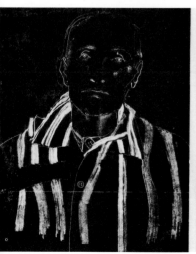

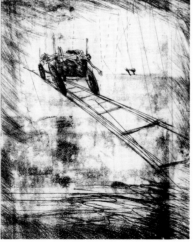

134.

somber image implies that the tendency to make war is, in effect, an irredeemable aspect of the human condition, and not an evolutionary aberration we are "progressing" past. Torres's notion of perceiving the "big picture" through its parts is underscored by the fact that he devised his engraving from plates cut into pieces that fit together in puzzle fashion.

133. Ed Paschke. *Kontato*. Chicago, Landfall Press, 1984. Lithograph, printed in color, 34¼ × 24″ (87 × 61 cm). Lent by the publisher, Chicago

Kontato is the archetypal evil military man. He confronts us through the eerie glow of the color television screen, diminished not at all by the horizontal distortion lines. Is he announcing a successful military *coup*? Imposing martial law? Calling up fresh recruits? Regardless, he is as powerful in his media presence as he is in his military command. All that is amoral, authoritarian, or dictatorial is contained in Paschke's iconic portrait of a generic strong man, the embodiment of the phrase "might makes right."

134. Mary Frank. *Cart* from *The Cart Series*. (1986). Monotype, 25¹⁄₁₆ × 37⅛″ (63.6 × 94.3 cm). Courtesy Zabriskie Gallery, New York

Frank's monotype is one in a series of more than thirty prints, all done in black and white, that incorporate this cart and a figure in prison garb. Some works in the series pair views of the cart as seen from different vantage points; others juxtapose two figures. This imagery derives from a still photograph Frank saw for an instant on a television program about the Holocaust. It was several years later that the image of the cart and tracks emerged in Frank's work. Although the scene is from a concentration camp, Frank's composition has a universal quality. She has said that the cart sometimes reminds her of scenes from South African mines.

135. Sue Coe. *Nicaragua*. 1987. Etching, 20 × 11⅞" (50.8 × 30.2 cm). Courtesy Sally Baker, New York

Coe has said that *Nicaragua*, her first etching, is dedicated to friends who were political prisoners in England and was done in solidarity with them. Their names are etched across the bottom. The print depicts peaceful farmworkers on its lower half, a ferocious dog and a caricature of President Reagan on its upper. A silver dollar becomes part of the President's body in an expression of Coe's belief that "economics is the skeleton of everything, politics is the flesh."

Before attempting this first etched work Coe did a group of photoetchings from drawings, with the aim of making her work available to a larger public. She has also done numerous illustrations for newspapers, magazines, books, and posters. She has said that all her work is done "with reproduction in mind."

136. Josely Carvalho. Untitled panel from the installation *Rape and Intervention*. 1984. Silkscreen, printed in color with hand additions, on silk, 6'9¹⁵⁄₁₆" × 21⅜" (208.1 × 54.3 cm). Collection the artist, New York

The present work is one panel of a six-panel installation created for Artists Call Against U.S. Intervention in Central America, a nationwide series of protest events undertaken by hundreds of artists in 1984. It was part of a collaborative exhibition mounted by two South American artists (Carvalho and Catalina Parra) and two North American artists (Paulette Nenner and Nancy Spero). Each artist contributed an individual work, but all the pieces were done on the theme of rape and intervention, a subject the artists had analyzed together in earlier discussions. Carvalho's piece, a unique work, incorporates elements from a vocabulary of silkscreened images developed over a period of years. She uses here a small, strikingly vulnerable girl juxtaposed with armed soldiers. In other panels the artist refers to the cycle of life by substituting a young woman or an old woman for the little girl, keeping the same image of soldiers.

135.

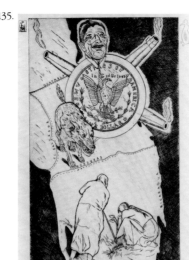

136.

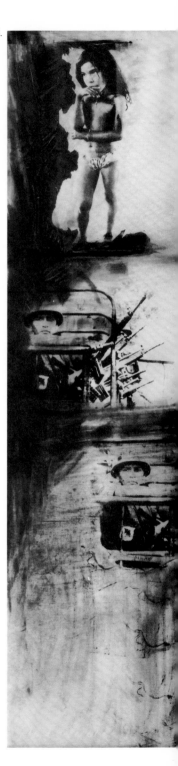

137.

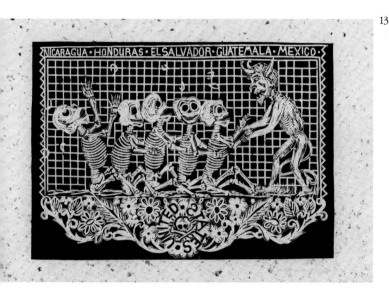

138.

137. Eric Avery. *History*. (1983). Linoleum cut, 25½ × 37″ (64.8 × 94 cm). Courtesy Mary Ryan Gallery, New York

Inspired by the book *The Cry of the People* (Penny Lernoux, 1982), on the subject of the United States involvement in Latin America, Avery appropriated a Mexican paper cutout to symbolize the relationship of the United States to the countries of Nicaragua, Honduras, El Salvador, Guatemala, and Mexico. He transferred the Mexican image to linoleum, slightly altering the skeleton figures and adding the names of the countries, all with macabre results. The United States becomes Satan, controlling the activities of the others. Such animated skeletons, known in Spanish as *calaveras*, are well-known symbols of the Mexican artist José Guadalupe Posada, who used them in countless political broadsides. Avery, who often appropriates images from art history and then alters them to his own ends, lives in Texas, one block from the United States/Mexican border.

138. Leon Golub. *Merc*. New York, Artists Call Against U.S. Intervention in Central America, 1984. Lithograph, printed in color, 30⅛ × 22¼″ (76.5 × 56.5 cm). Courtesy Barbara Gladstone Gallery, New York

Conceived in 1984 to benefit the national protest mounted by Artists Call Against U.S. Intervention in Central America (an organization for which Golub was a steering-committee member), this lithograph depicts a Mercenary, one of three major types in the artist's personal iconography since the late seventies. Golub uses Mercenaries, Interrogators, and White Squads in his work to explore the theme of how the amoral powerful behave toward the utterly powerless.

The figure in *Merc* lunges aggressively toward us, thrusting the highly mechanized weapon that is the tool of his trade: he looks us straight in the eye, pointing an implicating finger. Golub's is one of four prints published to benefit Artists Call. Others were by Sol LeWitt, Louise Bourgeois, and Claes Oldenburg.

139. Ilona Granet. *Missiles for Minors*. New York, the artist and John Spray, 1981. Silkscreen on steel, printed in color, 11 × 18″ (27.9 × 45.7 cm). Courtesy P.P.O.W., New York

139.

Granet's silkscreen on enamel emanates from the artist's ongoing preoccupation with nuclear war. Her visual language derives from years as a professional sign painter. Granet grew up on Long Island only a mile from what was then Mitchell Air Force Base; as a child she always worried about what went on there.

The daughter of a nuclear engineer, Granet has done performances on the subjects of nuclear war and the manufacture of armaments: "I make bombs," goes one of Granet's monologues, "I work on the bomb line." The announcement for a performance asks "Is it work? Or is it war?" Granet handed out paper versions of *Missiles for Minors* during these performances.

140.

140. Yong Soon Min. *Solidarity II*. 1984. Lithograph and aquatint, printed in color, 29¹⁵⁄₁₆ × 22⁵⁄₁₆″ (76 × 58.3 cm). Collection the artist, New York

Yong Soon Min's emblematic image was conceived in solidarity with the people of Nicaragua. The artist was inspired by a documentary film on the subject that emphasized the power of collective action in overcoming oppression.

A Korean-born artist who came to the United States at the age of seven, Min is deeply involved with the Korean-American community here and with issues relating to Korea. She has said that she believes conditions in many Third World countries parallel those in Korea. *Solidarity II* is part of a series of works printed in the colors of the Sandinista revolutionary flag, with design variations meant as an homage to it. The central rectangle shows a cross that could fit perfectly in the notch below it as a symbol of solidarity. For Min the cross gives a spiritual dimension to the composition and suggests the positive force of belief and commitment.

141.

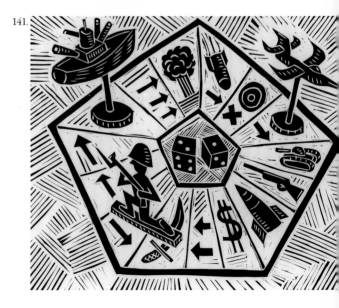

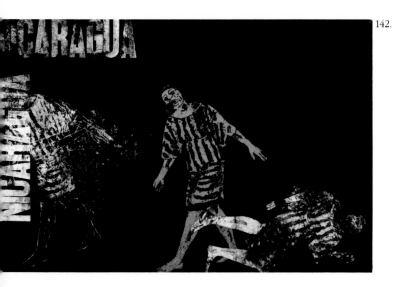

142.

143.

141. Richard Mock. *A Runaway Pentagon* from the portfolio *Mock of the Times*. (1984). New York, Mock Studios, 1986. Linoleum cut, 19½ × 26″ (49.5 × 66 cm). Courtesy Rosa Esman Gallery, New York

Mock's woodcut was conceived for the op-ed page of *The New York Times* to illustrate an article on the extraordinary budget of the Pentagon, written by a Department of Defense officer. The article states in part: "Despite the biggest sustained budget growth since the World War II mobilization, the Pentagon still regards a shortage of money as the main obstacle to a full renaissance of American military power." Mock's Pentagon has the impact of a logo but actually forms a board game with no beginning and no end. A Brooklyn chapter of Vietnam Veterans Against War later reproduced this image on posters that were used in a veterans' parade.

142. Nancy Spero. *Nicaragua*. 1985. Zinc-cut stamps and zinc-cut stamp collage, printed in color, 24 × 39″ (61 × 99 cm). Courtesy Josh Baer Gallery, New York

Spero has done numerous works on Latin American subjects, beginning with her *Torture in Chile* of 1974. One of two works executed in 1986 that incorporate blue paper and seemingly X-rayed figures (the other being *El Salvador*), *Nicaragua* focuses on the condition of women—noncombatants—in a place given over to the battles of soldiers. Spero uses the no-

tion of irradiation—a deadly force visited indiscriminately upon its victims, a force against which there is no defense—to suggest the effects of violent civil strife on women.

Although Spero localizes this work by printing the word "Nicaragua" at upper left, the condition she describes is timeless. The same figure seen in three stamped impressions in this print is also found, with arms outstretched, in the piece *Mourning Women/Irradiated* (1985). These and other recent irradiation works seem to evoke the ultimate state of victimization.

143. John Pitman Weber. *Daniel's View*. 1983. Silkscreen and lithograph, printed in color, 14¹⁵⁄₁₆ × 21¹⁵⁄₁₆″ (37.9 × 55.7 cm). Collection the artist, Chicago

Weber's theme in *Daniel's View* is violence, repression, and civil strife in Central America. Through his imagery he succeeds in making us appreciate what is often "lost in transmission" with televised news reports. When we look at the battered female captive on the right in the way the pensive children on the left might, a different picture emerges. Weber asked his own young son, Daniel, to draw some scenes of El Salvador for this work. He incorporates Daniel's helicopters, bombs, and plea for peace.

144. Claes Oldenburg. *Proposal for a Monument to the Survival of the University of El Salvador: Blasted Pencil (That Still Writes)*. New York, Multiples, Inc., for Artists Call Against U.S. Intervention in Central America, 1984. Etching and aquatint, printed in color, 22¹¹⁄₁₆ × 30¼″ (57.6 × 76.8 cm). Courtesy Multiples/Marian Goodman Gallery, New York

In 1980 the military closed the University of El Salvador during a period of intense civil strife. Oldenburg's print proposes a monument for the university: a giant fragment of a sharpened pencil that resembles nothing so much as a missile. The model that inspired the print was on view in an exhibition for Artists Call Against U.S. Intervention in Central America, and the print was issued to benefit that organization.

Oldenburg also designed the Artists Call poster, which contains a statement of purpose that begins: "If we can simply witness the destruction of another culture, we are sacrificing our own right to make culture. Anyone who has ever protested repression anywhere should consider the responsibility to defend the culture and rights of the Central American people."

145. William Wiley. *El Salvador*. San Francisco, Experimental Workshop, 1983. Woodcut, 53⅝ × 26¹⁵⁄₁₆″ (136.2 × 68.4 cm). Lent by the publisher, San Francisco

Wiley, who plays the guitar a bit, chose to make the blocks for his first woodcuts in the shapes of guitars. The guitar shape evokes

144

the populist tradition of the folk-singer/social critic, which has encompassed such figures as Woody Guthrie and Pete Seeger. Not surprisingly, all three resulting prints—*MX, Agent Orange*, and the present work—make reference to political issues. (After he pulled the prints, Wiley added strings to the guitar-shaped blocks, giving them a sculptural dimension.)

In *El Salvador*, the artist employs his usual cryptic iconography to fashion a riddlelike arrangement of symbolic shapes and letters on the body of the guitar. Some of the triangles, circles, and curled lines coalesce into a face with a tear falling from one eye. This mysterious and melancholy image incorporates the text "El Salvador" as a detail at left center. The handle of the guitar clearly pays homage to the great Mexican printmaker José Guadalupe Posada.

145.

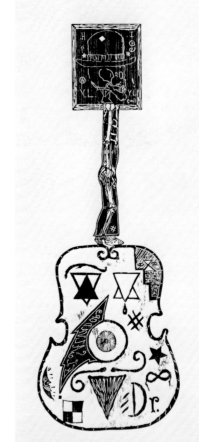

Artists' Books

146. Sabra Moore. *Reconstructed Codex* (photocopy version). New York, 1984. Photocopy, printed in color; 8¼ × 3¾″ (20.9 × 9.5 cm), variable 26 leaves. Collection the artist, Brooklyn, New York

This collaborative project, conceived and organized by Sabra Moore, involved twenty North and South American women artists and was done for Artists Call Against U.S. Intervention in Central America. For this collaboration a parallel was drawn between the burning of Mayan codices in the Yucatan by sixteenth-century missionaries and the recent United States activities in the same region. Four Mayan codices survived the book burnings, and Moore chose in her artists' book to match their format, "as an homage to the partially destroyed culture and in an effort to learn by repetition." The twenty artists who contributed to *Reconstructed Codex* are Emma Amos, Camille Billops, Frances Buschke, Josely Carvalho, Catherine Correa, Christine Costan, Colleen Cutschall, Sharon Gilbert, Kathy Grove, Marina Gutiérrez, Virginia Jaramillo, Kazuko, Sabra Moore, Helen Oji, Catalina Parra, Linda Peer, Liliana Porter, Jaune Quick-To-See Smith, Nancy Spero, and Holly Zox.

ECONOMICS/ CLASS STRUGGLE/ THE AMERICAN DREAM

147. Alfredo Jaar. Two-part panel from the project *Rushes* (installed in a New York subway station, 1986). (1986). Electrostatic dot plotting (computer print), printed in color, each part 42 × 28" (106.7 × 71.1 cm). Collection the artist, New York

Jaar's two-part panel belongs to a set of eighty works the artist installed in a New York subway station in December 1986. His project, titled *Rushes*, was one segment of a four-part series of exhibitions on the subject of a massive gold rush in a remote area of Brazil. Jaar had visited the area and photographed and interviewed the prospectors. More than one hundred thousand formerly unemployed men have come to these Brazilian mines obsessed with the hope of riches. Only a very few have found gold.

Jaar's subway installation had a powerful impact, with its depiction of so many bodies desperately climbing up and down the craterlike excavation. Although the miners' activity, clothing, and surroundings were strange to the commuters who confronted the installation in the subway station, the close-ups of the Brazilians' faces forged a link. The two-part panel here derives its power from the contrast between a figure in a most primitive setting and a slick graphic text that relates to high finance and Wall Street.

147.

148. Jane Dickson. *Thou Shalt Not Steal* from the portfolio *The Ten Commandments*. New York, Art Issue Editions, Inc., 1987. Lithograph, printed in color, 24 × 18" (61 × 45.7 cm). Lent by the publisher, New York

Dickson's lithograph is part of a collaborative portfolio project in which artists were invited to execute prints on one of the Ten Commandments. Dickson's print represents a seemingly clandestine meeting of two executives in a modern office building. The implication is of shady dealings and white-collar crime. This focus on the powerful in our society is unusual in

148.

149.

Dickson's work. Influenced by her neighborhood in New York's Times Square, Dickson has often portrayed the nighttime activities of the down and out, as well as scenes of amusement parks and demolition derbies. In working on *Thou Shalt Not Steal*, however, she decided that the pickpockets and petty thieves of Times Square were really minor players in the greater scheme of things. She executed the print at a time when news reports of insider trading on Wall Street appeared almost daily.

149. Hans Haacke. *Tiffany Cares.* Oakland, Crown Point Press, 1978. Etching, 29 × 41″ (73.6 × 104.2 cm). The Museum of Modern Art, New York. Lent by the publisher, San Francisco

The Tiffany & Co. logo, the engraved calligraphic lettering, and the fine deckle edge of the paper have immediate impact in Haacke's etching, signaling the realm of the upper class. A closer reading reveals an unusual treatise on the social benefits provided by the rich and a call from the unemployed for "more millionaires." The fine print at lower left identifies the text in that half as an actual advertisement, one that appeared in the June 6, 1977, edition of *The New York Times*. The text on the right was composed by Haacke.

According to the catalogue of a recent retrospective of Haacke's work at The New Museum of Contemporary Art, the

chairman of Tiffany's in the seventies regularly used the company's advertising space to editorialize on a variety of subjects. Haacke, in his usual critical mode, here subverts the subliminal message commonly transmitted by such advertising. He manipulates an advertising technique to raise questions about the function of advertising, of the news media, and of a corporation considered by many to be synonymous with luxury.

150. Ed Paschke. *Execo.* New York, Business Committee for the Arts, Inc., 1983. Lithograph, printed in color, 34¼ × 24″ (87 × 61 cm). Lent by Landfall Press, Chicago

Paschke's corpulent executive, with his shiny suit and blank expression, is certainly not the man to look straight in the eye for an important business decision. In fact he may be the individual who gave meaning to the term "shifty-eyed." His look of dissipation suggests too many three-martini business lunches.

The full measure of Paschke's irony emerges when it is known that this lithograph was commissioned by the Business Committee for the Arts and *Forbes* magazine, for the seventeenth annual Business in the Arts Awards, in 1983. Examples of it were presented to the corporations that had played the most important roles in the arts for the year. Paschke was commissioned to do the print because he lived in Chicago, where the 1983 presentation ceremonies took place.

150.

151. Christy Rupp. *Rat Posters* (installed in New York, 1979). (1979). Offsets, each 5½ × 17½" (14 × 44.5 cm). Courtesy P.P.O.W., New York

In 1979 Rupp mounted four thousand *Rat Posters* around garbage cans and trash sites on New York streets as part of her *Rat Patrol* campaign. In these posters, the rats we hope never to see are stopped in their tracks and positioned so that they are impossible to ignore. While there is a certain humor in the audacity of these pests, our overwhelming reaction is revulsion.

Rupp's posters were a means of "making visible during the day what went on at night." And the campaign, designed to bring attention to improper disposal of garbage, did in fact receive widespread attention. The artist, who also created life-size sculptures of rats, wanted to channel this feedback and subsequently organized a series of exhibitions and executed a number of works involving animals in urban contexts. According to Rupp, however, this work has not been about animals but about infestation as it relates to "the environment and economics." She has said, "Rats are a symptom. Garbage is the cause."

151.

152. Rebecca Howland. *The Real Estate Show*. 1980. Stencil, printed in color, 30¼ × 22⁹⁄₁₆" (76.8 × 57.3 cm). Collection the artist, New York

The Real Estate Show was an artist-organized exhibition on the subjects of land speculation, tenants' rights, and property misuse. It was mounted by a group of artists associated with Collaborative Projects, Inc., in a city-owned, abandoned building on New York's Lower East Side. Although it was closed by the city a day after the opening, negotiations with civic authorities eventually led to the offer of the Rivington Street location in which ABC No Rio, an artist-run gallery and performance space, opened later that year.

Howland's grasping octopus was depicted on many of the posters and flyers connected

152.

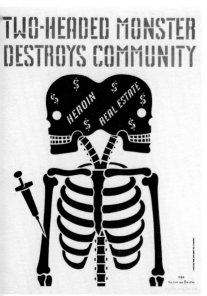

153.

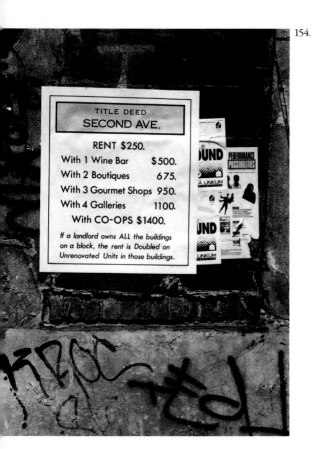

154.

with *The Real Estate Show*. It was also drawn on the side of the building on Delancey Street where the show took place. The stenciled work reproduced here was also sprayed on newsprint. Howland was inspired in her choice of motif by Frank Norris's novel *The Octopus* (1901), in which the industrialization of America is likened to a monster that grows uncontrollably.

153. Anton van Dalen. *Two-Headed Monster Destroys Community*. 1983. Silkscreen, printed in color, 23½ × 17¼″ (59.7 × 43.8 cm). Courtesy Edward Thorp Gallery, New York

Van Dalen's silkscreen addresses major problems on New York's Lower East Side, where he has lived since the sixties. For years the artist watched as his neighbors struggled with the effects of poverty and drug addiction; now he sees the displacing effects of real estate speculation in a prime Manhattan location. Dollar signs indicate an economic role in this "destruction" of the existing community.

The artist's gruesome visual interpretation, which reads like a warning against poison, was originally used as a street poster. The Lower East Side Printshop printed the silkscreen edition in exchange for van Dalen's input at a stencil-making class the printshop held at a local school.

154. Dennis Thomas/Day Gleeson. *Art for the Evicted* (installed in New York, 1984). 1984. Silkscreen with chine collé, 29 × 25½″ (73.7 × 64.8 cm). Collection the artists, New York

Thomas and Gleeson's silkscreen parody of a Monopoly deed was conceived for the second street action organized by Political Art Documentation/Distribution's Not for Sale Committee, in the spring of 1984. The print was posted on abandoned buildings on the Lower East Side as part of a campaign to bring attention to housing issues, such as the art community's role in the changing neighborhood. The work of thirty-seven artists was installed in what were designated as street-corner "galleries" with such names as Guggenheim Downtown and The Discount Salon.

In their print Thomas and Gleeson (who live in the neighborhood) enumerate the factors leading to rising rents. They believe that artists must acknowledge their part in neighborhoods' shifting population patterns. They have donated examples of this print to benefit various neighborhood groups and tenants' committees.

155. Michael Lebron. *Out in the Cold.* (1982). Photographic study for unrealized subway poster, 38¼ × 49½" (97.1 × 125.7 cm). Collection the artist, New York

Lebron's subway-poster design was originally conceived for a campaign to be mounted by a minority urban-development group. After the campaign was canceled Lebron added his own text to the work, and *Out in the Cold* was shown in an exhibition on New York issues. The text, which states in part "communities do disappear in the face of progress," focuses on the effects of urban renaissance on the poor.

For Lebron, advertising encourages the public's uncritical consumption of information. By using a format that apes that of advertising, the artist attempts to subvert the usual response to mass-media messages. His posters are especially disorienting and problematic when the artist places them in sites normally reserved for commercial announcements.

156. Les Levine. *We Are Not Afraid* (installed in a New York subway car, 1982). New York, Museum of Mott Art, Inc., 1982. Offset, printed in color, 21½ × 20½" (54.6 × 52.1 cm). Collection the artist, New York

Levine rented advertising space on New York subways for a month in 1982 and put up 4,800 ambiguous placards bearing the text "We Are Not Afraid." He believes that public art must deal with public concerns, and should not simply be "gallery" art taken outside. This project fit

the artist's definition of public art by addressing the subject of fear in a high-crime environment, a sensation with which most city-dwellers are all too familiar. When confronted with the placards on the subway viewers had no idea of their purpose, and such ambiguity was unnerving. Levine has said that he hopes to broach common concerns with uncommon images, to encourage people to have "new thoughts, rather than the same old ideas."

157. Tomie Arai for Political Art Documentation/Distribution. *Rising Waters.* (1986). Silkscreen, printed in color, 24¹¹⁄₁₆ × 19⁷⁄₁₆" (62.7 × 49.4 cm).

158. Robert Longo for Political Art Documentation/Distribution. *Monument to the Homeless.* (1986). Silkscreen, printed in color, 22 × 27½" (55.9 × 69.9 cm).

Two prints from the portfolio *Concrete Crisis: Urban Images of the '80s.* New York, PAD/D, 1987. Courtesy Exit Art and PAD/D (Political Art Documentation/Distribution) Archive, New York

The artists' group Political Art Documentation/Distribution was founded in New York in 1980 to "demonstrate the political effectiveness of image making." For its *Concrete Crisis* project seventy-eight artists made poster designs focusing on social, political, and psychological issues confronting New Yorkers. All works were exhibited at Exit Art, New York, in 1987, and fourteen were selected to become part of a limited-edition portfolio. A

155.

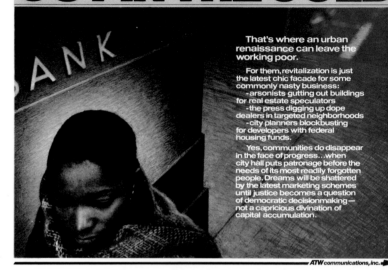

156.

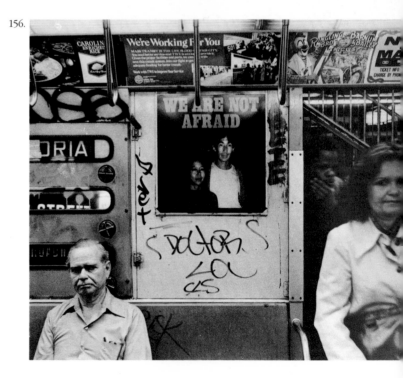

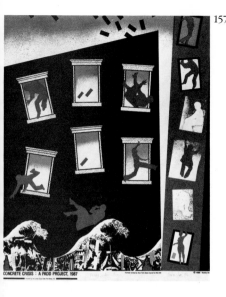

157.

CONCRETE CRISIS : A PADD PROJECT, 1987

159.

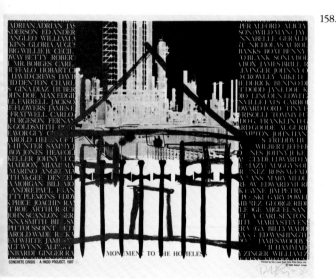

158.

MONUMENT TO THE HOMELESS

CONCRETE CRISIS : A PADD PROJECT, 1987

separate edition of these port-folio works, printed on different paper, was posted on the streets. The portfolio comprises works by Vito Acconci, Tomie Arai, Keith Christensen, Anton van Dalen, Antonio Frasconi, Tim Hillis/Gale Jackson, "Jeff," Janet Koenig, Robert Longo, Alfred Martinez, William C. Maxwell/Gina Marie Terranova, Rachel Romero, George "Geo" Smith, and Nancy Spero/Leon Golub.

Tomie Arai titled the silk-screen print *Rising Waters* after a poem by Langston Hughes. The waves, the artist has explained, are meant to reflect an inability to "keep afloat" in a city of "tremendous tension"; the fig-ures are always kept off balance by the "constant anticipation of change." The anonymous city-dwellers in Arai's print seem to tumble out of control, swept along as if by a tidal wave of urban stresses that shakes even the foundations of the buildings.

One measure of those urban stresses is homelessness. Robert Longo speaks eloquently to that issue in his *Monument to the*

Homeless. He lists on right and left, in a manner recalling a war memorial, the names of home-less people who have died, as recorded by charitable organiza-tions. Superimposed on what appears to be a futuristic city in the background of the print are the rough outlines of a house, the way to which is blocked by a high fence—an impassable row of swordlike bars that also sug-gest grave markers.

159. Anton van Dalen. *Car on Fire*. (1981). Stencil, printed in color, 16⅟₁₆ × 21⅛″ (40.8 × 53.7 cm). Cour-tesy Edward Thorp Gallery, New York

The car motif is often used by van Dalen as metaphor for American culture. He has incor-porated it in sculptures and in paintings, in images of dilapi-dated heaps and of luxury lim-ousines. With this stencil the artist directs attention to the abandoned cars so common in his Lower East Side neigh-borhood, creating an emblem of urban blight. Van Dalen has done more than forty such em-blematic images since 1981, and he thinks of the series as both a social document and an auto-biography that marks concerns of home, street, neighborhood, and government. Other stencils depict such things as a hammer, a handgun, the cross of a store-front church, and a tank.

160. Luis Jimenez. *Cruzando el Rio Bravo (Border Crossing)*. Santa Fe, New Mexico, the artist and Hand Graphics, 1986. Lithograph, printed in color, 38¾ × 28⅝″ (98.4 × 72.7 cm). Courtesy Phyllis Kind Gallery, New York

Jimenez's *Border Crossing* re-creates a scene that the artist witnessed daily while growing up in the border town of El Paso, Texas. The artist's family grouping embodies the power of familial bonds, of determination, and of hope for the future.

Jimenez's work often deals with cultural archetypes, particularly those relating to Chicano life in rural parts of the American Southwest. This print is derived from one of Jimenez's working studies for a public sculpture commissioned for MacArthur Park in Los Angeles. Celebrated as a hippie haven in the sixties, MacArthur Park now serves a neighborhood of recent immigrants from Central America. It is for this reason that Jimenez chose to treat the border-crossing theme in the commissioned sculpture.

161. Leslie Bender for Political Art Documentation/Distribution. Untitled from the project *Not for Sale*. New York, PAD/D, 1983. Stencil, printed in color, 24¹⁄₁₆ × 22¹⁵⁄₁₆″ (61.1 × 58.3 cm). Collection PAD/D (Political Art Documentation/Distribution) Archive, New York

Political Art Documentation/Distribution's Not For Sale committee organized its first anti-gentrification project, with exhibitions and special events, in 1983. Bender, Michael Anderson, and Eva Cockcroft constituted the Not for Sale stencil team for that project. They each designed stencils incorporating visual symbols that immediately called to mind the poverty and real estate speculation that are major ingredients in the housing situation on the Lower East Side. The text "Stop Gentrification" was added to each design.

Bender's work refers to the rampant practice of arson, which has become an accompaniment of the gentrification process. She chose to place her message in the prohibitive diagonal format recognized from warning signs worldwide. She and the other stencil-team members sprayed their images on abandoned buildings around the neighborhood as a backdrop to the larger campaign.

160.

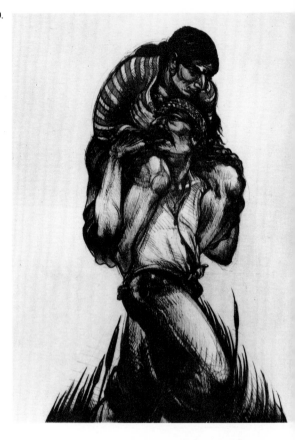

161.

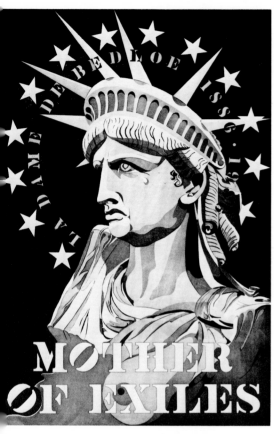

162.

163.

162. Robert Indiana. *Mother of Exiles*. Vinalhaven, Maine, Vinalhaven Press, 1986. Etching and aquatint, printed in color, 47⅜ × 31½″ (120.8 × 80 cm). Lent by the publisher, Vinalhaven, Maine

Indiana conceived his Statue of Liberty print at the time of the centennial celebration for the monument. Although he has lived in Maine for the past decade, he was a resident of Lower Manhattan for twenty-five years prior to that, and the statue was part of his everyday surroundings. Given his long artistic involvement with cultural icons and his fascination with the American Dream in particular, it is not surprising that he would be drawn to this popular symbol at a time of such public commotion about it.

With his Liberty in a halo of stars, Indiana joins in the birthday commemorations, yet evokes melancholy rather than hopeful aspirations. His title designates America's new residents as "exiles" rather than as immigrants, stressing the harsh reasons some left their native countries. Here the poster qualities of the print belie the rather psychological portrait of the statue as "Mother." The tear is the most striking element of melancholy and suggests the complexities of the American experience. In a magazine interview conducted soon after the celebrations Indiana said, "I think that Liberty has a great deal to cry for."

163. Richard Mock. *How Insurers Invite Arson* from the portfolio *Mock of the Times*. (1980). New York, Mock Studios, 1986. Linoleum cut, 26 × 19½″ (66 × 49.5 cm). Courtesy Rosa Esman Gallery, New York

Mock's woodcut was created to illustrate a letter published on the op-ed page of *The New York Times* decrying the "incentive to commit arson-for-profit provided by insurance company practice." The writer describes a fire—labeled "suspicious" by the fire department—that destroyed the older apartment building in which he lived. He goes on to express his opposition to the practice of insuring such old buildings not at their market value but at their (much higher) replacement cost.

In Mock's awesome scene of conflagration flames envelop the building, dwarfing it. Matches at the base indicate the fire was deliberately set. The conception thus represents the building as a kind of innocent victim, simply a link in a chain of events well outside itself. The implication is that unannounced agendas can become determining factors in people's lives.

164. Paul Marcus. *The Auction*. New York, Pycus Studio, 1986. Woodcut, 48″ × 6′6″ (121.9 × 198.2 cm). Courtesy P.P.O.W., New York

Marcus evokes the era of the Great Depression in his huge recent woodcut, through the social realism of the subject matter and the stylized narrative format. But the problem he addresses is contemporary: the economic crisis of the American farmer. In his depiction of a farm family's belongings being sold out from under them, piece by piece, Marcus shows us what it is to leave the land.

This large-scale print is one of several executed by Marcus on such themes as city-dwellers' evictions, aliens hiding in sewer tunnels, and Mexicans crossing the border into the United States. The huge wood-blocks from which they are printed are made into relief paintings after the artist pulls a small edition of prints. He has worked as a master printer in etching but prefers the direct impact of woodcuts for his own art.

165. Jerry Kearns. *Naked Brunch*. 1985. Lithograph, 28⅞ × 26⅜″ (73.4 × 67 cm). The Museum of Modern Art, New York. John B. Turner Fund

Kearns's scene of savage hunger superimposed on the serene face of the Statue of Liberty resonates with tense contrast. This image was created by the artist at the time of the preparations for the statue's centennial celebrations, when stories of its inspiring symbolism for arriving immigrants were the subject of a

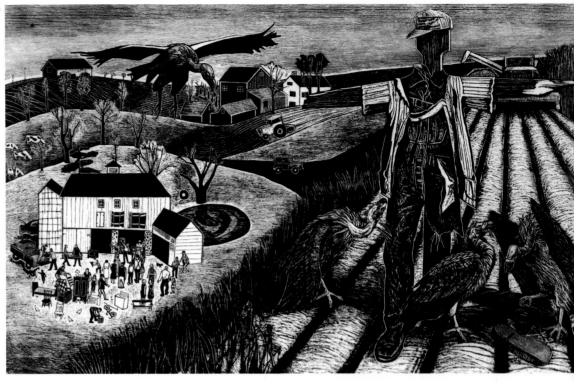

164

media blitz. Kearns's work often juxtaposes cultural icons with imagery from comic books and other popular sources. He uses the trendy concept of the urban brunch in this title, but gives it a hard edge through the word-play reference to William Burroughs's *Naked Lunch* (1959), a novel on the hunger of drug addiction. By bringing together several of what he calls "symbols of fact and fantasy" Kearns offers a sobering view of the often unfulfilled promise of the American Dream.

165.

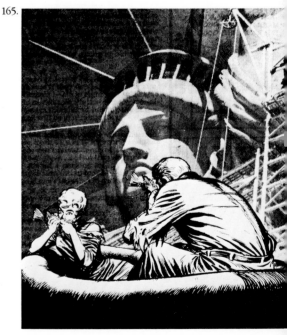

tists' Books

Artists Meeting for Cultural
nge. *An Anti-Catalog*. New York,
alog Committee of Artists Meeting
Cultural Change, 1977. Offset; 12 ×
30.5 × 22.8 cm), 42 leaves. The
seum of Modern Art, New York

late 1975 a group of New York
ists learned of plans by the
itney Museum of American
to exhibit the private collec-
n of John D. Rockefeller 3rd,
part of its Bicentennial pro-
mming. *An Anti-Catalog* sets
th these artists' many objec-
ns to the show, which they
ieved exemplified "the use
more aptly the *misuse*) of art
d art institutions to serve the
erests of a wealthy minority at
expense of the majority."
o at issue was the fact that in
Bicentennial exhibition at a
blicly funded institution, the
erican art shown included
ot a single work by a Hispanic
native American and only one
rk by a woman artist and one
rk by a Black." *An Anti-Cata-*
is described by its authors as
ot a listing of valuable objects
a definitive statement of what
or is not significant art. This
i-catalog does not attempt to
authoritative, but to call into
estion the very notion of 'au-
ritative' views of culture."
The group Artists Meeting for
ltural Change arose from the
etings and protests surround-
this exhibition. *An Anti-*
alog was written, designed,
produced by the Catalog
mmittee of Artists Meeting for

Cultural Change: Rudolf Baranik,
Sarina Bromberg, Sarah Charles-
worth, Susanne Cohn, Carol
Duncan, Shawn Gargagliano, Eu-
nice Golden, Janet Koenig,
Joseph Kosuth, Anthony McCall,
Paul Pechter, Elaine Bendock
Pelosini, Aaron Roseman, Larry
Rosing, Ann Marie Rousseau,
Alan Wallach, and Walter Weissman,
with contributions by Jimmy
Durham and Gerald Horne.

167. Michael Corris. *Typographic Sam-
ples, Pictures & Polemics*. Atlanta,
Nexus Press, 1986. Offset, printed in
color and black; 17 × 11"
(43.2 × 27.9 cm), 38 leaves. The
Museum of Modern Art, New York

For Corris the very physical
shape of the word becomes a
work of art through the manip-
ulation of type sizes and faces.
But each word and phrase in his
artist's book is also carefully
chosen for what it signifies. The
resulting theoretical treatise on
the underpinnings of art, gov-
ernment, economics, and class,
and on their interconnections, is
as provocative to look at as it is
to read. Corris combines dispa-
rate design elements in a co-
herent whole of extreme visual
clarity, while expressing notions
that are complicated and multi-
leveled. Intermingled with the
theoretical and the poetic are
references to specific issues
such as nuclear war and the
"obsolescence" of certain skilled
workers, and a rendering of a
geopolitical landscape in which
Grenada, Nicaragua, Cuba, Chile,
and Libya are being attacked by
fighter planes. All the pages of
this book also exist as individual
art works. Pages titled *Logo for
the Cultivated*, *Logo for the Activ-
ist*, *Logo for the Dispossessed*,
and *Logo for the Confused* have
been done at poster size.

168. Dona Ann McAdams. *Alphabet
City*. New York, 1983. Offset; 8½ × 11"
(21.6 × 27.9 cm), 37 leaves. The Mu-
seum of Modern Art, New York

McAdams's artist's book re-
produces the photographs she
has taken to document the re-
cent changes in her neigh-
borhood on New York's Lower
East Side, where avenues are
given the letter names of A, B, C,
and D. It is a devastating account
of urban decay, with abandoned
buildings and seemingly endless
expanses of rubble. McAdams
also includes scenes of the fire
department putting out the nu-
merous fires that she believes
are an inevitable accompani-
ment of property speculation
and gentrification. On the cover
of McAdams's book, in Spanish
and in English, is a definition of
the verb "to gentrify": "to con-
vert (a poor or working-class
property or area) to one that is
more expensive or exclusive,
especially in order to raise prop-
erty value."

Chronology, 1960–1987

The following sampling of social, political, and art-activist events is offered as a frame of reference for the works of art discussed in this publication.

1960

Soviet Union shoots down U.S. U-2 reconnaissance plane; pilot Francis Gary Powers is held.

Thousands demonstrate against apartheid pass laws in Sharpeville, South Africa; 89 are killed.

John F. Kennedy is elected President.

Sit-ins at segregated lunch counters begin in South.

Food and Drug Administration approves birth control pill.

1961

East Germans erect wall dividing East and West Berlin.

Bay of Pigs invasion of Cuba fails.

U.S. pledges aid to South Vietnam; sends military advisers.

Series of Freedom Rider bus trips challenge segregation in South.

1962

President Kennedy orders naval and air quarantine on military shipments to Cuba; Cuban missile crisis ensues.

James Meredith becomes first black student at University of Mississippi; riots prompted by his attempts to enroll are quelled by state troops.

Cesar Chavez founds United Farm Workers Union.

Thalidomide is removed from market for causing birth defects.

Artists for CORE (Congress of Racial Equality) begins annual benefit exhibitions; also issues benefit prints.

Institute of American Indian Art (previously the Santa Fe Indian School) is founded in Sante Fe, New Mexico.

1963

President Kennedy is assassinated in Dallas; Lee Harvey Oswald, charged with the murder, is killed shortly thereafter by Jack Ruby. Vice President Lyndon B. Johnson becomes President.

Governor George Wallace "stands in the schoolhouse door" to maintain segregation at University of Alabama.

Sniper kills Medgar Evers, a leader in the National Association for the Advancement of Colored People (NAACP), in Jackson, Mississippi.

In Washington, D.C., 200,000 demonstrate demanding full civil rights for blacks. Rev. Dr. Martin Luther King Jr. gives "I Have a Dream" speech at Lincoln Memorial.

Bomb explosion in Birmingham, Alabama, church kills four black girls.

The Spiral, an organization of black artists, forms in New York; mounts sole exhibition in 1965.

1964

The black South African leader Nelson Mandela is sentenced to life imprisonment for his role in encouraging armed resistance to apartheid.

Congress passes Gulf of Tonkin Resolution granting President Johnson power to take action as deemed necessary "to maintain peace" in Vietnam.

Congress approves President Johnson's "War on Poverty" bill; Johnson pledges to build a "Great Society."

Omnibus civil rights bill passes; discriminatory practices in voting, jobs, public accommodations, etc., are banned.

Civil rights workers James Chaney, Andrew Goodman, and Michael Schwerner are murdered in Mississippi.

Malcolm X forms Organization of Afro-American Unity.

1965

Cultural Revolution begins in China.

Fourteen thousand U.S. troops are sent to Dominican Republic during civil war there.

U.S. forces in Vietnam raised to 125,000; draft is doubled.

Demonstrations against U.S. involvement in Vietnam are staged in cities from New York to Berkeley; counter-demonstrations and rallies follow.

Blacks riot in Watts area of Los Angeles.

Civil rights march from Selma to Montgomery, Alabama, is led by Rev. Dr. Martin Luther King Jr.

Malcolm X is shot and killed in New York.

United Farm Workers organize strike against California grape growers.

Several hundred artists take full-page ad in The New York Times *headed "End Your Silence," in protest against U.S. involvement in Vietnam and the Dominican Republic.*

1966

U.S. troops in South Vietnam reach 385,000; monthly draft is highest sin[ce] Korean War.

James Meredith is shot and wounde[d] during voter-registration pilgrimage [in] Mississippi.

CORE endorses militance in its call [for] black power; Student Non-Violent C[o]ordinating Committee concurs. NA[ACP] rejects black power concept as sepa[-]ratist.

National Organization of Women forms.

Stephen Radich of Stephen Radich A[rt] Gallery, New York, is charged with violating flag desecration laws in e[x]hibiting a protest work made from American flags.

Los Angeles Artists Protest Committe[e] erects The Peace Tower, affixed with hundreds of panels by artists from around the country.

1967

Arab-Israeli Six Day War is waged.

Che Guevara is killed in Bolivia.

Puerto Rico votes to remain a commonwealth associated with the U.S.

Anti–Vietnam War demonstrations ta[ke] place in New York, San Francisco, an[d] Washington, D.C. Rev. Dr. Martin Luther King Jr. urges draft boycott. A[n] estimated 70,000 march in pro-U.S.-policy parade in New York.

Blacks riot in Newark; Detroit; Phila[-]delphia; and Rochester, New York.

Thurgood Marshall becomes first bla[ck] U.S. Supreme Court Justice. Carl

Stokes of Cleveland and Richard Hatcher of Gary, Indiana, are first blacks elected mayors of major U.S. cities.

President Johnson calls for regulatory procedures to control air pollution.

Week of the Angry Arts Against the War in Vietnam, a series of protest events in New York, includes actions by artists in all fields; 200 visual artists contribute to related Collage of Indignation mural.

Artists and Writers Protest Against the War in Vietnam issues benefit portfolio.

Wall of Respect, a mural by black artists, is painted on Chicago's South Side.

1968

Soviet Union invades Czechoslovakia, crushing Party First Secretary Alexander Dubcek's liberal regime.

Student protests in France lead to month of civil violence as ten million strikers paralyze country.

Civil strife in Nigeria results in mass starvation in Biafra.

Viet Cong and North Vietnamese launch surprise offensive during Tet (lunar new year) truce.

Rev. Dr. Martin Luther King Jr. is assassinated in Memphis.

Senator Robert F. Kennedy is assassinated in Los Angeles.

Police clash with antiwar protesters at Democratic National Convention in Chicago. Eight key figures in demonstrations are charged with conspiracy amid reports of police brutality.

Richard M. Nixon is elected President.

The Studio Museum in Harlem opens.

Cityarts Workshop is founded in New York as center for community-oriented public art; collaborations on murals and mosaics are emphasized.

The exhibition Benefit for the Student Mobilization Committee to End the

War in Vietnam *is installed at Paula Cooper Gallery, New York.*

Lower East Print Shop, an artist-run workshop offering printing facilities, instruction, and other services, opens in New York.

Anti–Mayor Daley exhibition is mounted at Feigen Gallery, Chicago, to protest police actions at Democratic National Convention there.

1969

Civil strife mounts in Northern Ireland; Bernadette Devlin, student civil rights leader, wins seat in British House of Commons.

Neil Armstrong is first man to set foot on the moon.

U.S. forces in Vietnam peak at 543,000; withdrawal begins as "Vietnamization" policy is launched.

Hundreds of thousands demonstrate in opposition to the Vietnam War in Moratorium Day events across the nation; candlelight procession past the White House is led by Coretta Scott King, widow of Martin Luther King Jr.

Lt. William L. Calley Jr. and others are charged in massacre of Vietnamese civilians in My Lai in 1968; Calley is convicted of murder in 1971.

Native Americans occupy Alcatraz Island in San Francisco Bay.

Gay uprising takes place at Stonewall Bar in New York after repeated raids by police; gay community parade is held annually thereafter to commemorate Stonewall confrontation.

El Museo del Barrio, dedicated to art by Puerto Rican artists, opens in New York.

Black Emergency Cultural Coalition (BECC) is founded in New York; mounts protests against The Metropolitan Museum of Art. Negotiates demands with Whitney Museum of American Art and organizes prison art program in 1971. With Artists and Writers Protest Against the War in Vietnam publishes Attica Book, *1972.*

Cinque Gallery, a forum for black artists, is founded in New York.

Art Workers' Coalition, a militant artists' group, forms in New York to reform policies and structures of major art institutions and to protest U.S. intervention in Southeast Asia, among other activities. In this year joins Artists and Writers Protest Against the War in Vietnam in antiwar procession, carrying body bags and banners marked with names of war dead. Publishes Q. And Babies? A. And Babies poster and participates in Art Strike Against Racism, War and Repression in 1970.

Women Artists in Revolution (W.A.R.), an offshoot of Art Workers' Coalition, forms in New York.

Taller Boricua, a cultural center/workshop for the Puerto Rican community, opens in New York; offers graphics studio and sponsors music, poetry, and dance events.

1970

U.S. invades Cambodia.

Marxist leader Salvador Allende is elected President of Chile.

Four students are killed by National Guardsmen during antiwar demonstrations at Kent State University, Ohio; two are killed by police at Jackson State University, Mississippi.

After years of strikes and a nationwide boycott, Cesar Chavez of the United Farm Workers signs contracts with grape growers in California.

Hundreds of Mexican-Americans riot in Los Angeles in city's worst unrest since Watts uprising of 1965; Ruben Salazar, newspaperman and prominent spokesman for the city's Mexican-Americans, is killed.

Millions participate in antipollution demonstrations to mark Earth Day.

Art Strike Against Racism, War and Repression is formed in New York; more than 500 artists stage sit-in at The Metropolitan Museum of Art, de-

manding closing to protest U.S. invasion of Cambodia and killings at Kent State and Jackson State.

Many American artists withdraw from Venice Biennale in protest against American actions abroad.

Artists and Writers Protest Against the War in Vietnam and the Art Workers' Coalition execute letter campaign urging Picasso to withdraw Guernica *from The Museum of Modern Art to protest U.S. involvement in Vietnam.*

Artists participate in Collage of Indignation II exhibition in New York by creating images for antiwar posters. Robert Rauschenberg's design is made into a poster edition.

Peoples Flag Show, at Judson Memorial Church, New York, is closed by police with arrest of organizers, labeled the Judson Three. All are found guilty of flag desecration in 1971.

Basement Workshop, an Asian-American community arts center in New York's Chinatown, is founded to offer publishing services, music, dance, literary events, performances, exhibitions, graphics workshops, and other benefits to the community.

Ad Hoc Women Artists' Committee, W.A.R., and Women Students and Artists for Black Art Liberation stage series of demonstrations at New York museums.

First feminist art class is organized, by Judy Chicago at California State University, Fresno.

Los Angeles Council of Women Artists protests underrepresentation of women artists at Los Angeles County Museum of Art.

Chicago Mural Group forms; later becomes Chicago Public Art Group.

1971

People's Republic of China is admitted to the United Nations; Nationalist China is ousted.

The New York Times publishes classified "Pentagon Papers" on U.S. involvement in Vietnam.

Six are killed in a disputed escape attempt at San Quentin Prison, including "Soledad Brother" George Jackson, author of published prison letters.

More than 1,000 New York State Troopers and police storm Attica State Correctional Facility to end inmate takeover; several dozen inmates and hostages are shot to death in assault.

Campus riots erupt in Puerto Rico between ROTC cadets and students advocating Puerto Rican independence.

The Store Front Museum, devoted to Afro-American and African art, history, and culture, is founded in Jamaica, New York.

Women in the Arts forms in New York; organizes Women Choose Women *at New York Cultural Center in 1973, first all-woman exhibition in major cultural institution.*

West-East Bag (WEB) forms nationwide feminist art network.

Feminist Art Program is inaugurated at California Institute of the Arts, Valencia. Sponsors collaborative exhibition/installation Womanhouse *and West Coast Conference of Women Artists in 1972. Produces the books* Anonymous Was a Woman *in 1974 and* Art: A Woman's Sensibility *in 1975.*

La Raza Graphic Center, a nonprofit Latino and Chicano graphic arts facility and poster workshop, is founded in San Francisco.

1972

Arab terrorist attack ends in deaths of 11 Israeli athletes at Munich Olympics.

"Bloody Sunday" in Northern Ireland: 13 unarmed civilians are killed in Belfast.

President Nixon visits China.

Employees of Nixon reelection campaign are arrested while burglarizing Democratic National Committee head-

quarters in Watergate complex, Washington, D.C.

Senate approves Equal Rights Amendment banning discrimination against women; sends legislation to states for ratification. Ratification attempt fails in 1982.

Alabama Governor George Wallace is seriously wounded by sniper at Presidential campaign stop.

Native Americans occupy Bureau of Indian Affairs in Washington, D.C., in protest action.

Near total ban is declared on pesticide DDT.

Artists and Writers Protest Against the War in Vietnam and Artists' Poster Committee issue Four More Years? *poster in reference to President Nixon's reelection campaign.*

SoHo Arts Festival for McGovern presents performances, exhibitions, street events, films, and music in ten locations in New York.

The exhibition Artists' Benefit for American Civil Liberties Union *is mounted at Castelli Gallery in New York.*

A.I.R., a cooperative women's gallery, forms in New York, one of several women's galleries initiated in the mid-seventies. Artemesia, Chicago; Women's Interart Gallery of the Women's Interart Center, New York; Atlantic Gallery, Brooklyn; Hera, Wakefield, Rhode Island; and Muse, Philadelphia, are notable among them.

Self-Help Graphics and Art, an arts organization and workshop serving the Chicano community, is founded in East Los Angeles.

Kearny Street Workshop, an Asian-American community arts center offering courses, graphic services, lectures, performances, and exhibitions, is founded in San Francisco.

1973

Yom Kippur War between Israel and Arab countries is waged.

Arab oil embargo is declared; energy crisis ensues.

Military *junta* overthrows President Salvador Allende's Marxist government in Chile.

Vietnam peace pacts are signed in Paris.

U.S. ceases bombing in Cambodia.

Hearings on Watergate scandal open.

U.S. Supreme Court rules abortion legal.

American Indian Movement members occupy Wounded Knee, South Dakota, in protest action.

New York artists protest the military takeover in Chile by re-creating in New York a revolutionary mural that had been painted in Chile.

Museum workers strike for seven weeks at The Museum of Modern Art; many in art community join marchers.

Woman's Building, a center for women's art and culture, opens in Los Angeles; among members are Womanspace, first women's exhibition space on West coast, and Feminist Studio Workshop, an experimental program in women's art education, with its Women's Graphic Center and Center for Feminist Art Historical Studies.

1974

Yasir Arafat, leader of Palestine Liberation Organization, is declared sole representative of Palestinian Arabs.

House Judiciary Committee, in televised hearings, recommends three articles of impeachment against President Nixon; President Nixon resigns. Vice President Gerald Ford becomes President; issues unconditional pardon to former President Nixon.

Kenkeleba House, an alternative environment for artists generally excluded from cultural mainstream, opens on Lower East Side in New York with exhibition areas, rehearsal space, classrooms, workshops, archive, and studio spaces.

Asian-American art community lea[d] demonstrations at Confucius Plaza construction site in New York's Chinatown in protest against under[] representation of Asian-American a[nd] other minority workers.

Women's Caucus for Art, an arts org[a]nization and support system comprised of art historians, critics, artis[ts,] educators, and gallery and museu[m] professionals, forms as an offshoot [of] College Art Association.

1975

Fall of Saigon: South Vietnam surrenders to Viet Cong and North Vietnamese.

Pol Pot's Khmer Rouge capture Phn[om] Penh to establish control of Cambo[dia.]

Special commission uncovers illeg[al] domestic CIA operations, including infiltration of agents into black, ant[i-]war, and other activist movements, [as] well as telephone and mail surveillance.

Artists Meeting for Cultural Change[, a] Marxist-oriented discussion and pr[o]test group, forms in New York; publishes An Anti-Catalog *in 1977.*

Artists' Poster Committee organizes benefit exhibition of posters for the Attica Legal Defense Fund, A Decad[e] of Political Posters by American Art[ists,] 1965–1975, *New York.*

Wilfred Owen Brigade, a political-poster group, forms in San Francisc[o,] later becomes the San Francisco Po[ster] Brigade. In 1980 organizes Interna[-]tionalist Art Show: Anti–World War [II,] which travels to Los Angeles, Tucso[n,] and New York.

Movimiento Artistico Chicano (MARCH) is organized in Chicago; promotes art of Chicanos and othe[r] North and South American indigenous groups through exhibitions, li[ter]ary events, posters, and poetry chapbooks.

1976

Chairman Mao Tse-tung and Premier Chou En-lai die.

Civil war breaks out in Lebanon.

Demonstrations and rioting occur in Soweto, South Africa, over Afrikaans language requirements in black schools; 176 are killed.

Chile's military government is accused of police terror by Organization of American States.

Orlando Letelier, formerly a cabinet minister in the Allende administration in Chile, is killed with associate Ronni Moffitt in Washington, D.C.

Jimmy Carter is elected President.

U.S. celebrates Bicentennial.

The Silkscreen Project is organized at St. Mark's Church in the Bowery, New York, to produce low-cost posters, leaflets, brochures, and banners for community action groups.

Social and Public Arts Resource Center (SPARC), a multicultural arts center that produces, exhibits, distributes, and preserves public art works, is founded in Los Angeles; houses printing workshops, mural studio, and center for mural research.

Great Wall of Los Angeles, an epic mural of California's multicultural history, is begun by the artist Judy Baca.

Mission Cultural Center, an arts organization serving the Latino community of the Mission District, opens in San Francisco; houses Mission Gráfica print workshop.

1977

Black student leader Steve Biko dies in police custody in Pretoria, South Africa.

U.S. Defense Department announces plans to deploy neutron weapons, designed to kill people without damage to property, in West Germany as part of NATO defense system.

U.S. farmers demonstrate across the nation, driving tractors and trucks into state capitals to focus attention on farm crisis.

Puerto Rican nationalists occupy Statue of Liberty and hang Puerto Rican flag; call for Puerto Rican independence and release of imprisoned nationalists.

The exhibition Solidarity with Chilean Democracy: A Memorial to Orlando Letelier *is organized at Cayman Gallery, New York.*

First issue of Heresies, *a feminist magazine of art and politics, is published by the Heresies Collective, founded in New York in 1975; the journal* Chrysalis *is launched in Los Angeles. Other notable women's art magazines of the period include* Feminist Art Journal, Women Artists Newsletter *and* Womanart, *all published from New York.*

Many Asian-American artists participate in protests against razing of International Hotel, a low-income residence in San Francisco's Chinatown and Manilatown.

Japantown Art and Media Workshop, an arts organization serving the Asian-American community with graphics workshops and other programs, opens in San Francisco.

Atlatl, a nonprofit Native American arts organization, is founded in Phoenix, Arizona.

1978

Political and religious turmoil mounts in Iran.

President Sadat of Egypt and Prime Minister Begin of Israel agree on framework for peace at Camp David conference initiated by President Carter.

Civil war breaks out in Nicaragua.

Organization of American States criticizes several member nations, notably Uruguay and Paraguay, for persistently violating human rights; delegation is appointed to investigate alleged violations in Argentina.

Fashion Moda, an alternative arts collective with a storefront space, forms in New York's South Bronx; sponsors projects in neighborhood.

Collaborative Projects, Inc. (Colab), an artists' group committed to addressing social and artistic issues through experimental mediums, forms in New York. Organizes The Real Estate Show *and* The Times Square Show, *1980; and the* A. More Store *shop/gallery, 1980 to present; among other projects.*

Gallery 345/Art for Social Change, Inc., organizes in New York to mount exhibitions—on such subjects as the elderly, child abuse, hunger, and nuclear weapons—as vehicles for education and calls to action.

American Indian Community House Gallery/Museum is founded in New York; holds exhibitions, poetry readings, and music, dance, film, and dramatic events.

1979

China condemns Cultural Revolution.

Soviet Union invades Afghanistan.

Shah of Iran is exiled; Ayatollah Khomeini returns and becomes leader of Iranians. U.S. Embassy in Teheran is seized and diplomats are held hostage.

Violence mounts in El Salvador.

Amnesty International reports surge of political imprisonments and murders in Guatemala since 1978.

Major nuclear accident occurs at Three Mile Island power plant near Harrisburg, Pennsylvania.

Over 200,000 march in Washington, D.C., in support of gay rights.

Group Material, an artists' collective dedicated to cultural activism and the exhibition of socially and politically motivated art, forms in New York. Organizes such thematic exhibitions as M-5, *1981;* Subculture, *1983;* Timeline: A Chronicle of U.S. Intervention in Central America, *1984; and* Liberty and Justice, *1986.*

Bread and Roses, a cultural project of the National Union of Hospital and Health Care Employees, is organized; projects include such traveling exhibitions as *The Working American, 1979;* Images of Labor, *1981;* Social Concern and Urban Realism; *and* Disarming Images: Art for Nuclear Disarmament, *1983. Also mounts exhibitions at its Gallery 1199 in New York; publishes books, posters, and postcards.*

Action Against Racism in the Arts forms emergency coalition to protest the exhibition Nigger Drawings *at Artists Space, New York; organizes exhibitions and investigates inequalities in minority funding in the arts.*

Feminist Art Institute, an educational program focusing on visual arts from a feminist perspective, opens in New York.

The Dinner Party, a feminist collaboration, opens at San Francisco Museum of Modern Art.

1980

U.S. aborts secret rescue mission of hostages in Iran.

Iraq and Iran enter into open warfare.

Strikes in Poland lead government to allow independent trade unions.

Archbishop Oscar Romero is assassinated in a San Salvador church; four American churchwomen are later killed by Salvadoran soldiers.

Ronald Reagan wins Presidency in landslide victory.

Racial rioting in Miami leaves 18 dead.

State of emergency is declared at Love Canal, New York, because of toxic waste contamination from a chemical dump site.

Political Art Documentation/Distribution (PAD/D), an artists' resource and networking organization, forms in New York; offers study groups, performance programs, archive of information on social and political art, and the publication Upfront. *Organizes such major art events and programs as* Death and Taxes, *1981;* State of

Mind/State of the Union, *1985;* Not for Sale, *1983, 1984; and* Concrete Crisis, *1987.*

ABC No Rio, an artist-run gallery and performance space, opens on Lower East Side, New York; organizes theme shows, including Suicide, Murder and Junk, *1980;* Animals Living in Cities, *1980;* Crime Show, *1982;* Suburbia, *1983.*

Institute of American Indian Art Museum, Sante Fe, New Mexico, mounts exhibition Years of Protest; *Native American art from the late sixties and early seventies is shown.*

1981

After 444 days of captivity, U.S. hostages are released from Iran.

Martial law is declared in Poland; Lech Walesa, Solidarity union leader, is detained.

Bobby Sands, a 27-year-old member of the outlawed Irish Republican Army, starves to death in act of protest in Maze Prison, Belfast.

Anwar Sadat is assassinated in Cairo.

U.S. military advisers in El Salvador are photographed in combat zone wearing rifles and pistols.

President Reagan is shot in Washington, D.C.

Sandra Day O'Connor becomes first woman on U.S. Supreme Court.

Series of murders of black children takes place in Atlanta, Georgia.

Carnival Knowledge, an artists' group, is founded in New York in response to Moral Majority antiabortion campaign; organizes Abortion Rights Festival in 1982 and The Second Coming; Could There Be Feminist Porn?, a month-long program of visual and performing arts, in 1984.

Artists' Coalition for Equality in Los Angeles protests lack of women and minorities in Los Angeles County Museum of Art programs.

Sisters of Survival, an antinuclear performance art group, is founded in Los Angeles.

Peace Museum, a center for peace education through visual, literary, and performing arts, opens in Chicago.

1982

Israel invades Lebanon. Lebanese Christian militiamen kill scores of Palestinians in Sabra and Shatila refugee camps in West Beirut; Israeli negligence is decried.

Argentina seizes Falkland Islands; British task force counters and retakes islands shortly thereafter.

Civil strife intensifies in El Salvador. International Catholic peace organization and El Salvador Human Rights Commission cite killings by the armed forces and right-wing death squads.

U.S. military advisers increase in Honduras.

Memorial to 57,939 U.S. soldiers killed or missing in the Vietnam War is dedicated in Washington, D.C.

Hundreds of thousands demonstrate against nuclear arms in New York.

Artists for Nuclear Disarmament (AND), a 300-member New York organization of painters, architects, graphic artists, sculptors, curators, teachers, and others creates events and art for June 12 nuclear freeze rally.

Artists Against Nuclear Armament (AANA), an ad hoc artists' group in New York, places ad in The New York Times *calling for a nuclear freeze and elimination of nuclear arms.*

Dangerous Works Conference exhibitions and workshops on antinuclear themes take place at Parsons School of Design in New York.

The exhibition The Atomic Salon: Artists Against Nuclear War *is mounted at Ronald Feldman Fine Arts, Inc., in New York; the gallery and* The Village Voice *collaborate on related special issue on nuclear disarmament.*

Target L.A.: The Art of Survival, a series of antinuclear art events and exhibitions, is produced by L.A. Artists for Survival.

1983

Soviet Union shoots down an unarmed South Korean commercial airliner flying off course.

Suicide commando drives truck filled with explosives into Marine Corps bunker at Beirut airport; Marine death toll reaches 241.

Two million in Europe demonstrate against planned deployment of U.S. missiles there.

U.S. invades Grenada.

U.S. government names acquired immune deficiency syndrome (AIDS) top medical priority.

Times Beach, Missouri, declared disaster area because of dioxin threat.

Commission on Wartime Relocation and Internment of Civilians recommends compensation to Japanese-Americans who were placed in American detention camps during World War II.

Artmakers, an artists' group for community-based public art, forms in New York; creates La lucha continua, *a group of 24 murals on the Lower East Side in 1985.*

The exhibition 1984—A Preview *is mounted at Ronald Feldman Fine Arts, Inc., in New York; the gallery and* The Village Voice *collaborate on a related special issue, "A Preview of 1984 and Beyond."*

1984

Leaking gas from Union Carbide plant in Bhopal, India, kills 2,500; hundreds of thousands affected.

World responds to Ethiopian famine.

Military regime in Uruguay permits election of civilian government; relinquishes rule in 1985.

CIA manual distributed to rebels in Nicaragua creates uproar.

Daniel Ortega Saavedra, Sandinista leader, is elected President of Nicaragua.

Congress condemns U.S. role in mining Nicaraguan ports.

Democratic Party nominates Geraldine Ferraro of New York as Walter Mondale's Vice Presidential running-mate.

Artists Call Against U.S. Intervention Central America is launched from New York, a nationwide mobilization of artists and intellectuals protesting the Reagan Administration's Central American policies through exhibition and related events; more than 1,000 artists take part in New York alone.

Art Against Apartheid, a nationwide coalition of artists and arts organizations, organizes first series of exhibitions and cultural events; more than 400 artists participate in New York.

Artists' Poster Committee in New York issues anti-Reagan poster, We Begin Bombing in Five Minutes, *in an edition of 60,000.*

Women's Caucus for Art organizes a protest against The Museum of Modern Art's reopening exhibition, An International Survey of Recent Painting and Sculpture, *for underrepresentation of women artists.*

1985

Palestinian terrorists hijack the Italian cruise ship *Achille Lauro,* demanding release of Palestinians from Israeli prisons.

TWA plane is held for two weeks by Muslim terrorists demanding Israeli release of Lebanese prisoners.

Nelson Mandela, leader of South Africa's banned African National Congress, refuses an offer of freedom based on his consenting to renounce violence; counters with request that

government renounce violence. Winnie Mandela defies government restrictions on her movements.

Nine Argentinian military commanders are tried for activities that resulted in the "disappearance" of thousands of citizens between 1976 and 1982, a period of military rule.

Amid protest, President Reagan visits military cemetery in Bitburg, West Germany, that contains Nazi SS graves.

Guerrilla Girls, an anonymous group of women in the arts, begins posting statistics about art world sexism on streets of New York.

1986

Philippine election creates chaos; Corazon Aquino becomes President; former President Ferdinand Marcos is forced into exile.

The worst nuclear-power-plant accident in history occurs at Chernobyl facility, in the Soviet Union.

U.S. planes bomb Libya, citing acts of state-sponsored terrorism against U.S. citizens.

U.S. violates Iran arms boycott in secret hostage-swap plan; diversion of profits to Nicaraguan Contras is later revealed.

U.S. space shuttle *Challenger* explodes; all seven aboard die.

William Rehnquist becomes Chief Justice of U.S. Supreme Court amid controversy over his views.

Wall Street financier Ivan F. Boesky is charged with insider-trading violations; agrees to implicate others.

The exhibition Artists Support Black Liberation *takes place in New York, a benefit for the Malcolm X Centers for Black Survival.*

The Law and Order Show, *an exhibition and auction anticipating bicentennial of the U.S. constitution, is mounted at galleries in New York to benefit the Center for Constitutional Rights.*

Women's Caucus for Art organizes Women Artists Visibility Event *in 15 American cities to protest discrimination against women in the visual arts.*

1987

South African miners stage largest strike in country's history.

President Reagan orders U.S. Navy escort for Kuwaiti oil tankers in Persian Gulf. Iranian mining of shipping lanes and missile attacks lead to U.S. bombing of strategic Iranian sites.

Congressional hearings on Iran arms sale and diversion of funds to Contras take place.

President Reagan's nomination of Robert Bork to U.S. Supreme Court sparks national controversy and is rejected by the Senate.

Stock market plummets in record one-day decline, causing worldwide concern about U.S. economic stability.

Hundreds of thousands march in Washington, D.C., in support of gay rights and funding for AIDS research and treatment.

Benefit exhibitions take place at more than 70 New York galleries as part of Art Against AIDS *fundraising drive for AIDS research.*

Connections Project/Conexus, *a feminist collaboration between artists from Brazil and the United States, includes an exhibition at the Museum of Contemporary Hispanic Art, New York, and publication of* 150 Artists Book.

The benefit exhibition Home, *for New York's homeless, is held at Goddard-Riverside Community Center; work by more than 80 artists is shown.*

Kiva Foundation for Art sponsors 24-hour performance-art marathon in support of New York's Food and Hunger Hotline.

Notes on the Artists

Compiled by Wendy Weitman and Deborah Wye

The biographical notes that follow are comprised of information most relevant to the themes of this publication. It is hoped that readers will refer to the works cited at the end of each note for further reference.

Vito Acconci

Born in 1940. Resides in New York. An internationally acclaimed conceptual artist whose work has encompassed sculpture, body art, and film as well as installation, video, and performance art. Most recently has created architectural or furniturelike pieces, several with strong political overtones. These include a memorial to Amsterdam's World War II dead, *Monument to the Dead Children*, executed at the Stedelijk Museum (1978). Subjects of the 1983 *Mask* print series include a Nazi concentration camp (*People's Mask*); art from China (*Red Mask*); and a nuclear cloud (*End Mask*). Confrontation of the superpowers is the theme of a newsprint mask reproduced in the catalogue *Preparing for War*, a publication of *The Terminal Show*, Brooklyn, New York (1983). Incorporated images of guns, explosions, and violent graffiti in the portfolio *Stones for a Wall* (1977). Recently contributed to the Political Art Documentation/Distribution *Concrete Crisis* project, an art campaign that addressed issues of concern to New York (1987). Has written extensively, including poetry, articles on performance art, and for artists' books.

Ref.: La Jolla, La Jolla Museum of Contemporary Arts. *Vito Acconci: Domestic Trappings.* 1987. Text by Ronald J. Onorato. See also bibl. nos. 5, 7, 29, 30, 44, 51, 53, 69, 72, 73, 90, 106, 134, 135, 137.

Jerri Allyn

Born in 1952. Resides in New York. Studied at Goddard College, Burlington, Vermont, in the area of art and community, and continued graduate work through the Feminist Studio Workshop at the Woman's Building, Los Angeles (1976–78). Has taught and lectured widely on performance art and on art and social issues, particularly at the Woman's Building (1977–81). Has worked extensively with video, artists' books, page art, computers, and electronic signs, and has aired work on radio and on cable television. Cofounded the Los Angeles Women's Video Center. Has participated in the performance art groups The Waitresses and Sisters of Survival, Los Angeles. Designed a program for the Times Square Spectacolor Board and contributed to *Connections Project/Conexus* (1987).

Ref.: See bibl. nos. 9, 25, 29, 49, 57, 134.

Luis Alonso

Born in 1951. Resides in Puerto Rico. A printmaker and poster artist concerned with oppression and social injustice. Has concentrated on woodcuts, exploiting that medium's inherent expressionist qualities in subtle landscapes of suffering and protest. Has used a motif of repeated figures to evoke demonstration and/or unemployment lines. As a student, designed posters for the Department of Cultural Activities at the University of Puerto Rico. After graduating began working in the Workshop of Graphic Art of the Institute of Puerto Rican Culture.

Ref.: Ponce, Puerto Rico, Museo de Arte de Ponce. *Xilografías y carteles de Luis Alonso.* 1987. Texts by Marimar Benítez and José Antonio Torres Martíno.

Emma Amos

Born in 1938. Resides in New York. Has addressed issues of black culture and feminism in her paintings and prints, often in portraits of cultural heroes such as Billie Holiday, Bessie Smith, and Joe Louis. Has been actively involved in printmaking since 1960. Participated in and wrote a catalogue essay for *Art in Print: A Tribute to Robert Blackburn*, a traveling exhibition marking the thirty-fifth anniversary of Blackburn's seminal Printmaking Workshop in New York (1984). Was a member of The Spiral, a New York–based organization of black artists (1964–66). Has taken part in activities of the Heresies Collective, a feminist art group, since 1984, in 1986 serving on the editorial board for an issue of *Heresies* magazine. Has taught at the Mason Gross School of Art at Rutgers University, New Brunswick, New Jersey, since 1980. Was appointed Governor of the Skowhegan School of Painting and Sculpture in Maine in 1987. Participated in *Connections Project/Conexus* (1987).

Ref.: See bibl. nos. 14, 15, 17, 126.

Benny Andrews

Born in 1930. Resides in New York and Georgia. Has been a major figure in American arts activism as an artist, educator, arts administrator, and social activist, focusing on issues of racism and oppression. Also works as a writer and book illustrator. Founded, with Henri Ghent and Ed Taylor, the Black Emergency Cultural Coalition (BECC) (1969) and spearheaded a landmark prison art program at the Manhattan House of Detention, New York, which became a model for nationwide programs organized by BECC (1971). Co-edited, with Rudolf Baranik, *Attica Book* (1972), an artistic statement on the 1971 uprising at Attica State Correctional Facility, New York. Since the late sixties has participated in numerous protest demonstrations, has written articles, and has organized exhibitions to further recognition of black artists.

Participated actively in Artists Meeting for Cultural Change in the mid-seventies. Directed the Visual Arts Program of the National Endowment for the Arts (1982–84) and the National Arts Program (1985). Has taught extensively at a variety of institutions, including Queens College, New York (1967 to present).

Ref.: Atlanta, Southern Arts Federation. *Icons and Images in the Work of Benny Andrews*. 1984. Text by Janet Heit. See also bibl. nos. 4, 13, 21, 26, 31, 54, 78, 85, 88, 99.

Ida Applebroog

Born in 1929. Resides in New York. A painter, printmaker, and performance artist whose cartoonlike yet psychologically charged vignettes address the ironies and anxieties of contemporary life. Has also worked extensively with artists' books, developing a strong narrative style and storybook imagery. Published her first artist's book series, *Black Books*, in 1977, distributing many copies herself through the mail. In 1979 published her second series, *White Books*, involving male/female confrontations. Satirized conservative views in America in the series *Blue Books* (1981). Designed a program for the Times Square Spectacolor Board (1983). Has written for the feminist magazine *Heresies;* contributed to *Connections Project/Conexus* (1987).

Ref.: New York, Ronald Feldman Fine Arts, Inc. *Ida Applebroog*. 1987. Texts by Ronald Feldman, Lucy R. Lippard, et al. See also bibl. nos. 7, 9, 29, 37, 38, 39, 49, 67, 74, 108, 137.

Tomie Arai

Born in 1949. Resides in New York. Has worked extensively in community mural-painting and has lectured widely on the subject. With Cityarts Workshop directed the following mural projects in the Chinatown and Lower East Side neighborhoods of New York: *Wall of Respect for the Working People of Chinatown* (1977),

Crear una sociedad neuva (1976), *Women Hold Up Half the Sky* (1975), and *Wall of Respect for Women* (1974). Has been involved in a broad range of art workshops for children, including ones on printmaking, puppetry, murals, and banner making. Worked at Robert Blackburn's Printmaking Workshop in New York (1984–85) and was active in the Basement Workshop in Chinatown, making posters for a variety of community causes. Contributed to *Connections Project/Conexus* (1987).

Ref.: See bibl. nos. 1, 3, 23, 29, 113, 126, 134, 135.

Robert Arneson

Born in 1930. Resides in California. An acclaimed American sculptor known primarily for comic and expressionist ceramic works. Has worked extensively in bitingly satirical portraiture. Most recently has executed political images, such as *Ronny* (1986), which effectively fuse politics, humor, and art. Has encountered controversy because of his work, most notably for his bust of the murdered San Francisco Mayor George Moscone (1981). Became increasingly concerned in the eighties with the subject of nuclear power and weapons, as evidenced in such works as the bronze sculpture *Ground Zero* (1983) and the lithograph *General Nuke* (1986). Has worked in lithography, cast paper, and woodcut. Has taught extensively, particularly at the University of California at Davis (1962 to present).

Ref.: Des Moines, Des Moines Art Center. *Robert Arneson: A Retrospective*. 1986. Text by Neal Benezra. See also bibl. nos. 27, 41, 52, 54, 104, 106, 108.

Artists Meeting for Cultural Change

A coalition of approximately eighty artists, formed in 1975 by activists protesting exhibition policies at the Whitney Museum of American Art, New York. Soon after evolved into a discussion group, with weekly meetings held until 1978. "Artists Meeting for Cultural Change," wrote the artist-member May Stevens in 1977, "is a large, loose, open coalition of Marxists of many stripes, including Art and Language people (many of whom write for and/or edit *The Fox*), feminists, anarchists, and others. The differences are raging, but discontent with museums, galleries, and current art world practices provides common ground. Meetings are divided between plans for action . . . and theoretical discussion." A statement in the group's *Anti-Catalog* (1977) further explains: "Part of the role of AMCC has been to provide a forum for the examination of the political nature of culture—how it is used, how it uses us."

Ref.: See bibl. no. 29.

Artists and Writers Protest Against the War in Vietnam

A loose, New York–based association of artists, writers, and critics whose membership has varied from project to project. The group's name has also varied since its origins in the fifties: "Artists Protest," "Artists Protest Committee," "Artists and Writers Dissent," and "Artists and Writers Protest" are among the various versions. Projects include an open letter to *The New York Times* protesting United States involvement in Vietnam and the Dominican Republic (1965). During the Week of the Angry Arts Against the War in Vietnam mounted the *Collage of Indignation*, a collaborative mural by a variety of visual artists (1967). Issued *Artists and Writers Protest Against the War in Viet Nam*, a portfolio of the work of sixteen visual artists and eighteen poets (1967). Many in the group joined the Art Workers' Coalition in an antiwar procession, carrying body bags and banners with names of war dead (1969). Again with the Art Workers' Coalition mounted a letter campaign to Picasso urging the removal of *Guernica* from The Museum of Modern Art as a war protest (1970). Copublished, with Black Emergency Cultural Coalition, *Attica Book*, in re-

sponse to the 1971 uprising at Attica State Correctional Facility (1972). With the Artists' Poster Committee issued the anti-Nixon poster *Four More Years?* for Senator George McGovern's Presidential campaign of 1972.

Ref.: See bibl. nos. 29, 111.

Art Workers' Coalition

Founded in New York in 1969, a militant artists' group committed to challenging the art-world status quo and advancing the cause of peace. At the coalition's "Open Public Hearing" of 1969 more than three hundred artists and observers aired grievances and helped formulate programs. The Museum of Modern Art became a major target of the group's numerous manifestos, demonstrations, and sit-ins protesting a variety of museum policies. Organized events intended to strengthen artists' rights, to achieve greater representation of minority artists, and to initiate artist participation in museum affairs. Antiwar activities included joining Artists and Writers Protest Against the War in Vietnam in a 1969 march up New York's Sixth Avenue, in which participants carried body bags marked with casualty statistics and banners bearing the names of American and Vietnamese war dead. In 1970 staged a protest in Washington, D.C., in which hundreds of "Lieutenant Calley" masks were distributed, suggesting public responsibility for the My Lai massacre. Was one of the main groups supporting Art Strike Against Racism, War and Repression, which engineered the closing of major museums and galleries in New York in 1970. At the time of its disbanding in 1971 the coalition had spawned several art-activist groups and arts organizations that continued into the seventies. The Art Workers' Coalition Poster Committee, now the Artists' Poster Committee, remains active today; committee membership varies according to each individual project.

Ref.: Art Workers' Coalition. *Art Workers' Coalition: Documents I* (vol. 1) and *Art Workers' Coalition: Open Hearing* (vol. 2). New York: Art Workers' Coalition, 1969. See also bibl. nos. 5, 29, 34.

Eric Avery

Born in 1948. Resides in Texas. A printmaker who works primarily in woodcut and linoleum cut. Trained as a medical doctor, he has treated Vietnamese boat people in Indonesia (1979–80), and spent six months in Somalia with a Christian relief agency working with famine victims (1980). Made woodcuts while in Somalia inspired by this experience, which were on view in his exhibition *Images of Life and Death*, at the Rosenberg Public Library, Galveston, Texas (1982).

Ref.: Corpus Christi, Texas, Weil Gallery, Corpus Christi State University. *Eric Avery: Healing Before Art.* 1987. Text by David Bjelajac.

Luis Cruz Azaceta

Born in 1941 in Havana. Became an American citizen in 1967; resides in New York. In works such as *Subway Series* (1974) has painted expressionist, allegorical depictions of cruelty and deprivation in everyday life. Has also executed numerous portraits and self-portraits incorporating themes of victimization and torture, most recently *Bound and Gagged* and *Charge It* (1985), which allude to political prisoners in South America. Has often utilized in his work highly stylized, macabre symbols of death, such as skeletons and skulls. Has worked in lithography, etching, and silkscreen and has lectured widely on art and political issues.

Ref.: New York, Museum of Contemporary Hispanic Art. *Luis Cruz Azaceta: Tough Ride Around the City.* 1986. Texts by Susanna Torruella Leval and Linda McGreevy. See also bibl. nos. 2, 91.

Sonia Balassanian

Born in 1942 in Iran. Lived in the United States from 1966 to the early seventies; returned in 1978. Resides in New York. Worked as an abstract painter and poet in Teheran. Her work became highly politicized following the Iranian revolution in 1979. Took part in activities of Artists Call Against U.S. Intervention in Central America (1984), and has participated in numerous exhibitions with political and feminist themes.

Ref.: See bibl. nos. 67, 68, 75, 96, 98.

Rudolf Baranik

Born in 1920 in Lithuania; moved to the United States in 1938. Resides in New York. A well-known painter and political activist who in his painting has focused primarily on poetic and enigmatic abstractions. Began the important painting series *Napalm Elegies* in the late sixties; in the early eighties began *Word* paintings. Was among the core members of Artists and Writers Protest Against the War in Vietnam in 1965 and served as a New York sponsor of *The Peace Tower* in Los Angeles in 1966. Was among the organizers of Week of the Angry Arts Against the War in Vietnam in New York (1967). Co-edited, with Benny Andrews, *Attica Book* (1972). Was a founding member of Artists Meeting for Cultural Change (1975). Was among the curators of a memorial exhibition for the slain Chilean diplomat Orlando Letelier (1977). Actively participated in activities of Artists Call Against U.S. Intervention in Central America (1984). Has executed several posters for activist events.

Ref.: Columbus, The Ohio State University Gallery of Fine Art. *Rudolf Baranik, Elegies: Sleep—Napalm—Night Sky.* 1987. Texts by Donald Kuspit and the artist. See also bibl. nos. 10, 21, 29, 31, 51, 52, 66, 81, 88, 90, 113, 134, 135.

Romare Bearden

Born in 1914. Resides in New York. Has received wide acclaim for his collages depicting the rural and urban life of black Americans. Other prominent themes in his work have included biblical subjects and images from classical history. Was a founding member of The Spiral in 1963; has worked since then through that group and independently to advance the position of black artists. Served as Art Director of the Harlem Cultural Council (1964). Co-organized *The Evolution of Afro-American Artists: 1800–1950* at City College, New York (1967), and was among the founders of Cinque Gallery, a New York forum for young black artists (1969). Cowrote *Six Black Masters of American Art* and contributed to *Attica Book* (1972). Has executed many murals and mosaics for civic institutions around the country. Has illustrated several books—including *Poems from Africa* by Samuel Allen (1973) and *The Autobiography of W. E. B. Dubois* (1976)—as well as newspaper articles, book jackets, and jazz-record jackets on Afro-American themes.

Ref.: Charlotte, North Carolina, Mint Museum. *Romare Bearden: 1970–1980.* Texts by Dore Ashton and Albert Murray. See also bibl. nos. 1, 4, 13, 26, 31, 33, 41, 85, 86, 88, 111, 112.

Nan Becker

Resides in New Jersey. An installation and book artist who has focused on the issue of sterilization abuse and is currently investigating the theme of hunting. Was Assistant Director and then Director of Printed Matter, which heightened her interest in artists' books and their political aspects. Participated in the Collaborative Projects, Inc., exhibitions *The Times Square Show*, New York (1980), and *The Ritz*, Washington, D.C. (1983). Contributed to the feminist magazine *Heresies* (1983).

Rudy Begay

Born in 1946, a member of the Navajo nation. Resides in Arizona. Studied at Institute of American Indian Art, Santa Fe (1972–73), and California Institute of Arts, Valencia (1973–75). Participated in several experimental

printmaking courses in the seventies. Currently works as a graphic designer in the Chínle, Arizona, school system, while continuing to explore the mediums of drawing and painting. Received Mamie Mizen Printmaking Award (1973).

Leslie Bender

Resides in New York. An artist and teacher deeply involved in community affairs. Has executed numerous murals, including ones with Cityarts Workshop, for schools and community centers in New York (1981–83). Has instructed and collaborated with local schoolchildren in the arts of mural making and printmaking. Has participated in exhibitions with social and political themes, particularly those bearing on community issues and the environment, and has been active in Political Art Documentation/Distribution, New York.

Ref.: See bibl. nos. 89, 113.

Black Emergency Cultural Coalition

An artists' group founded in 1969 by Benny Andrews, Henri Ghent, and Ed Taylor to further the cause of black artists within the art establishment. Came together in reaction to the lack of input from the black community in The Metropolitan Museum of Art's exhibition *Harlem on My Mind* (1969). Staged numerous protests at major New York museums in a drive for greater representation of black artists and equal opportunity for black curators. Conducted antiwar protests in Washington, D.C. (1971). Copublished *Attica Book* with Artists and Writers Protest Against the War in Vietnam (1972). Joined other political groups in a major protest of the Whitney Museum of American Art's Bicentennial exhibition of the John D. Rockefeller 3rd collection (1976).

Ref.: See bibl. no. 4.

Jonathan Borofsky

Born in 1942. Resides in California. A well-known installation artist whose work often incorporates social and political references. Gained recognition in the mid-seventies for his use of personal dream imagery, usually projected onto the floor and walls, and for his conceptual counting process. More recently has referred to such issues as the superpower arms race (*Ping-Pong Table*, 1981) and Nazism. His work has also included imagery of the Ayatollah Khomeini, Cambodian boat people, and oppression in South Africa. Has worked extensively with lithography, silkscreen, and multiples. Taught at the School of Visual Arts, New York (1969–77).

Ref.: Philadelphia, Philadelphia Museum of Art. *Jonathan Borofsky*. 1984. Texts by Richard Marshall and Mark Rosenthal. See also bibl. nos. 98, 104.

Louise Bourgeois

Born in 1911 in Paris. Moved to New York in 1938; became a United States citizen in 1951. A seminal postwar sculptor whose work has encompassed totemic wood figures, surrealist marble biomorphs, architectural constructions, and environmental installations. Has also worked in painting, drawing, printmaking, and performance. Has participated in activities related to such social and political issues as feminism, the plight of prostitutes, world hunger, and the nuclear threat, and has supported such organizations as the American Civil Liberties Union and Artists Call Against U.S. Intervention in Central America. Has designed posters for and participated in a wide variety of demonstrations, benefits, and honorary committees. Contributed to *Connections Project/ Conexus* (1987).

Ref.: New York, The Museum of Modern Art. *Louise Bourgeois*. 1982. Text by Deborah Wye. See also bibl. nos. 5, 6, 7, 10, 57.

Vivian Browne

Resides in New York. A painter, printmaker, and activist particularly concerned with minority and feminist issues. Has worked in printmaking with Robert Blackburn at the Printmaking Workshop, New York. Was active in the Black Emergency Cultural Coalition (BECC) in the early seventies. Also participated in several protest demonstrations, contributed to *Attica Book* (1972), and taught in BECC's prison art program. Contributed to *Heresies* magazine (1979, 1980) and to *Connections Project/Conexus* (1987). In the mid-seventies was actively involved with Artists Meeting for Cultural Change. Has participated in several panels and symposia concerning black women artists. Since 1971 has taught at Rutgers University, Newark, New Jersey.

Ref.: See bibl. nos. 15, 29, 83, 88, 126.

Chris Burden

Born in 1946. Resides in California. A pioneering conceptual artist who works in video, installation, performance, and body art. Engaged in unprecedented, often violent performances that blurred the boundaries dividing aesthetics, religious experience, and political statement and frequently involved self-mutilation. Since the late seventies has often explored issues of war and nuclear holocaust, in such pieces as *The Reason for the Neutron Bomb*, a symbolic representation of the Russian tank force facing Western Europe (1979), *The Atomic Alphabet* (1979–80), *Warning! Relax, or You Will Be Nuked Again* (1980), and *Cost Effective Micro Weaponry that Works* (1983).

Ref.: Burden, Chris. *Chris Burden 71–73* and *Chris Burden 74–77*. Los Angeles: the artist, 1974 and 1978. See also bibl. nos. 5, 29, 38, 44, 72, 73, 74, 103, 106, 107, 108, 137.

Luis Camnitzer

Born in 1937. A citizen of Uruguay who has lived in the United States since 1964; resides in New York. Works as a sculptor and printmaker within a conceptual art framework, often ad-dressing social and political subjects, such as the Vietnam War, nuclear power, and the instability in Latin America. The early conceptual text pieces *Death Sentence* (1968) and *Campo de concentracion* (1969) spe[?] to the issue of institutionalized tortur[?] Has focused on the destructive powe[?] of chemicals in the subtly chilling photoetching series *Agent Orange* (1984 to present). Has published numerous articles on art and politics an[?] has taught extensively, most notably a[?] the State University of New York, College at Old Westbury (1969 to present).

Ref.: Montevideo, Uruguay, Museo Nacional de Artes Plásticas. *Luis Camnitzer*. 1986. Text by Angel Kalenberg. See also bibl. nos. 29, 66, 86.

Josely Carvalho

Born in Brazil; came to the United States in 1964. Resides in New York. Has worked in video, performance, and book arts, in addition to painting, printmaking, and installations, focusing on feminist and Latin American issues. Has participated in a wide variety of workshops, lectures, and panels on women's issues, social-change art, and silkscreen technique. Since 1976 has directed the Silkscreen Project, St. Mark's Church in the Bowery, New York, which assists community groups with silkscreen printing. Organized the exhibitions *Latin American Solidarity Art by Mai*[?] for Artists Call Against U.S. Intervention in Central America (1984–86); *Choice Works* (on reproductive rights[?] Central Hall Gallery, New York (1985) and, with Sabra Moore, *Connections Project/Conexus* (a feminist collabor[?] tion), Museum of Contemporary Hispanic Art, New York (1987).

Ref.: See bibl. nos. 49, 75, 126, 134.

Elizabeth Catlett

Born in 1919. Resides in Mexico and New York. A printmaker and sculptor who has focused in her work on issu[?]

of black culture and the black woman. Has worked extensively at the Taller de Gráfica Popular in Mexico since the forties. Has contributed printed works to UNICEF and to several black cultural organizations and has received many sculpture commissions in Mexico and the United States. Has been a featured guest at numerous conferences and panels on Afro-American art and has taught extensively, notably at the School of Fine Arts, Universidad Nacional Autónoma de México (1958–76).

Ref.: Lewis, Samella. *The Art of Elizabeth Catlett.* Claremont, California: Hancraft Studios, 1984. See also bibl. nos. 1, 10, 13, 17, 85, 88.

Judy Chicago

Born Judith Cohen in 1939; legally changed name to Judy Chicago in 1970. Resides in New Mexico. Has exercised a wide-reaching influence on feminist art and feminist art education. Is noted for her emphasis on a collective art-making process, involving large numbers of participants. Has worked primarily as a sculptor and painter, incorporating biomorphic imagery suggestive of female sexuality. Has also executed several interior and outdoor installations and environments. Conceived and administered the first women's art curriculum, at California State University, Fresno (1970). Cofounded and directed the Feminist Art Program at California Institute of the Arts, Valencia (1971–73). In Los Angeles, cofounded Womanspace, an alternative art gallery (1972), the Feminist Studio Workshop (1973), and the Woman's Building (1974). Books published include *The Dinner Party* (1979), *Embroidering Our Heritage* (1980), *Through the Flower: My Struggle as a Woman Artist* (1975), and *The Birth Project* (1985).

Ref.: New York, ACA Galleries. *Judy Chicago: The Second Decade 1973–1983.* 1984. Text by Jan Butterfield. See also bibl. nos. 5, 7, 9, 10, 25, 29, 30, 35, 36, 57.

Eva Cockcroft

Has lived in Latin America (1959–60, 1962–64, and 1980–81) and currently resides in New York. A muralist, painter, arts activist, writer, and photographer. Painted her first mural, *Women's Liberation—People's Liberation,* for the New Brunswick, New Jersey, Women's Center (1972). Recent murals include *Homage to Revolutionary Health Workers,* Leon, Nicaragua (1981); *La lucha continua,* the Lower East Side, New York (1985); and *Homage to Seurat: La Grande Jatte in Harlem,* Harlem, New York (1986). Has been an active participant in Political Art Documentation/Distribution (1983 to present). Was an organizer of Artists Call Against U.S. Intervention in Central America and participated in Art Against Apartheid exhibitions (1984). Has directed Artmakers, Inc., a community mural group, since 1983. Has participated in numerous stencil and billboard projects with political and community themes. Has organized several exhibitions on Latin American subjects and contributed to *Connections Project/Conexus* (1987). Has taught and lectured extensively on Latin American issues, community murals, and political art, presently at the New York University for Latin American and Caribbean Studies.

Ref.: Cockcroft, Eva, John Weber, and James Cockcroft. *Toward a People's Art: The Contemporary Mural Movement.* New York: E. P. Dutton & Co., Inc., 1977. See also bibl. nos. 1, 3, 10, 29, 113, 120, 121, 126, 134, 135.

Sue Coe

Born in 1951 in Tamworth, England. Moved to New York in 1972. A painter and book artist preoccupied with themes of the oppressed and disenfranchised; has also executed illustrations for posters, newspapers, magazines, and books. Women, urban blacks, and the people of Central America and South Africa have been the subjects of her expressionist, often ghoulish depictions of violence and social atrocities. Since the mid-seventies has initiated several series based on political themes: *Ku Klux Klan* (1974); *Manhattan Streets* (1977); *Terrorist and Mercenary* (1978); *Bobby Sands, Vivisection,* and *El Salvador* (all 1981); *Detainees of South Africa* (1983); and *Malcolm X* (1985). Began political printmaking in 1984.

Ref.: Richmond, Virginia, Anderson Gallery, Virginia Commonwealth University. *Sue Coe: Police State* by Mandy Coe. 1986. Texts by Donald Kuspit and Marilyn Zeitlin. See also bibl. nos. 30, 44, 49, 54, 94, 104, 126, 134, 135.

Collaborative Projects, Inc.

An artists' group founded in 1978, dedicated to the organization of experimental, collaborative exhibitions of work in a variety of mediums that address social and artistic issues. Has sponsored numerous exhibitions as well as film, video, and publishing projects. Functions primarily as an artist-run exhibition network that bypasses the commercial gallery system. Core membership has remained at about fifty, although active membership continually changes and nonmembers are invited to participate in specific Colab events. Provided initial funding for several landmark projects, including ABC No Rio (1980); *The Times Square Show,* New York (1980); A. More Store, a gallery/store open each Christmas season in various locations (initiated in 1980); the exhibition *The Ritz* (with Washington Project for the Arts), Washington, D.C. (1983); and *Sculpture on the Williamsburg Bridge,* New York (1983). Film and video projects have included *The Wild Style,* a film by Charles Ahearn; *B-Movies* by Beth B. and Scott B.; and *Potato Wolf,* a long-running artists' cable-television series. Publications have included *X Magazine* and *Spanner* and *Bomb* magazines, and, most notably, *Art Direct: The Artists' Direct Mail Catalog,* published with Printed Matter, which offered inexpensive art objects by mail order (1982).

Ref.: See bibl. nos. 29, 30, 32, 121.

Michael Corris

Born in 1949. Resides in New York. A conceptual artist who uses language and theoretical constructs to make aesthetic statements on social and political issues. Has worked as a graphic designer, and has utilized sophisticated typographical schemes in critiques of government, art-world, and corporate institutions and their overlap. Has been an active member of the collaborative group Art and Language. Has written extensively, especially for *The Fox,* a journal published by Art and Language, as well as for the Red Herring editorial collective. Has also participated in activities of Artists Meeting for Cultural Change. Designed a prize-winning poster for Artists Against Nuclear Madness in 1982. Addressed the economics of housing in forums such as the Political Art Documentation/Distribution projects *Not for Sale,* on gentrification (1984), and *Concrete Crisis,* on a variety of urban issues (1987).

Ref.: See bibl. nos. 53, 66, 134, 135.

Carlos Cortez

Born in 1923, the son of a union organizer. Resides in Chicago. An experienced printmaker and linoleum-cut poster-maker who works in a style influenced by Mexican broadsides. Has treated such themes as labor organization and United States military engagements in his work. After World War II joined International Workers of the World (IWW), one of the first unions to organize Mexican workers in the Southwest. Has contributed numerous illustrations, as well as articles and poetry, to *Industrial Worker,* the official magazine of IWW. Has been active in and has executed posters for Movimiento Artistico Chicano and Galeria Casa Aztlán, important Chicano art organizations in Chicago, and has participated in the Chicago Mural Group and Artists Call Against U.S. Intervention in Central America.

Ref.: See bibl. no. 121.

Anton van Dalen

Born in 1938 in Amstelveen, Holland. Emigrated with his family to Toronto in 1954; arrived in New York in 1966. Currently resides in New York. A painter of surrealist scenes of urban life, inspired by his neighborhood on New York's Lower East Side. A trained graphic designer, has made stencil work a vital part of his image making and has applied his emblems of gentrification, drug culture, and militarism to buildings throughout his neighborhood. Has stated that his involvement with community life and with collaborative artists' projects, such as those of ABC No Rio, Group Material, and Political Art Documentation/Distribution, has added a new dimension to his painting.

Ref.: See bibl. nos. 30, 44, 54, 67, 70, 93, 113, 134, 135.

Jane Dickson

Born in 1952. Resides in New York. A painter and printmaker who has actively participated in artists' cooperatives in New York since the late seventies. Is known for her tension-filled scenes of urban street life at night. Was a founding member of Collaborative Projects, Inc., and an organizer of *The Times Square Show* (1980), for which she also designed a poster. Has executed artists' books that graphically and often humorously address the changing roles of men and women in contemporary society. Has participated extensively in activities of ABC No Rio and Fashion Moda. Through the Public Art Fund organized the innovative *Messages to the Public* project for the Spectacolor Board in Times Square (1982). Took part in Artists Call Against U.S. Intervention in Central America (1984).

Ref.: See bibl. nos. 30, 45, 113.

Jim Dine

Born in 1935. Resides in Vermont. An internationally acclaimed painter and prolific printmaker known for his painterly renderings of everyday objects and images, most notably tools, bathrobes, and hearts. Often associated with Pop art, was recognized in the early sixties for his constructions on canvas that frequently incorporated household items such as furniture and clothing. Has also executed numerous portraits and self-portraits throughout his career. Was a leading proponent in the sixties of Happenings, multimedia theatrical events considered the forerunners of performance art.

Ref.: D'Oench, Ellen G., and Jean E. Feinberg. *Jim Dine: Prints 1977–1985*. New York: Harper & Row, Publishers, 1986. See also bibl. nos. 29, 46, 112.

James Dong

Born in 1949. Resides in San Francisco. A muralist, photographer, printmaker, graphic designer, and leading figure in San Francisco's Asian-American arts community. Was an editor of *AION Magazine*, an Asian-American periodical (1969–71). In 1972 founded the Kearny Street Workshop, a Chinatown community arts center. Has executed several murals, including *International Hotel Mural*, with the Kearny Street Workshop, which depicts the housing crisis of the elderly (1974–75). Since 1982 has been on the advisory board of the Mural Resources Center. Has been a board member of Japantown Art and Media Workshop since its founding in 1977 and has served on the Chinatown Council for the Performing and Visual Arts since 1973. Has taught Asian-American studies and photography at several institutions in California.

Ref.: See bibl. nos. 1, 101.

Mary Beth Edelson

Resides in New York. A performance artist, book artist, and painter concerned with feminist issues who has been a leading figure in the feminist art movement. Was a founding member of the Heresies Collective (1975). Has conducted several group performances, often accompanied by installations and murals, that address ritual, myth, and female symbolism. Has designed numerous artists' books on feminist themes, some executed as free handouts and mail art. Contributed to *Connections Project/Conexus* (1987). Has also worked in photography, installation, and sculpture. Has lectured widely and participated in numerous workshops around the country.

Ref.: Edelson, Mary Beth. *Seven Cycles: Public Rituals*. New York: Seven Cycles: Public Rituals, 1980. Introduction by Lucy R. Lippard. See also bibl. nos. 5, 7, 9, 36, 64, 75, 77.

Melvin Edwards

Born in 1937. Resides in New York. A well-known sculptor and installation artist who has also worked with drawing and printmaking. Achieved recognition in the early years of the civil rights movement for his *Lynch Fragments* series of welded-steel wall pieces (1963). Introduced barbed wire and chains into his work in the late sixties as further symbols of violence and danger. Has participated in activist events since the sixties and contributed to *Attica Book* (1972). His use of African motifs grew out of extensive travel in Africa during the seventies. Has received several commissions for outdoor sculpture.

Ref.: Paris, Maison de L'Unesco. *Melvin Edwards Sculptures 1964–1984*. 1984. Text by Mary Schmidt Campbell. See also bibl. nos. 4, 13, 14, 22, 67, 68, 78, 88, 110.

Marguerite Elliot

Resides in California. A sculptor, ceramicist, and installation artist whose work has addressed a variety of social and political themes, including those of nuclear power and ecology. Was a founding member of L.A. Artists for Survival and served on the coordinating committee for Target L.A.: The Art of Survival, a series of antinuclear art events (1982). Has also been an active participant in projects at the Woman's Building, Los Angeles.

Ref.: See bibl. no. 59.

John Fekner

Born in 1950. Resides in New York. A performance, video, and installation artist who often incorporates audio components in his pieces. Is known for his word installations targeting social and political issues, stenciled buildings throughout New York. Wrote music and lyrics for *Idioblast*, a twelve-inch LP (1984). Has been included in numerous alternative exhibitions, at ABC No Rio and Fashion Moda, among other places. Designed a program for the Times Square Spectacolor Board (1984). Has executed performances and installations in such places as The Kitchen (1981) and Franklin Furnace (1982), New York, and at the Social Public Art Resource Center, Venice, California (1983).

Ref.: See bibl. nos. 29, 30, 32, 70, 72, 73, 83, 89, 92, 113, 137.

Mary Frank

Born in 1933 in London. Resides in New York. A figurative sculptor who has worked extensively with monotypes since the seventies. Has been included in several important print exhibitions. Has illustrated three books, *Enchanted* by Elizabeth Coatsworth (1968), *Buddha* by Jean Cohen (1969), and *Son of a Mile Long Mother* by Alaonzo Gibbs (1970). Has taken part in numerous activist events and has been a member of the Artists Poster Committee, New York.

Ref.: Moorman, Margaret. "In a Timeless World." *Art News* (New York), vol. 86, no. 5 (May 1987). See also bibl. nos. 7, 52.

Antonio Frasconi

Born in 1919 in Buenos Aires. Moved to Uruguay in 1919 and to the United States in 1945. Resides in Connecticut.

One of the foremost woodcut artists of the postwar period; has also worked with lithography and photocopy. Has executed numerous posters, magazine illustrations, illustrated books, and even a United States postage stamp. Has been a committed social activist throughout his career, participating in a wide variety of projects and groups, including Week of the Angry Arts Against the War in Vietnam (1967), *Attica Book* (1972), and Artists for Nuclear Disarmament (1982). Since the thirties has made woodcuts intended to reveal injustice and oppression around the world. As a teenager worked as a political cartoonist and caricaturist for a newspaper in Uruguay, executing caricatures of such figures as Franco and Hitler. More recently has done portraits of Cesar Chavez, Einstein, and Malcolm X, among others. Has illustrated themes ranging from the Spanish Civil War and the American civil rights movement to the unemployed of the Great Depression and the slain students of Kent State University. Has taught woodcut, the art of the book, and art as social statement at State University of New York at Purchase since 1973.

Ref.: *Frasconi Against the Grain: The Woodcuts of Antonio Frasconi*. New York: Macmillan Publishing Co., Inc., 1974. Texts by Nat Hentoff and Charles Parkhurst. See also bibl. nos. 11, 21, 85, 86, 135.

Rupert Garcia

Born in 1941. Resides in California. A political printmaker and poster and pastel artist. Served in the Air Force from 1962 to 1966, part of that time in Vietnam. In 1968 began making silk-screened posters concerning Vietnam and other Third World countries as part of a poster group that arose out of the upheaval at San Francisco State College. Went on to address the uprising at Attica State Correctional Facility and the killings at Kent State University among numerous other subjects. Has also created bold, graphic portraits of political, social, and cultural

heroes. Helped organize Galeria de la Raza, an important San Francisco forum for Chicano art (1970). Was active at La Raza Graphic Center, a major graphics workshop of the Bay Area Chicano community (1971). Has also created posters for the Chicano/Latino cultural movement in San Francisco's Mission District. Has worked primarily in pastels since 1975. Has taught art, art history, and Chicano studies, notably at San Francisco State College/University (1969–81).

Ref.: San Francisco, The Mexican Museum. *The Art of Rupert Garcia: A Survey Exhibition*. 1986. Text by Ramón Favela. See also bibl. nos. 1, 19, 26, 101, 104, 105, 106, 112.

Sharon Gilbert

Born in 1944. Resides in New York. Originally worked with abstract sculpture; has done several artists' books since 1980. Did a window installation, *A Nuclear Alphabet*, at Printed Matter, New York (1980). Participated in numerous group exhibitions of artists' books, and in shows with social and political themes, particularly those of feminism and ecology. Organized *The Future Is Ours: Art for Action and Change* at the Arsenal Gallery, New York, in conjunction with the Women's Caucus for Art (1982). Served on the advisory board of the New York Women's Caucus for Art (1979–83) and contributed to *Connections Project/Conexus* (1987).

Ref.: See bibl. nos. 42, 134.

Mike Glier

Born in 1953. Resides in New York. A painter and installation artist committed to social change. His narrative wall drawings, such as *The Exploding Refrigerator* (1982), *South Africa Drawings* (1986), and *Second Sketch of Chernobyl* (1986), address issues ranging from apartheid and nuclear power to governmental oppression and contemporary consumerism. Power and its abuse are other frequent themes,

most dramatically explored in the installation *Training for Leisure: A Public Display of Collapsed Desire for the Next World's Fair* (1980). Has executed several posters and postcards on behalf of social and political causes. Has been an active member of Collaborative Projects, Inc., since the late seventies and participated in *The Real Estate Show* and *The Times Square Show* (1980). With Lucy Lippard, organized the artists' book exhibition *Vigilance: Strategies for Social Concern* (1980). Took part in Artists Call Against U.S. Intervention in Central America (1984).

Ref.: See bibl. nos. 29, 30, 37, 52, 67, 87, 92, 108, 110, 113.

Leon Golub

Born in 1922. Resides in New York. A painter, activist, and teacher deeply committed to a wide range of political issues. Has been a leading participant in numerous activist organizations and events since the sixties, among them Artists and Writers Protest Against the War in Vietnam (1965), *The Peace Tower*, Los Angeles (1966), Week of the Angry Arts Against the War in Vietnam (1967), and the anti–Mayor Daley exhibition at Feigen Gallery, Chicago (1968). Contributed to *Attica Book* in 1972 and has been involved with the Art Workers' Coalition (1970) and Artists Call Against U.S. Intervention in Central America (1984). His many painting series incorporating the human figure reflect a longstanding concern with the contrast of power and powerlessness. His early work focused on inner turmoil, but by 1970 he began to explore external events. Initiated the series *Athletes* in 1957, *Burnt Man* in 1960, *Combat* in 1962, *Gigantomachies* in 1965, *Napalm* in 1969, and *Mercenaries* in 1976. In the mid-seventies executed more than one hundred portraits of powerful male figures including Henry Kissinger, Nelson Rockefeller, Fidel Castro, Francisco Franco, and Chou En-lai. More recently initiated the series *Interrogators* and *White Squads* (1982). Has

taught throughout his career, notably at Rutgers University (1970 to present).

Ref.: Kuspit, Donald. *Leon Golub: Existential/Activist Painter*. New Brunswick, New Jersey: Rutgers University Press, 1985. See also bibl. nos. 21, 26, 29, 31, 38, 40, 51, 66, 75, 88, 91, 99, 104, 110, 126, 134, 135.

Peter Gourfain

Born in 1934. Resides in New York. A sculptor, painter, ceramicist, and committed social activist involved with issues ranging from the civil strife in Northern Ireland and nuclear disarmament to ecology. Has created political banners for events such as the June 12, 1982, demonstration in New York for nuclear disarmament and for Art Against Apartheid, Artists Call Against U.S. Intervention in Central America, and the Irish nationalist group H-Block Armagh. Has published banner "how-to" instructions in the activist magazine *Cultural Correspondence*. While a visiting artist at Kent State University completed a set of oak and ceramic doors as a memorial to the students killed there in 1970 (1979–80). Has executed numerous urns and plaques with political and social subjects. Since 1980 has taught as Recreation Director for the Division of Senior Citizens of the City of New York.

Ref.: Brooklyn, New York, The Brooklyn Museum. *Peter Gourfain: Roundabout and Other Works*. 1987. Text by Charlotta Kotik. See also bibl. nos. 29, 113, 120, 134, 135.

Ilona Granet

Resides in New York. A performance artist, painter, and printmaker involved with antinuclear and women's issues. Has studied, in addition to the visual arts, music, dance, and voice. Worked as a sign painter for more than ten years, which led to a return to painting and to the use of stencil and silk-screen. Has been included in several group exhibitions with political and

social themes, including many organized by Collaborative Projects, Inc.

Ref.: See bibl. nos. 9, 29, 30, 52, 87.

Group Material

Founded in 1979 by Douglas Ashford, Julie Ault, Mundy McLaughlin, and Tim Rollins, an innovative artists' group dedicated to cultural activism and to the exhibition of socially and politically motivated art. Has functioned primarily as a curatorial group that bypasses the commercial gallery system and arranges thematic exhibitions on specific issues. Its frequently controversial exhibitions have put on view cultural artifacts and work by established artists, as well as work that has not received extensive exposure. Originally operated out of a Lower East Side storefront; since 1981, in an effort to reach a broad audience, has exhibited in such places as New York buses, subways, churches, streets, and numerous alternative spaces. Has organized more than twenty-five exhibitions ranging in subject from United States policies in Central America to contemporary attitudes toward religion, consumerism, gender roles, and popular culture. Among its exhibitions are *The Salon of Election '80* (1980); *The Gender Show* (1981); *M-5*, on city buses (1981); *Subculture*, on city subways (1983); *Timeline: A Chronicle of U.S. Intervention in Central and Latin America* (1984); and *Resistance, Anti-Baudrillard* (1987).

Ref.: See bibl. nos. 30, 32, 37, 44, 55.

Dolores Guerrero-Cruz

Resides in California. Has worked in mural painting and silkscreen, both as artist and teacher. Is actively involved with Chicano community issues, particularly those affecting children. Coordinated a children's project at Self-Help Graphics and Art, Los Angeles (1975). Taught art in a local elementary school (1983–85). Printed T-shirts for the East Los Angeles Rape Hotline and Child Abuse Center (1985). Partici-

pated in a postcard program at the Woman's Building, Los Angeles (1986).

Guerrilla Art Action Group

A militant artists' group formed in 1969 by Jon Hendricks and Jean Toche, which arose out of the Action Committee of the Art Workers' Coalition. Engaged in some of the most dramatic art-oriented protest activities of the seventies, in the form of "actions," related to Happenings and theater but staged in nonart environments rather than in artificial settings. Among its primary means of expression and provocation were numerous protest manifestos and letter actions to government leaders in support of artists, activists, political prisoners, and other individuals and causes. Supported artists' rights and addressed such political issues as the Vietnam War, racism, and class struggle. Among its extreme actions was a "bloodbath" protest in the lobby of The Museum of Modern Art (1969); other early actions include a demonstration against the exhibition *New York Painting and Sculpture 1940–1970*, mounted at The Metropolitan Museum of Art, and another at the Whitney Museum of American Art, in protest against its refusal to close for Moratorium Day (1969). Was most active between 1969 and 1976, but actions continue to be undertaken on occasion. GAAG has essentially been the project of Hendricks and Toche, although Poppy Johnson, Joanne Stamerra, and Virginia Toche have also participated at various times.

Ref.: See bibl. nos. 5, 29, 73, 74, 111.

Marina Gutiérrez

Born in 1954. Resides in New York. A painter, printmaker, and book artist concerned with issues of race and culture. Has participated in Artists Call Against U.S. Intervention in Central America and Art Against Apartheid exhibitions and events since 1984. Contributed to the feminist magazine *Heresies* (1982, 1984) and to *Connec-*

tions Project/Conexus (1987). Won a poster competition sponsored by National Hispanic Heritage Week (1986). Has taught actively in the community, notably as Director of the Cooper Union Saturday Program, New York (1979–84); as Instructor, Community Outreach Program, Printmaking Workshop, New York (1980–84); and in several art and language courses for Native Americans.

Ref.: See bibl. nos. 44, 77, 134, 135.

Hans Haacke

Born in 1936 in Germany. Resides in New York. A leading conceptual artist who is committed to the integration of aesthetic and political expression. In provocative installations has focused on themes of power and institutional injustice in both corporate and governmental spheres. In the early seventies began repeated attacks on capitalism, as evidenced in such pieces as *Shapolsky et al. Manhattan Real Estate Holdings . . .* (1971). Has explored the links between art, economics, and politics in numerous pieces including, most recently, *Metro-Mobiltan* (1985). Other controversial installations have targeted sterilization abuse, ecology, and the power of the media. Has taught at Cooper Union, New York, since 1967. Was an early member of the Art Workers' Coalition (1969–70) and participated actively in Artists Meeting for Cultural Change in the mid-seventies.

Ref.: New York, The New Museum of Contemporary Art. *Hans Haacke: Unfinished Business*, Brian Wallis, ed. 1986. Texts by Rosalyn Deutsche, Hans Haacke, et al. See also bibl. nos. 5, 24, 26, 28, 29, 37, 51, 52, 53, 65, 72, 74, 98, 107, 134, 137.

David Hammons

Born in 1943. Resides in New York. A sculptor, printmaker, and installation and performance artist whose work has addressed issues of black culture, among other themes. Became politi-

cally active in the late sixties and executed a haunting series of body prints. In the mid-seventies developed an abstract style incorporating black cultural references, including found objects such as spades, hair, bottle caps, and shoes. Constructed *Delta Spirit* for Art on the Beach, New York, a shanty made of found objects that evoked black poverty in rural America (1985). Was commissioned to execute *Higher Goals*, in Brooklyn, which consists of telephone poles covered with bottle caps and topped with basketball hoops (1986). (Another version had been made in an empty lot in Harlem in 1982.) Designed a program for the Times Square Spectacolor Board (1982). Executed an outdoor sculpture in Atlanta on the subject of Nelson Mandela, commissioned by the Public Art Fund (1987).

Ref.: Jones, Kellie. "David Hammons." *Real Life Magazine* (New York), no. 16 (Fall 1986). See also bibl. nos. 1, 4, 13, 17, 22, 29, 47, 58, 68, 77, 88.

Keith Haring

Born in 1958. Resides in New York. A renowned graffiti artist who has drawn and painted his signature comic-book-style figures and motifs on canvas, paper, buildings, and subway walls and has had them printed on billboards, posters, and T-shirts. Has engaged his ubiquitous "crawling baby" and "barking dog" figures in scenes of war, sex worship, racism, capitalism, and nuclear conflagration. Designed a program for the Times Square Spectacolor Board (1982). Has executed murals in cities throughout the world, notably on the Berlin Wall and on buildings in impoverished New York neighborhoods as part of an antidrug campaign (1986). Has participated in many benefits, particularly those on behalf of needy children, including UNICEF's African Emergency Relief Fund (1985); Children's Village, Dobbs Ferry, New York (1984, 1985); and International Youth Year (1985). Created the logo for a New York City Sanitation Department campaign

against littering (1984). Produced and distributed 20,000 *Free South Africa* posters (1985).

Ref.: Amsterdam, Stedelijk Museum. *Keith Haring.* 1986. Text by Jeffrey Deitch. See also bibl. nos. 29, 30, 32, 52, 104.

Edgar Heap of Birds

Born in 1954, a member of the Cheyenne/Arapaho nation. Resides in Oklahoma. A painter and video and conceptual artist who has often used textual compositions to address discrimination against Native Americans. As a member of Makers, a Native American artists' group, has organized traveling exhibitions to educate the public about Indian issues; these shows include *No Beads No Trinkets* (1984), *Offerings: TsisTsistas Hinanaeina* (1986), and *Hand Into Wing, Wing Into Tongue* (1987). Has participated in artists' collaboratives such as Political Art Documentation/Distribution, Group Material, and ABC No Rio in recent years. Has also lectured extensively on Native American affairs, in the United States and in Europe.

Ref.: See bibl. nos. 18, 44, 48, 67, 76, 95, 100, 135.

Heresies Collective

Founded in 1975, a feminist art group and publishing collective comprised of women from diverse backgrounds and various art-related fields, from painting and sculpture to anthropology. The first issue of *Heresies: A Feminist Publication on Art and Politics*, published by a collective of over twenty women, appeared in January 1977. Each issue, with its own editorial board, is designed around a particular theme and incorporates articles and art of political and cultural relevance. More than one hundred women have served on the various editorial boards. The collective has also sponsored performances, benefit exhibitions, and festivals concerning feminist issues.

The twenty-one issues published thus far have addressed women vis à vis such topics as racism, violence, the Third World, ecology, food, and performance art.

Ref.: New York, The New Museum of Contemporary Art. *Events: En Foco, Heresies Collective.* 1983. See also bibl. nos. 10, 29, 74, 121.

Jenny Holzer

Born in 1950. Resides in New York. A conceptual artist who, since 1977, has created insightful, often acerbic textual pieces in a variety of mediums. After the initiation of the *Truisms* series in 1977 contrasted extreme left- and right-wing political positions in *Inflammatory Essays* (1979–82) and executed the *Living Series*, short texts on more personal issues (1980–82). In her *Survival Series*, used ironic phrases to expose the superficiality of a range of social conventions (1984–85). Her most recent series, *Under a Rock*, consists of short descriptive texts on violence (1985 to present). With Collaborative Projects, Inc., co-organized *The Manifesto Show*, a comprehensive exhibition of artists' political statements (1979). Designed a Times Square Spectacolor Board program (1982) and sponsored *Sign on a Truck*, a project in which artists programmed images concerning the Presidential election on an electronic sign board on a truck (1984).

Ref.: Des Moines, Des Moines Art Center. *Jenny Holzer: Signs.* 1986. Text by Joan Simon; interview by Bruce Ferguson. See also bibl. nos. 29, 30, 32, 37, 40, 42, 52, 53, 56, 61, 72, 74, 76, 87, 91, 92, 103, 104, 113, 137.

Rebecca Howland

Resides in New York. Since the mid-seventies has worked primarily as a sculptor. Has focused on the manipulation of the individual by corporate and financial powers in society, often addressing environmental issues. Her most well known pieces on this theme

include *Brainwash*, an outdoor fountain (1982), and *Transmission Towers* (1986). Began making multiples, frequently sardonic critiques of social and political ills, in 1981, and has made several silkscreened and photocopied posters. Was among the prime organizers of numerous alternative art activities, including *The Times Square Show* and *The Real Estate Show* (1980). Was President of Collaborative Projects, Inc. (1979–84), and cofounded ABC No Rio, New York (1980). Organized *Sculpture on the Williamsburg Bridge*, New York (1983).

Ref.: See bibl. nos. 30, 32, 70, 72, 137.

Arlan Huang

Born in 1948. Resides in New York. A painter and printmaker who has had extensive experience as a muralist. Began working on his *History of the Chinese Immigration* murals, Chatham Square, New York, with Cityarts Workshop in 1972. Other mural work includes, as project director, *Let Our People Grow*, Forsythe Street, New York (1976), and an interior mural for the Northside School for Mentally Disabled Children, New York (1978); as codirector, *Harlem Mural Project*, New York (1977). Hosted a delegation of peasant painters from China on the occasion of their New York visit and exhibition (1979). Made numerous community posters at the Basement Workshop, an arts center in New York's Chinatown.

Ref.: See bibl. nos. 23, 75, 134.

Robert Indiana

Born in 1928. Resides in Maine. An acclaimed Pop art painter and sculptor whose stylized renderings of words, particularly his *Love*, have become icons of the late sixties and early seventies. Has executed several variations of the peace symbol accompanied by stenciled captions alluding to war, civil rights, and Native American issues, and has depicted such consummately American symbols as the Brooklyn Bridge and the Statue of

Liberty. Has been actively involved in printmaking, predominantly in silkscreen. Has received many commissions for political and cultural projects, including a benefit for Jimmy Carter's Presidential campaign (1976) and a United States postage stamp (1973). Has created works for various political causes throughout his career, including a prize-winning mural on the Korean War (later destroyed). Other activist activities include contributions to the Congress of Racial Equality and support of artists' rights.

Ref.: Washington, D.C., National Museum of Art. *Wood Works: Constructions by Robert Indiana.* 1984. Text by Virginia M. Mecklenburg. See also bibl. nos. 31, 41, 46, 78, 112.

Carlos Irizarry

Born in 1938. Lived in New York in the sixties; currently resides in Puerto Rico. Has executed paintings, collages, and prints that speak to issues of war, poverty, and class struggle both in the United States and Puerto Rico; focused on the Vietnam War in the late sixties. Has also explored the subject of Third World hunger and strife, in such works as *Biafra* and *Reflections of Pakistan* (1970). Recent work has addressed the issue of Puerto Rican independence. Has taught extensively since the early seventies.

Ref.: See bibl. no. 86.

Alfredo Jaar

Born in 1956 in Chile; moved to New York in 1982. A politically motivated conceptual artist who has been working in installation, photography, film, and architecture. Focuses in his work on issues of the Third World and the role of the media in the dissemination of information. In such pieces as *America America* (1982) has highlighted the contrasts between North and South America. In *Businessweek Cover, December 24, 1984* (1984), reproduced an actual magazine cover on which an executive of Union Carbide is juxtaposed with a victim of the

Bhopal catastrophe under the headline "Union Carbide Fights for Its Life." A recent four-part installation series incorporated dramatic photographs of impoverished gold miners in Brazil and sumptuous gilded objects (1987). Designed *A Logo for America* (1987), a Times Square Spectacolor Board program that graphically emphasized that the United States is only a part of America.

Ref.: Venice, XLII International Exhibition: The Venice Biennale. *Alfredo Jaar: Gold in the Morning*. 1986. Texts by Dore Ashton and Patricia C. Phillips. See also bibl. nos. 48, 53, 66, 79, 109, 113, 134.

Luis Jimenez

Born in 1940. Resides in New Mexico. A figurative sculptor and draftsman whose work depicts the rural life of Mexican-Americans. A longtime resident of the Southwest, has created vibrantly colored fiberglass images of the Mexican cowboy, the working-class Chicano, and such icons of the West as the automobile and the rodeo. Has worked extensively in printmaking, primarily in lithography. During a five-year stay in New York in the mid-sixties, organized youth activities in Hispanic neighborhoods. Participated in the controversial *Peoples Flag Show* (1970), at Judson Memorial Church, New York. Has received numerous sculpture commissions, from such places as the Veterans Administration Hospital, Oklahoma City (1982), and MacArthur Park, Los Angeles (1986).

Ref.: Austin, Texas, Laguna Gloria Art Museum. *Luis Jimenez*. 1983. Texts by Annette Carlozzi and Dave Hickey. See also bibl. nos. 2, 19, 31, 39, 54.

Jasper Johns

Born in 1930. Resides in New York and St. Martin. An internationally acclaimed painter, sculptor, and master printmaker whose work has profoundly influenced the art of the last

quarter century. Came to prominence following a landmark exhibition at the Leo Castelli Gallery in 1958 of his painterly representations of universally recognizable flat entities—the American flag, the target, and the numeral. Engendered the later developments of Pop art in his now iconic images of flashlights, light bulbs, and ale cans. Has donated work to numerous benefits and nonprofit organizations. In 1963 cofounded, with John Cage, the Foundation for Contemporary Performing Arts, an artists' support organization.

Ref.: New York, The Museum of Modern Art. *Jasper Johns: A Print Retrospective*. 1986. Text by Riva Castleman. See also bibl. nos. 4, 5, 7, 10, 30, 31, 41, 112.

Jerry Kearns

Born in 1943. Resides in New York. An activist and painter concerned with the theme of popular myth versus political reality in America. Stopped exhibiting and concentrated primarily on political activities from 1974 until the early eighties. During this period participated with several groups focusing on art and social change, including Artists Meeting for Cultural Change, the Red Herring collective, the Anti-Imperialist Cultural Union, the Black United Front, Committee Against Fort Apache in the South Bronx, and, most recently, Political Art Documentation/Distribution and Artists Call Against U.S. Intervention in Central America. Organized exhibitions at Bread and Roses Gallery 1199 in New York on social and political themes. Has photographed numerous protest demonstrations and activist events, leading to the incorporation of photographic imagery in his later paintings. Has collaborated with the critic Lucy Lippard on numerous activist-art projects. Has written on political topics and has taught art and art in social contexts at the University of Massachusetts at Amherst (1971 to present).

Ref.: New York, Kent Fine Art, Inc. *Jerry Kearns: Risky Business*. 1987. Text

by Lucy R. Lippard. See also bibl. nos. 29, 30, 43, 66, 67, 72, 79, 110, 113, 134, 137.

Edward Kienholz

Born in 1927. Resides in Hope, Idaho, and West Berlin. Has achieved international recognition for his figurative assemblages and for his tableaux: intricate, often grotesque environments that offer biting social commentary. Since the sixties his art has challenged certain American attitudes toward such subjects as religion, marriage, the elderly, war, minorities, and prostitution. In 1958 executed his first piece on a specific event, Little Rock's school integration crisis (*The Little Eagle Rock Incident*). Other well-known tableaux include *Roxy's* (1961); *The Beanery* (1965); *The State Hospital* (1966); *Five Card Stud*, a study on race-related violence (1972); and *The Art Show* (1977). Has executed numerous pieces with his wife, Nancy Reddin Kienholz, including the recent *Ozymandias Parade*, a study on political oppression (1985).

Ref.: San Francisco, San Francisco Museum of Modern Art. *Edward and Nancy Reddin Kienholz: Human-Scale Works*. 1984. Texts by Ron Glowen, Lawrence Wechsler, et al. See also bibl. nos. 3, 21, 31, 33, 41, 46, 47, 78, 104, 106, 107, 108.

Janet Koenig

Resides in New York. Has contributed to numerous exhibitions with social and political themes, supporting the projects of Group Material, Artists Call Against U.S. Intervention in Central America, and Art Against Apartheid. Has written articles for several periodicals, including *Upfront* and *Women Artists' News*. Has been a member of a variety of activist-art groups and committees, among them the catalogue committee of Artists Meeting for Cultural Change, which produced *An Anti-Catalog* (1977). Took part in the editorial collective for a *Heresies* issue

on women and violence (1978) and served on the Not for Sale Committee which organized Political Art Documentation/Distribution's *Not for Sale* antigentrification projects (1983, 198

Ref.: See bibl. nos. 30, 44, 113, 121, 134, 135.

Margia Kramer

Resides in New York. In documentary videotapes and installations has addressed feminist, civil rights, and civil liberties issues and has criticized F surveillance activities and United States covert operations in Latin America. Commonly incorporates government documents and newspaper images in her prints, photostats, po ers, and artists' books to articulate advocacy of government accountabi Is most well known for her numerous videotapes, installations, and artists' books on the actress Jean Seberg. H been a member of the editorial boa of the activist magazine *Upfront* and contributed a catalogue essay and poster design to Political Art Documentation/Distribution's *Concrete C sis* exhibition (1987). Has written several articles and taught and lectured widely on sociopolitical art, p ticularly in the medium of video.

Ref.: See bibl. nos. 29, 43, 56, 60, 66, 74.

Barbara Kruger

Born in 1945. Resides in New York. Came to prominence as a conceptu artist working with photographs in early eighties; has also worked as a writer, editor, and performance arti Has critiqued mass media—particularly advertising—and politics i her work, often from a feminist per spective. After working for several years in graphic design, developed photomontage format in which sho confounding phrases are integrated with blowups of photographs. Participated in Artists Meeting for Cultura Change activities in the mid-seventi Has organized several exhibitions o

activist art. Has executed numerous billboards in the United States and abroad, and has mounted her provocative posters on buildings throughout New York. Edited *TV Guides*, a collection of critical essays on American culture and the influence of television (1985). Coedited an issue of *Flue* magazine, a Franklin Furnace publication, on politics and language (1981).

Ref.: London, Institute of Contemporary Arts. *Barbara Kruger: We Won't Play Nature to Your Culture*. 1983. Texts by Craig Owens and Jane Weinstock. See also bibl. nos. 29, 32, 37, 52, 55, 65, 72, 76, 87, 92, 103, 104, 134, 137.

Suzanne Lacy

Born in 1945. Resides in Los Angeles. A pioneering performance artist and activist committed to feminist issues. Has also worked with film, video, and artists' books, focusing on such issues as violence against women and aging in a youth-oriented culture. Began large-scale participatory performances with *Three Weeks in May*, on the subject of a series of rapes in the Los Angeles area (1977). Has collaborated with other feminists, particularly Leslie Labowitz, on works such as *In Mourning and Rage*, a media campaign and performance in memory of victims of the Hillside Strangler and in protest against sensational media coverage (1977). Organized *The International Dinner Party*, an homage to Judy Chicago comprised of dinner parties around the world honoring important living women (1979). Has served on the boards of several women's organizations, including the Woman's Building, Los Angeles (1974–80), and the Women's Caucus for Art (1979–82). Has written extensively on feminism, art, and the media and has taught at numerous institutions, including the Feminist Studio Workshop at the Woman's Building (1974–79).

Ref.: See bibl. nos. 9, 10, 25, 28, 29, 35, 36, 57, 62, 74, 79, 97, 106.

Jean LaMarr

Born in 1945, a member of the Paiute/Pit River nation. Resides in California and New Mexico. A printmaker, muralist, and Native American activist who has sought in her art to differentiate between myth and the reality of contemporary Native American life. Has collected oral histories from Native American elders and has executed murals based on these accounts. Has also worked extensively with Native American youth, often collaborating with students on mural projects concerned with issues of cultural identity. Has been an active member of and has participated in several benefits for the American Indian Movement (AIM): designed a poster to raise funds for AIM members involved in the occupation of buildings at Wounded Knee, South Dakota (1973), and organized activities in support of the Native American occupation of Alcatraz Island (1969). Currently teaches printmaking at the Institute of American Indian Art in Santa Fe.

Ref.: See bibl. nos. 8, 50, 95.

Jacob Lawrence

Born in 1917. Resides in Seattle. A preeminent realist painter who focuses on the black experience in America. Has been known since the forties for his painting series depicting episodes in Afro-American history— *The Life of Frederick Douglass* (1938), *Migration of the Negro* (1940), *Harlem* (1942), and *Civil Rights* (1961)—and for similar silkscreened series. His early success led to numerous painting commissions, including one for a series of ten works on Southern life and culture, *In the Heat of the Black Belt* (1947), assigned by *Fortune* magazine. Was elected President of the Artists Equity Association of New York in 1957. Has illustrated such books as *One Way Ticket* by Langston Hughes (1948) and *Harriet and the Promised Land*, a children's book on the life of the renowned abolitionist and creator

of the Underground Railroad, Harriet Tubman (1969). Contributed to *Attica Book* (1972). Has been commissioned to create murals and posters for a range of political and social groups, among them works publicizing Labor Day events (1980) and activities associated with Artists Call Against U.S. Intervention in Central America (1984).

Ref.: Seattle, Seattle Art Museum. *Jacob Lawrence: American Paintings*. 1986. Text by Ellen Harkins Wheat. See also bibl. nos. 1, 3, 4, 10, 11, 12, 13, 26, 31, 33, 54, 78, 85, 86, 88, 99.

Michael Lebron

Born in 1954. Resides in New York. Works with photography and text in an advertising format, exploiting the format's familiarity to encourage critical thinking about such issues as government and corporate control, poverty, and oppression in the Third World. Has specifically chosen publicly owned sites for his poster campaigns—among them *Ground Zero*, in New York subways (1983), and *The Jellybean Republic* (1984) and *The War on Children* (1987), in Washington, D.C., subways—to exercise and emphasize his First Amendment rights. Organized the exhibition *Not Just Any Pretty Picture*, at Performance Space 122, New York (1985).

Ref.: See bibl. nos. 65, 66, 89, 100, 134.

Colin Lee

Born in 1953. Resides in New York. A painter and printmaker concerned with Asian-American issues. His subtle, often ambiguous imagery, combining abstraction and figuration, has evoked the cultural conflicts and the sense of "homelessness" that afflict Asian-American artists. In a 1979 project had abstract images printed in advertising space in the pages of a San Francisco Chinese newspaper to contrast traditional Asian characters with contemporary art forms. Has participated in several projects at the Basement Work-

shop, the community arts center in New York's Chinatown, and at the Chinese Cultural Center, San Francisco, and his work has been shown in numerous exhibitions in New York's East Village.

Ref.: See bibl. no. 23.

Jack Levine

Born in 1915. Resides in New York. A leading American painter of humanist themes and biting expressionist commentaries on social and political events, renowned for his unflattering painterly portrayals of powerful men. Worked intermittently in the Easel Division of the Works Progress Administration in Boston (1935–40). Often renders his figures in haunting chiaroscuro to heighten the impact of his critique—an effect that has contributed to his acclaim as a master of this genre. Began extensive printmaking in the early sixties. Has executed numerous satirical etchings attacking corruption in politics, the military, and business. Landmark images have included *The General* (1962–63), *The End of the Weimar Republic* (1967), *On the Convention Floor* (1968), *Warsaw Ghetto* (1969), and *Election Night* (1969). Has also executed numerous works on biblical themes and Jewish history.

Ref.: Prescott, Kenneth W., and Emma Stina-Prescott. *The Complete Graphic Work of Jack Levine*. New York: Dover Publications, Inc., 1984. See also bibl. nos. 1, 7, 11, 12, 29, 31, 33, 40, 47, 86.

Les Levine

Born in 1935 in Dublin. Resides in New York. Known since the sixties as a conceptual artist; a pioneer in video, media-installation, and performance works; and an accomplished painter, photographer, and printmaker. Has employed flattened forms and striking color in his ironic investigations of the use and misuse of advertising in American culture. Forces the viewer to question social norms through unset-

tling juxtapositions of text and image. Has explored issues ranging from the civil strife in Northern Ireland, in *The Troubles: An Artist's Document of Ulster, 1973*, to the plight of the Canadian Eskimo, in *Northern Landscapes* and *We Are Still Alive* (1974). Has executed billboards in numerous cities around the world to address the illusory nature of the American Dream, racial problems, environmental contamination, and other social concerns. Designed a program for the Times Square Spectacolor Board (1985). Has taught, lectured, and written extensively in the United States and abroad.

Ref.: London, Institute of Contemporary Arts. *Les Levine: Blame God, Billboard Projects*. 1986. Texts by Thomas McEvilley and the artist. See also bibl. nos. 24, 29, 30, 32, 37, 38, 39, 53, 72, 74, 98, 137.

Robert Longo

Born in 1953. Resides in New York. Known primarily for his monumental wall reliefs that juxtapose architectural structures with photorealistic figurative elements. Has also worked extensively in other mediums, including performance, video, installation, film, photography, printmaking, and sculpture. Has focused on themes of power and alienation in contemporary urban life, notably in *Men in the Cities*, a series of large-scale figurative drawings that was initiated in the late seventies. Executed his first print, *Empire*, an image of Berlin's Brandenburg Gate, in 1981. Has worked recently in lithography, in 1983–84 creating theatrical studies of tension-filled figures in motion.

Ref.: Ratcliff, Carter. *Robert Longo*. New York and Munich: Rizzoli and Schirmer/Mosel, 1985. See also bibl. nos. 52, 55, 104, 135.

Paul Marcus

Born in 1953. Resides in New York. Works primarily with relief paintings and woodcut prints. Produced a major

suite of twenty-one prints, titled *A Life Based on Experiences of a Runaway Child*, inspired by his work with runaways at Covenant House, New York (1986). Helped organize the exhibition *All the News That's Fit for Prints: A Parallel of Social Concerns of the 1930s & 1980s*, P.P.O.W., New York (1987).

Ref.: Feitlowitz, Marguerite. "Paul Marcus: Prints for the People." *The Print Collector's Newsletter* (New York), vol. 16, no. 4 (September/October 1985). See also bibl. nos. 49, 99.

Marisol

Born in 1930 in Paris of Venezuelan parents. Resides in New York. A Pop art sculptor who has worked since the mid-fifties with figurative wood constructions. Has executed numerous portraits and self-portraits as well as group configurations that often reveal a caustic humor. Has played the role of observer and social commentator on American values in such works as *The Family* (1962), *Dinner Date* (1963), and *The Dealers* (1965–66). The *Heads of State* series (1967) includes leaders such as Franco, de Gaulle, Mao, Johnson, and members of the British royal family. Has addressed feminism, artists' rights, and religion in numerous pieces throughout her long career. Has been an active printmaker, primarily in lithography, and has executed magazine covers and other printed works such as music programs and performance announcements.

Ref.: Worcester, Massachusetts, Worcester Art Museum. *Marisol*. 1971. Text by Leon Shulman. See also bibl. nos. 5, 7, 10, 31, 40, 41, 78, 99, 112.

Dona Ann McAdams

Born in 1954. Resides in New York. A photographer who has also worked extensively with photocopy and artists' books. Has used photography to comment on such sociopolitical issues as gentrification, the industrial complex, and nuclear power. Has published

work in numerous newspapers and periodicals. Was a member of the Not for Sale Committee, a group within Political Art Documentation/Distribution, New York, which organized the *Not for Sale* projects protesting displacement of established residents of New York's Lower East Side (1983, 1984). Conducts photography workshops for mental patients under the auspices of Hospital Audiences, New York. Has lectured widely in New York and California. Currently works as the staff photographer for Performance Space 122, New York.

Ref.: See bibl. nos. 30, 38, 44, 52, 72, 121, 134, 135, 137.

Yong Soon Min

Born in 1953 in South Korea. Moved to California in 1960; became a United States citizen in 1971. Resides in New York. A printmaker and installation artist whose subjects include the Third World and racial and cultural identity. Is widely experienced as a master printer in lithography and intaglio. Has actively taken part in Korean-American community affairs. Served as Administrative Coordinator, Alliance for Asian American Arts and Culture, New York, and organized the visual component of *Roots to Reality*, a multidisciplinary arts event at Henry Street Settlement, New York (1985). Has been a consultant to the Asian Arts Institute, New York (1986), a board member of the Young Korean-American Service and Education Center, New York (1987), and a member of the coordinating committee of the Coalition Against Anti-Asian Violence (1986–87).

Richard Mock

Born in 1944. Resides in New York. An expressionist painter and printmaker who became increasingly involved with activist art in the seventies, when he worked in environmental art in California. Notable sociopolitical works of the period include *Silo Missile Melodrama*, a conceptual piece

inspired by an abandoned missile sil[o] in New Mexico (1974). Collaborated with Cesar Chavez of the United Far[m] Workers on an environmental piece [i]support of the attempts to unionize California's migrant workers (1976). From 1980 to 1986 contributed sixty linoleum-cut illustrations on such su[b]jects as racism, American interventio[n] in Central America, and the welfare system to the op-ed page of *The Ne[w] York Times*.

Ref.: See bibl. nos. 30, 44, 73.

Sabra Moore

Resides in New York. Has worked extensively in book arts, photocopy, and installations. Her strong commit[ment] to feminism has led her to organize several exhibitions of work by women artists, often accompanie[d] by collaborative artists' books. Recen[t] photocopied artists' books include *Protective Devices* (1983), *Making* (1984), and *Wash and Iron* (1987). Coordinated *Reconstruction Project*, women's exhibition for Artists Call Against U.S. Intervention in Central America (1984). Co-organized *Conne[c]tions Project/Conexus*, a feminist col[-]laboration of 150 women artists from North and South America (1987). Sin[ce] 1982 has been a member of the Heresies Collective. Served as President of the Women's Caucus for Art, New York (1980–82). Has participate[d] in numerous panels focusing on women and art.

Ref.: See bibl. nos. 34, 82, 113, 134.

Robert Morris

Born in 1931. Resides in New York. A[n] acclaimed sculptor, writer, teacher, a[nd] conceptual artist whose approach to the process of art making has altere[d] art of the past two decades. Became known in the sixties as a minimalist sculptor and environmental artist. In 1970 was instrumental in the withdrawal of nearly half of the participa[t]ing artists from the American pavili[on] of the Venice Biennale in protest against United States policies in Sou[th]

east Asia; closed his exhibition at the Whitney Museum of American Art in protest as well. Served as Chairman of Art Strike Against Racism, War and Repression, a group that organized the closing of museums and galleries in New York for a day of protest (1970), and contributed to *Attica Book* (1972). Since 1981 has frequently addressed the threat of nuclear destruction in his work. Has taught at Hunter College, New York, since 1967.

Ref.: Chicago, Museum of Contemporary Art. *Robert Morris: Works of the Eighties*. 1986. Texts by Edward Fry and Donald Kuspit. See also bibl. nos. 5, 7, 29, 30, 38, 52, 81, 108, 137.

Bruce Nauman

Born in 1941. Resides in New Mexico. An internationally renowned conceptual artist who came to recognition in the late sixties for his sculpture and installations. From his early body pieces to his later large-scale fiberglass abstractions and neon word sculptures, has created personal, multifaceted works exploring environmental as well as psychological interiors. The political implications of his work intensified in the mid-seventies with such pieces as *Double Steel Cage Piece* (1974), a prisonlike construction. His early, aggressive word sculptures such as *Eat/Death* (1972) crystallized into the more explicit *American Violence* (1981–82) and *White Anger, Red Danger, Yellow Peril, Black Death* (1985), with its obvious connotations of violence and racism. Titles of recent hanging steel sculptures, such as *South America Triangle*, *Diamond Africa*, and *Tuned Chair D,E,A,D,* (1981), allude to scenes of repression, exploitation, and torture. Has preserved many of his numerous performance pieces on film and videotape, and recently returned to video as a primary medium with *Violent Accident* (1986).

Ref.: London, Whitechapel Art Gallery. *Bruce Nauman*. 1986. Texts by Jean Christophe Ammann and Joan Simon. See also bibl. no. 5.

Joseph Nechvatal

Born in 1953. Resides in New York. A painter, photographer, and performance, installation, and video artist whose primary subjects include nuclear holocaust and the information glut in the postmodern age. Has executed several murals, stage sets, and artists' books containing apocalyptic imagery, such as *End of the World* (1980), a mural for Real Art Ways, Hartford. Has posted photocopy works on the arms race and nuclear proliferation, most notably *20-Megaton Blast* (1980), on the streets of New York. Mailed more than five hundred copies of *Nuclear Drawing* to various individuals and groups in 1979. Cofounded, served on the board of directors of, and organized several exhibitions at ABC No Rio, New York. Collaborated with the avant-garde musician Rhys Chatham on the opera *XS* (1984). Has been an active member of Collaborative Projects, Inc., and a participant in Group Material projects. Serves currently as publisher of *Tellus*, an audio cassette magazine.

Ref.: See bibl. nos. 30, 45, 52, 55, 135.

Claes Oldenburg

Born in 1929 in Stockholm. Resides in New York. An internationally acclaimed Pop art sculptor who came to recognition in the early sixties for his oversize, "soft" renderings of food and ordinary household objects. Opened a "store" of his plaster objects on the Lower East Side for Christmas (1961), which was a precursor of more recent artistic developments. Has participated in numerous activist events and benefits for political and art world causes, including Week of the Angry Arts Against the War in Vietnam, New York (1967). Among other political actions, canceled a planned exhibition at Feigen Gallery, Chicago, in response to police activity at the 1968 Democratic National Convention in the city. Contributed to the anti–Mayor Daley show with which it was replaced (1968). Has made benefit prints for such organizations as the Attica Legal Defense Fund (1975) and Artists Call Against U.S. Intervention in Central America (1984); has also been involved with Artists for Nuclear Disarmament (1982). Is active in the Artists' Poster Committee, which conceived the anti-Reagan poster *We Begin Bombing in Five Minutes* (1984). Designed the poster for Artists Call Against U.S. Intervention in Central America (1984).

Ref.: Celant, Germano. *Il corso del coltello: Claes Oldenburg, Coosje van Bruggen, Frank O. Gehry*. New York: Rizzoli, 1986. See also bibl. nos. 5, 7, 10, 29, 30, 33, 41, 52, 78, 89, 112.

Ed Paschke

Born in 1939. Resides in Chicago. A painter of unidentifiable, lurid portraits and encounters evocative of distorted television images. Came to recognition in the seventies with sinister, neon-colored renderings of glamorous personalities and counterculture figures. More recently has applied his signature fluorescent bands to images of archetypal businessmen, commenting on the neutralizing effects of electronic media and on alienation in contemporary society. Has executed several images that make specific reference to political figures and groups, among them *Lee Harvey Oswald* (1967), *RFK at Arlington* (1970), and *Gestapo* (1970). Has participated in group exhibitions on nuclear disarmament and in Artists Call Against U.S. Intervention in Central America, Chicago.

Ref.: Chicago, The Renaissance Society, University of Chicago. *Ed Paschke: Selected Works 1967–1981*. 1982. Texts by Dennis Adrian, Linda Cathcart, et al. See also bibl. nos. 31, 38, 39, 41, 46, 47, 52.

Adrian Piper

Born in 1948. Resides in Washington, D.C. A conceptual artist who works in a variety of mediums including collage, drawing, installation, video, and performance art, often with audio components. Has addressed numerous political issues in her work since the early seventies, particularly racism and inequities in American society. Has taken part in many activist groups and events, including the Student Non-Violent Coordinating Committee (1962); the March on Washington (1963); Art Workers' Coalition (1970); and Women of African Descent in the Visual Arts (1987). Has executed several posters, including *Think About It* (1987), commemorating the 1983 March on Washington. Has also contributed to exhibitions organized by Group Material and to exhibitions on nuclear disarmament and racial issues. Has executed numerous performance pieces since the late sixties, including the recent *Funk Lessons* (1983–84). Has taught extensively, currently in the philosophy department at Georgetown University, Washington, D.C.

Ref.: New York, Alternative Museum. *Adrian Piper: Reflections 1967–1987*. 1987. Texts by Jane Farver and Clive Phillpot. See also bibl. nos. 5, 7, 9, 29, 51, 52, 56, 74, 80, 83, 88.

Susan Pyzow

Born in 1955. Resides in New York. Works primarily in painting and drawing; recently began making prints. Began showing in group exhibitions in 1980, largely in the East Village. Was chosen as artist in residence at the Tompkins Square Library in the East Village, as part of a program in which artists received studio space in the library in exchange for community service (1981).

Ref.: See bibl. no. 99.

Robert Rauschenberg

Born in 1925. Resides in New York and Florida. An internationally acclaimed painter, printmaker, and photographer whose combine paintings fusing painting and object are considered landmarks in contemporary art. Has

designed sets and costumes for the Merce Cunningham Dance Company since the mid-fifties and for Trisha Brown Dance Company since the late seventies; has also done choreography and performance work. Has been a prolific printmaker, executing numerous works to benefit political and social organizations, among them the Congress of Racial Equality, labor groups, NASA, and World Artists Against Apartheid, as well as several political campaigns. Designed the Hubert Humphrey Human Rights Award in 1981. Was invited by NASA to witness launches of an Apollo spacecraft (1969) and of the *Discovery* space shuttle (1984). Has donated considerable time and resources in support of young artists, medical assistance funds, and artists' rights. Established the Rauschenberg Overseas Culture Interchange (1984), a traveling exhibition program created to promote world peace and the understanding of art. The program was launched in Mexico City in 1985 and has continued in South America and Asia.

Ref.: Houston, Houston Contemporary Arts Museum. *Robert Rauschenberg: Work from Four Series*. 1985. Texts by Linda L. Cathcart, Monti Mayo, et al. See also bibl. nos. 5, 7, 10, 26, 29, 30, 31, 41, 46, 47, 52, 86, 106, 112.

Faith Ringgold

Born in 1934. Resides in New York and California. A painter, sculptor, performance artist, and fabric designer who has championed feminism and black arts activism. Has addressed political and social concerns in her work since the early sixties, beginning with *The American People* series, depicting racial confrontations, initiated in 1963. Painted her first murals on political themes in 1967 and began a series of political posters in 1969. Executed her *Slave Rape* series in 1972–73. Has been a committed activist throughout her career, joining the Art Workers' Coalition in 1969. Cofounded Ad Hoc Women Artists' Committee (1970) and Where We At, a black women artists'

group (1971). Painted a mural on an all-female theme for the Women's House of Detention, Riker's Island, New York, and contributed to *Attica Book* (1972). Was a member of Artists for Nuclear Disarmament (1982). Initiated Upstream Women in the Visual Arts, a slide registry for women artists (1983), and participated in *Connections Project/Conexus* (1987). Has taught extensively, in the New York public schools (1955–73) and currently at the University of California, San Diego.

Ref.: New York, The Studio Museum in Harlem. *Faith Ringgold: Twenty Years of Painting, Sculpture, and Performance (1963–83)*, Michele Wallace, ed. 1984. Texts by Freida High Wasikhongo, Lucy R. Lippard, et al. See also bibl. nos. 4, 5, 6, 7, 10, 13, 15, 29, 31, 41, 67, 77, 88, 90, 97, 111, 112, 114, 126.

Larry Rivers

Born in 1923. Resides in New York. A leading figure in American art since the fifties, active as a painter, printmaker, poet, video artist, and jazz musician. Has often incorporated political themes in his work, particularly those relating to United States history and to the minority experience in America. Important history paintings include *Washington Crossing the Delaware* (1953), *The History of the Russian Revolution: From Marx to Mayakovsky* (1965), and *History of Matzoh (The Story of the Jews)* (1982–83). Highlighted issues of Afro-American history in *Some American History*, a landmark installation commissioned by the Menil Foundation for Rice University, Houston (1970). Designed sets for two plays by LeRoi Jones (Amiri Baraka), *The Slave* and *The Toilet* (1964). Has executed numerous magazine covers, op-ed page illustrations, and posters on social and political issues such as Presidential campaigns, student uprisings, drug addiction, aging, the Holocaust, and AIDS. Was an active member of Artists for Nuclear Disarmament (1982). Currently teaches poetry in a New York nursing home.

Ref.: Harrison, Helen A. *Larry Rivers*. New York: Harper & Row, Publishers, 1984. See also bibl. nos. 7, 31, 41, 85, 99.

Elizabeth Rodriguez

Resides in New Jersey. A video, installation, and performance artist concerned with male and female roles in contemporary American society. Currently employs imagery appropriated from the media, achieving collagelike figurative effects. Has executed silkscreened books and has designed posters for local festivals in East Los Angeles through Self-Help Graphics and Art.

Tim Rollins and K.O.S.

Rollins born in 1955. Resides in New York. Known for his pioneering work with disadvantaged teenagers and his unique integration of art and literature. Cofounded Group Material, a group advocating socially committed art, in 1979. Participated as artist/teacher in an innovative city school program, Learning to Read Through the Arts (1980–82). Has worked as an artist/teacher in the South Bronx for New York City's Division of Special Education since 1982. Founded K.O.S. (Kids of Survival) and the Art and Knowledge Workshop, Inc., a program for teenagers with learning disabilities, in 1982. Has collaborated with K.O.S. on paintings and collages incorporating such texts as Kafka's *Amerika*, Orwell's *1984*, and the Bible.

Ref.: See bibl. nos. 26, 29, 30, 37, 44, 53, 58, 66, 67, 72, 110, 113, 134, 137.

Rachel Romero, Leon Klayman, and the Wilfred Owen Brigade

Rachel Romero and Leon Klayman founded the Wilfred Owen Brigade political-poster group—named after the British poet killed in World War I, who was outspoken in his antiwar convictions—in San Francisco in 1975. Later changed the name to San Francisco Poster Brigade. Mounted

linoleum-cut posters designed by Romero on city streets. Often disseminated images further through large offset editions. Have executed 180 posters on issues ranging from human rights in Central America and the arms race to apartheid and urban poverty. Have portrayed numerous political and cultural leaders, including Martin Luther King Jr., Mao Tse-tung, Langston Hughes, Frida Kahlo, Bob Marley, and Muddy Waters. Organized several political-art exhibitions, including *Internationalist Art*, ABC No Rio, New York (1980), and, in San Francisco, Tucson, and New York, *Internationalist Art Show: Anti–World War III*, a traveling exhibition and festival comprised of political work from over forty-five countries (1980–81).

Ref.: See bibl. nos. 29, 102, 121, 134, 135.

James Rosenquist

Born in 1933. Resides in New York and Florida. Renowned as a Pop art painter and prolific printmaker. His most celebrated political painting, *F-111* (1965), comments on the Vietnam War and excessive defense spending. Executed *Smog on 14th Street* (1969), a print on ecological issues, as well as a poster of Mayor Daley for a protest exhibition held at Feigen Gallery, Chicago, after the Democratic National Convention in 1968. Has been involved in numerous political events throughout his career. Participated in *The Peace Tower*, Los Angeles (1966), and contributed to *Collage of Indignation* during Week of the Angry Arts Against the War in Vietnam (1967). Took part in Art Workers' Coalition antiwar events (1969–70). In 1972–73 engaged in a campaign for artists' rights with Robert Rauschenberg, which led to a Senate subcommittee hearing in 1975. Has contributed art regularly to support political campaigns.

Ref.: Denver, Denver Art Museum. *James Rosenquist*. 1985. Text by Judith Goldman. See also bibl. nos. 5, 29, 41, 86, 112.

Martha Rosler

Resides in New York. A photographer and video, performance, and book artist who is strongly committed to social change. Is also well known for critical writing that explores contemporary aesthetic approaches to political ideology. Has addressed issues of feminism and class struggle to underscore the contradiction between myth and reality in society. Executed photomontages in the late sixties that contrasted scenes from the Vietnam War with ones of middle-class suburban affluence. Has done performances and videos on women's relationship to food, including *A Budding Gourmet* (1974), *A Gourmet Experience* (1974), and *Losing: A Conversation with the Parents*, on anorexia and starvation (1977). Has also addressed the media and channels of information in several works, including the performance *Domination and the Everyday* (1978–79). Executed *Secrets from the Street: No Disclosure*, a work focusing on themes of gentrification and class structure, in San Francisco's Mission District (1980).

Ref.: See bibl. nos. 9, 29, 42, 51, 56, 57, 60, 62, 66, 74, 80, 134.

Erika Rothenberg

Resides in New York and Los Angeles. An artist who uses bold, graphic imagery in paintings, artists' books, and other mediums to comment on American attitudes concerning subjects ranging from abortion and pornography to racism and war. Has repeatedly utilized the format of the television commercial, perhaps a legacy of previous work as an art director at an advertising agency. Has participated in events and exhibitions sponsored by Artists Call Against U.S. Intervention in Central America and Group Material. Contributed to the feminist magazine *Heresies* (1983, 1986) and to *Connections Project/Conexus* (1987). Was artist in residence at WPLG/TV in Miami as part of an innovative program in which artists design projects to be executed within the context of a live media organization (1985).

Ref.: See bibl. nos. 24, 65, 66, 72, 94, 103, 108, 134, 137.

Christy Rupp

Born in 1949. Resides in New York. Known primarily for her sculptures and installations that address economic and ecological issues. Organized several alternative exhibitions for ABC No Rio, of which she was a founding member (1980). Actively participated in the exhibitions *The Times Square Show* (1980), *The Real Estate Show* (1980), *Sculpture on the Williamsburg Bridge* (1983), all in New York, and others mounted by the collectives Collaborative Projects, Inc., Fashion Moda, and Group Material. Participated in events related to Artists Call Against U.S. Intervention in Central America (1984) and in numerous exhibitions with political themes. Was commissioned by the *SoHo News* to create the full-page *Monumental Confrontations* (1981). Designed a program for the Times Square Spectacolor Board (1985).

Ref.: See bibl. nos. 29, 30, 32, 45, 70, 72, 113, 114, 137.

Jos Sances and Mission Gráfica

Born in 1952. Resides in San Francisco. Known as a painter and printmaker with a strong commitment to community causes. Has also worked extensively as a commercial silkscreen printer. Has participated in numerous political exhibitions on Third World issues, including shows associated with Artists Call Against U.S. Intervention in Central America, San Francisco (1984). Since 1981 has codirected, with René Castro, Mission Gráfica, the graphics workshop of the Mission Cultural Center, located in San Francisco's Mission District. Mission Gráfica designs and prints posters for the community at low cost, and conducts silkscreen and drawing classes. Sponsors an ongoing apprentice program and hosts guest artists, primarily from Latin America. The workshop has served many political groups, including antinuclear, antiapartheid, and environmental organizations.

Ref.: See bibl. nos. 66, 67, 102, 105.

Juan Sánchez

Born in 1954. Resides in New York. A painter, photographer, and writer whose work explores his Puerto Rican heritage and the issue of Puerto Rican independence. Has organized several exhibitions, including *Ritual and Rhythms: Visual Forces for Survival*, at Kenkeleba House Gallery, New York (1982), and *Beyond Aesthetics: Art of Necessity by Artists of Conscience* (1982) and *Evidence: Twelve Photographers* (1983), both at Henry Street Settlement, New York. Has written articles and catalogues and has lectured widely on activist art and Puerto Rican issues. Has participated in Art Against Apartheid (1984–85) and Artists Call Against U.S. Intervention in Central America (1984), and with artists' collaboratives such as Group Material and Political Art Documentation/Distribution.

Ref.: See bibl. nos. 26, 29, 52, 68, 69, 75, 77, 83, 90, 109, 113, 126, 134, 135.

Peter Saul

Born in 1934. Resides in Texas. A socially committed painter who has expressed political ideas in his work since the sixties. Has made biting, cynical caricatures of political leaders and heroes, as well as vivid, cartoonlike, and often grotesque images of racial, economic, and governmental injustice in America. The violent aspects of his work intensified in the late sixties in response to the Vietnam War and the growing domestic turmoil in America. Has executed several sardonic portraits of President Reagan, in addition to graphic depictions of contemporary urban violence.

Ref.: Dekalb, Swen Parson Gallery, University of Northern Illinois. *Peter Saul*. 1980. Text by the artist. See also bibl. nos. 31, 41, 46, 47, 52, 78, 91, 104, 106.

Miriam Schapiro

Born in 1923. Resides in New York. Known for her abstract painting, collage, and fabric work that combines complex patterning and decoration with a personal, feminist symbolism. Is acknowledged as an influential teacher and for her deep commitment to the feminist art movement. Has engaged in printmaking intermittently since her student years. Has highlighted female emblems, such as eggs (1961–63), kimonos (1976–79), fans (1978–79), and hearts (1979–80), in her work. Has served on the governing board of the Women's Caucus for Art and on the board of the College Art Association. Has taught extensively, notably as codirector (1971–72) and director (1973–74) of the Feminist Art Program, California Institute of the Arts. Cofounded *Heresies* magazine (1977) and the Feminist Art Institute in New York (1979). Participated actively in Artists Meeting for Cultural Change in the mid-seventies. Has written several articles on art and women's issues, and has lectured widely and participated in many panels and workshops on those subjects.

Ref.: Wooster, Ohio, The College of Wooster. *Miriam Schapiro, A Retrospective, 1953–1980*, Thalia Gouma-Peterson, ed. 1980. Texts by Norma Broude, Thalia Gouma-Peterson, et al. See also bibl. nos. 5, 7, 10, 35, 57.

Ben Shahn

Born in 1898 in Lithuania. Moved to the United States in 1906. Died in 1969. A prominent realist painter and printmaker renowned for his commitment to exposing social injustice and for his critiques of the political events of his time. Worked predominantly in lithography and silkscreen, commenting in his work on issues ranging from human rights and the threat of nuclear

war to racism and political conventions. Also worked extensively as a photographer and muralist. Executed numerous portraits, including landmark icons of Sacco and Vanzetti (1958), Frederick Douglass (1965), and Martin Luther King Jr. (1966). Designed posters for such organizations as United Textile Workers of America (1935); National Citizens Political Action Committee (1944); the Congress of Industrial Organizations, for which he was graphics director (1945–46); the Progressive Party (1948); Committee for a Sane Nuclear Policy (1960); and Eugene McCarthy's Presidential campaign (1968).

Ref.: Prescott, Kenneth W. *The Complete Graphic Works of Ben Shahn.* New York: Quadrangle/The New York Times Book Co., 1973. See also bibl. nos. 3, 4, 10, 11, 12, 21, 26, 31, 33, 40, 47, 78, 85, 86, 111, 112.

Sisters of Survival

An antinuclear performance art group founded in 1981 by Jerri Allyn, Nancy Angelo, Anne Gauldin, Cheri Gaulke, and Sue Maberry at the Woman's Building in Los Angeles. Has utilized images of nuns to symbolize sisterhood, and rainbow-colored habits to evoke hope, humor, and a celebration of diversity. Membership has varied according to each project. At the Women's Graphic Center, Los Angeles, has designed numerous postcards and other graphic handouts on issues of disarmament and world peace. Has been instrumental in organizing numerous peace activities and events, including *Artists React to Nuclear Issues,* an evening of performance for National Ground Zero Week (1981), and Target L.A.: The Art of Survival, an antinuclear festival of music and arts (1982). Toured Europe with *End of the Rainbow* performance in an extensive networking project with foreign artists and activists (1983).

Ref.: See bibl. nos. 25, 29, 59, 61, 63, 121.

Mimi Smith

Resides in New York. A painter, and performance, video, and book artist actively involved with social and political issues, including those of nuclear proliferation, toxic waste, and the influence of the media, especially television news. Posted the antinuclear photocopy poster *No Taxes for Bombs* on the streets of New York as part of the Political Art Documentation/Distribution (PAD/D) project *Death and Taxes* (1981). Executed the installation *Money, Money, Money* for *Art Lobby,* a controversial exhibition mounted in the lobbies of three Wall Street banks (1982). Contributed to Art Against Apartheid and Artists Call Against U.S. Intervention in Central America exhibitions (1984), in addition to numerous artists' book exhibitions. Also has been included in feminist shows and contributed to a 1985 issue of *Heresies* magazine. Has participated in activities of PAD/D, and is a member of their Archive Committee. Contributed to *Connections Project/Conexus* (1987).

Ref.: Waco, Texas, The Art Center. *Mimi Smith: Television Drawings.* 1980. Text by Paul Rogers Harris. See also bibl. nos. 44, 52, 66, 134, 135.

Vincent Smith

Born in 1929. Resides in New York. An expressionist painter and printmaker deeply rooted in the Afro-American experience. Has traveled extensively in Africa and the Caribbean. Has portrayed black cultural and political leaders and has incorporated in his art motifs from African landscapes and mythology, as well as scenes from urban life. Has also worked as a book illustrator. Has executed murals at Boys and Girls High School, Brooklyn (1976), and at Crotona Social Service Center, Bronx (1980). Has taught and lectured extensively, notably at the Whitney Museum of American Art's Art Resources Center, a Lower East Side center for neighborhood high school and college students (1967–1976). Was

invited to the second World Black and African Festival of Arts and Culture, Lagos, Nigeria (1977).

Ref.: See bibl. nos. 26, 85, 88, 90, 126.

Nancy Spero

Born in 1926. Resides in New York. Known for her scroll-like collages of haunting figures in motion. Originally painted on canvas; her collaged/printed images on paper first appeared in the *Codex Artaud* series (1970–71). Decided to focus exclusively on women protagonists in her work in the mid-seventies, beginning with *Torture in Chile* (1974), based upon Amnesty International accounts of victimized women. Exhibited a monumental, 215-foot scroll, *Notes in Time on Women,* a watershed piece chronicling women across cultures and history (1979). Has executed several series on social and political themes, including *War* (1966–70), *Torture of Women* (1974–76), and *Rebirth of Venus* and *Goddess* (1985). Has had a long involvement with activism, particularly in the anti–Vietnam War movement of the late sixties and early seventies. During this time participated in such artistic enterprises as *The Peace Tower,* Los Angeles (1966); Week of the Angry Arts Against the War in Vietnam, New York (1967); and the Art Workers' Coalition (1968–69). Has been active in a number of feminist concerns, among them Women Artists in Revolution (1969), Ad Hoc Women Artists' Committee (1970), and A.I.R. Gallery (as a founding member, 1972). Contributed to *Attica Book* (1972) and *Connections Project/Conexus* (1987); participated in Artists Call Against U.S. Intervention in Central America (1984).

Ref.: London, Institute of Contemporary Arts. *Nancy Spero.* 1987. Texts by Jon Bird and Lisa Tickner. See also bibl. nos. 5, 6, 7, 10, 26, 29, 34, 36, 38, 40, 48, 49, 51, 52, 53, 56, 64, 66, 67, 75, 79, 81, 87, 88, 91, 98, 108, 110, 114, 126, 134, 135.

Frank Stella

Born in 1936. Resides in New York. A seminal American abstract painter. Came to prominence in the late fifties with his *Black* paintings; first constructed his landmark monumental wall reliefs in the early seventies. Has contributed to various benefits for social and political causes: created a silkscreen edition on behalf of Referendum '70, a national organization that raised funds for congressional peace candidates (1970), and the lithograph *Yellow Journal* for the Howard Metzenbaum for Senate Committee (1982). Frequently incorporates political themes in his works' titles. His renowned *Black* series painting *Arbeit Macht Frei* (1958) borrows the infamous Nazi slogan that appeared over the gates of Auschwitz. His first wall reliefs, in the *Polish Village* series (1971–73), were named after Polish synagogues destroyed by the Nazis. An avid bird-watcher, named works in the *Exotic Bird* series (1976–80) after endangered or extinct species. In 1982 executed high reliefs titled after South African mines.

Ref.: Axsom, Richard H. *The Prints of Frank Stella: A Catalogue Raisonné 1967–1982.* New York: Hudson Hills Press, Inc., 1983. See also bibl. nos. 4, 5, 29, 31, 112.

May Stevens

Born in 1924. Resides in New York. A socially committed artist, writer, and teacher. Since the mid-sixties her paintings and collages have emphasized political themes, particularly those relevant to civil rights and feminism, in such series as *Freedom Ride, Big Daddy,* and *Rosa Luxemburg.* Has participated in many activist-art projects and events, including *The Peace Tower,* Los Angeles (1966); Week of the Angry Arts Against the War in Vietnam, New York (1967); and Artists Call Against U.S. Intervention in Central America (1984). Contributed to *Attica Book* (1972). Was a founding member of the Heresies Collective (1975). Par-

ticipated actively in Artists Meeting for Cultural Change in the mid-seventies. Has executed posters on feminist, labor, and antiwar themes. Has written poetry and several articles on politics and art, for the feminist magazine *Heresies* in particular. Participated in *Connections Project/Conexus* (1987). Teaches women's studies and art and politics at the School of Visual Arts, New York.

Ref.: Boston, Boston University Art Gallery. *May Stevens: Ordinary/Extraordinary, A Summation 1977–1984*. 1984. Texts by Donald Kuspit, Lucy R. Lippard, et al. See also bibl. nos. 5, 6, 7, 10, 26, 29, 31, 34, 36, 41, 51, 54, 56, 66, 75, 88, 90, 99, 114, 126, 134, 135.

Mark di Suvero

Born in 1933 in China. Moved to the United States in 1941. Resides in New York. Has created large-scale wood, steel, and found-object constructions since the sixties and is acknowledged as one of the leading sculptors of his generation. An outspoken opponent of the Vietnam War, lived in Europe from 1971 to 1975. Designed the structure for *The Peace Tower* in Los Angeles, a monumental antiwar artists' collaboration, and participated in the Week of the Angry Arts Against the War in Vietnam, New York (1967). Since the sixties has held art classes for disabled people at institutions around New York. Established the award-winning Socrates Sculpture Park, a nonprofit sculpture site with rotating exhibitions, in Long Island City, New York (1986). Has executed numerous commissioned outdoor sculptures for major institutions throughout the United States.

Ref.: New York, Whitney Museum of American Art. *Mark di Suvero*. 1975. Text by James K. Monte.

Dennis Thomas and Day Gleeson

Dennis Thomas born in 1955. Day Gleeson born in 1948. Reside in New York. Have collaborated since 1983. Have been working in photography and printmaking, creating art that addresses a wide range of social and political issues, particularly gentrification, consumerism, and feminism. Recently completed *Consumeris Expressionism*, a series of photocopy composites portraying advertising's manipulation of women (1985). Covered abandoned cars with Con-Tact paper, thereby focusing attention on neighborhood blight, as part of the exhibition *Art Is Not a Commodity* (1985). Have participated in exhibitions with Group Material, Political Art Documentation/Distribution, and Lower Manhattan Loft Tenants.

Francesc Torres

Born in 1948 in Barcelona. Moved to the United States in 1972. Resides in New York. An installation and video artist whose art confronts issues of war and violence through specific historical references as well as through potent symbolism. Considers himself a third-generation opponent of Spanish fascism. Often incorporates military imagery and political portraits in his multimedia environments, which include *Klausewitz's Classroom and/or Yalta Begins at School* (1984) and *The Dictatorship of Swiftness* (1986). Designed *When Boys Play Rough Toys Get Damaged* for the Times Square Spectacolor Board (1984). Has lectured widely and participated in numerous symposia in the United States and Europe.

Ref.: Stony Brook, The Fine Arts Center, State University of New York at Stony Brook. *Francesc Torres: Paths of Glory*. 1985. Text by Donald Kuspit. See also bibl. nos. 52, 66, 68, 74, 79, 98, 108.

Andy Warhol

Born in 1930; died in 1987. A renowned painter, filmmaker, photographer, editor, and prolific printmaker whose works are internationally acclaimed as icons of Pop art and American high style. With his silk-screens of political and cultural heroes such as John Kennedy, Mao, Lenin, and Jacqueline Kennedy, raised portraiture to the level of cultural symbolism. Employed his signature painterly/photographic style to comment on racial unrest (1964), nuclear disarmament (1965), and capital punishment (1971). Often contributed portraits to political campaigns, including those of Jimmy Carter, Edward Kennedy, and Carter Burden. His contributions to numerous causes included the donation of a portion of his *Endangered Species* series (1983) to wildlife organizations.

Ref.: Feldman, Frayda, and Jörg Schellmann, eds. *Andy Warhol Prints: A Catalogue Raisonné*. New York: Ronald Feldman Fine Arts, Inc., and Abbeville Press; Munich: Editions Schellmann, 1985. Texts by Roberta Bernstein and Henry Geldzahler. See also bibl. nos. 5, 7, 10, 29, 30, 31, 37, 41, 46, 47, 67, 90, 106, 111, 112.

John Pitman Weber

Born in 1942. Resides in Chicago. A muralist, printmaker, writer, and political activist committed to community-based public art. Founded and acted as Executive Director of the Chicago Mural Group, now known as Chicago Public Art Group (1970–81). Has painted a variety of murals around Chicago: *Unidos para triunfar (United to Triumph)* (1971), *Tug of War* (1974), and *Children Are Our Future* (1979), among others. With Cityarts Workshop, New York, executed a mural on the Lower East Side, *One Generation to Another* (1984). Has been an organizer of Artists Call Against U.S. Intervention in Central America events in Chicago (1984–87). In 1985 was invited to Nicaragua by the Cultural Workers Association to execute a mural with Nicaraguan artists in a Managua marketplace. Has given numerous lectures and organized workshops in the United States and abroad on murals and alternative public art issues.

Ref.: Cockcroft, Eva, John Weber, and James Cockcroft. *Toward a People's Art: The Contemporary Mural Movement*. New York: E. P. Dutton & Co., Inc., 1977. See also bibl. nos. 1, 3, 26, 121.

We're All in the Same Boat

An artists' collective comprised of thirteen artists, many of them Brooklyn neighbors: Noah Baen, Virginia Burroughs, Peter Gourfain, Betti Sue Hertz, Paula Hewitt, Bob Jacobs, Tom Keough, Manuel Macarrulla, Tom McDonald, Dona Nelson, Jared Pratt, Karen Schmeckpeper, and Seth Tobocman. Several members had worked together making banners for political rallies, and had participated in Art Against Apartheid and Artists Call Against U.S. Intervention in Central America activities (1984).

William Wiley

Born in 1937. Resides in California. A painter, sculptor, draftsman, and printmaker whose work incorporates a surrealistic and personal iconography within a narrative, linear web, often evidencing a lively sense of humor. Has frequently addressed political issues, for example in the sculpture *Blackball Violence*, a memorial to Martin Luther King Jr. (1968), and in a print on this subject. Has explored Native American issues, in *Now Here's That Blame Treaty* (1970) among other works. Has repeatedly confronted environmental issues in his art, particularly that of toxic waste. Executed numerous watercolors, paintings, and sculptures based on the nuclear accident at Three Mile Island in 1979 and a painting, *Nothing to Blame*, on the subject of illegal dumping of chemicals (1979). More recently completed a sculpture titled *Nomad Is an Island* based on the discovery of a major chemical dump site on the islands off the coast of San Francisco (1981).

Ref.: Minneapolis, Walker Art Center. *Wiley Territory*. 1979. Texts by Graham W. J. Beal and John Perreault. See also bibl. nos. 46, 52, 102.

John Woo

Born in 1951. Resides in New York. A painter, graphic artist, and designer of performance pieces that often explore Asian-American themes. Has played a major role in Asian-American community affairs in New York through the Basement Workshop, an Asian-American arts center, and was artist in residence and head of its graphics program from 1978 to 1981. Cofounded Basement Editions, a small press that published poetry broadsides to raise funds for other projects. Served as curator for the Catherine Gallery, the Basement Workshop's exhibition space. Also organized *Hong Kong—Tokyo—New York*, Kenkeleba House Gallery, New York (1984).

Ref.: See bibl. nos. 1, 23.

Qris Yamashita

Resides in California. A graphic designer who also works in video and the performing arts. Is actively concerned with Asian-American community issues. Among other projects, has worked for a community cultural center in Los Angeles and an Asian-American educational media group. Has been active in Asian-American rights associations. Has also participated in projects at the Woman's Building in Los Angeles.

Ref.: See bibl. no. 25.

Bibliography

The following bibliographic entries are cross-referenced by artist in the Notes on the Artists.

Background: Books

1 Barnett, Alan W. *Community Murals: The People's Art*. Philadelphia: The Art Alliance Press, 1984.

2 Beardsley, John, Jane Livingston, and Octavio Paz. *Hispanic Art in the United States*. New York: Abbeville Press, 1987.

3 Cockcroft, Eva, John Weber, and James Cockcroft. *Toward a People's Art: The Contemporary Mural Movement*. New York: E. P. Dutton & Co., Inc., 1977.

4 Fine, Elsa Honig. *The Afro-American Artist*. New York: Holt, Rinehart and Winston, 1983.

5 Lippard, Lucy R. *From the Center: Feminist Essays on Women's Art*. New York: E. P. Dutton & Co., Inc., 1976.

6 Miller, Lynn F., and Sally S. Swenson. *Lives and Works: Talks with Women Artists*. Metuchen, New Jersey, and London: The Scarecrow Press, Inc., 1981.

7 Munro, Eleanor. *Originals: American Women Artists*. New York: Simon and Schuster, 1979.

8 *Native Arts Network: A Special Report*. Phoenix, Arizona: Atlatl, 1986.

9 Roth, Moira, ed. *The Amazing Decade: Women in Performance Art in America 1970–1980*. Los Angeles: Astro Artz, 1983.

10 Rubinstein, Charlotte Streifer. *American Women Artists: From Early Indian Times to the Present*. Boston: G. K. Hall & Co., 1982.

11 Shikes, Ralph E. *The Indignant Eye: The Artist as Social Critic in Prints and Drawings from the Fifteenth Century to Picasso*. Boston: Beacon Press, 1969.

Background: Exhibition Catalogues

12 Boston, Boston University Art Gallery. *Social Concern and Urban Realism: American Painting of the 1930s*. 1983. A Bread and Roses Cultural Project of the National Union of Hospital and Health Care Employees. Texts by Patricia Hills and Raphael Soyer.

13 Lewisburg, Pennsylvania, The Center Gallery of Bucknell University. *Since the Harlem Renaissance: 50 Years of Afro-American Art*. 1985. Interviews with the artists.

14 Montclair, New Jersey, Montclair Art Museum. *The Afro-American Artist in the Age of Cultural Pluralism*. 1987. Texts by Wendy McNeil, Clement Alexander Price, and the artists.

15 New Brunswick, New Jersey, Douglass College Art Gallery, Rutgers University. *Fragments of Myself/The Women: An Exhibition of Black Women Artists*. 1980. Texts by Gail Aaron, Cettina Cardone, et al.

16 New York, Gallery of the American Indian Community House. *Women of Sweetgrass, Cedar and Sage: Contemporary Art by Native American Women*. 1985. Texts by Harmony Hammond, Lucy R. Lippard, et. al.

17 New York, The Studio Museum in Harlem. *Impressions/Expressions: Black American Graphics*. 1979. Text by Richard J. Powell.

18 Niagara Falls, New York, The Native American Center for the Living Arts. *American Indian Art in the 1980s*. 1981. Texts by Rick Hill, Lloyd Kiva New, et al.

19 Tucson, Arizona, Tucson Museum of Art. *Raices antiguas/Visiones nuevas (Ancient Roots/New Visions)*. 1977. Texts by Rebecca Kelly Crumlish, Thomas M. Messer, et al.

General: Books

20 Art Workers' Coalition. *Art Workers' Coalition: Documents I* (vol. 1) and *Art Workers' Coalition: Open Hearing* (vol. 2). New York: Art Workers' Coalition, 1969.

21 Bruckner, D. J. R., Seymour Chwast, and Steven Heller. *Art Against War*. New York: Abbeville Press, 1984.

22 Chaine, Erika T. "Black Protest Art." Typescript, 1970. The Museum of Modern Art Library, New York.

23 Chiang, Fay, ed. *Basement Yearbook 1971–1986*. New York: Basement Workshop, Inc., 1986.

24 D'Agostino, Peter, and Antonio Muntadas, eds. *The Unnecessary Image*. New York: Tanam Press, 1982.

25 *The First Decade: Celebrating the Tenth Anniversary of the Woman's Building*. Los Angeles: The Woman's Building, 1983. Texts by Michele Kort and Terri Wolverton.

26 Foner, Philip S., and Reinhard Schultz. *The Other America: Art and the Labor Movement in the United States*. West Nyack, New York: Journeyman Press, 1985.

27 Hobbs, Robert, and Fredrick Woodard, eds. *Human Rights/Human Wrongs: Art and Social Change*. Iowa City: University of Iowa, Museum of Art, 1986.

28 Kahn, Douglas, and Diane Neumaier, eds. *Cultures in Contention*. Seattle: Real Comet Press, 1985.

Lippard, Lucy R. *Get the Message?: A Decade of Art for Social Change.* New York: E. P. Dutton & Co., Inc., 1984.

Moore, Allan, and Marc Miller, eds. *ABC No Rio Dinero: The Story of a Lower East Side Art Gallery.* New York: ABC No Rio with Collaborative Projects, Inc., 1985.

Schwartz, Barry. *The New Humanism: Art in a Time of Change.* New York: Praeger Publishers, 1974.

Schwartzman, Alan. *Street Art.* Garden City, New York: The Dial Press, 1985.

Shapiro, David, ed. *Social Realism: Art as a Weapon.* New York: Frederick Ungar Publishing Co., 1973.

Skiles, Jacqueline, and Janet McDevitt, eds. *A Documentary Herstory of Women Artists in Revolution.* New York: Women Artists in Revolution, 1971.

Wilding, Faith. *By Our Own Hands: The Women Artists' Movement, Southern California, 1970–1976.* Santa Monica, California, Double X, 1977.

General: Exhibition Catalogues

Allentown, Pennsylvania, Center for the Arts, Muhlenberg College. *Women Look at Women: Feminist Art for the '80s.* 1981. Texts by Ruth Ammon, Anne E. Peterson, et al.

Atlanta, Georgia, Nexus Contemporary Art Center. *The Public Art Show.* 1985. Text by Ronald Jones.

Atlanta, Georgia, Nexus Gallery. *What Artists Have to Say about Nuclear War.* 1983. Texts by John Howett, Jeff Kipnis, et al.

Bayside, The Queensborough Community College Art Gallery, Queensborough Community College of the City University of New York. *The Parodic Power of Popular Imagery.* 1985. Text by Lenore Malen.

Bayside, The Queensborough Community College Art Gallery, Queensborough Community College of the City University of New York. *Politics in Art.* 1984. Text by Jo Ann Wein.

41 Berkeley, University Art Museum, University of California at Berkeley. *Made in USA: An Americanization in Modern Art, The 50's & 60's.* 1987. Text by Sidra Stitch.

42 Binghamton, University Art Gallery, State University of New York. *Nine Women Artists.* 1982. Text by Josephine Gear and interviews with the artists.

43 Boston, Boston University Art Gallery. *Social Concern in the '80s: A New England Perspective.* 1984. Texts by Patricia Hills and the artists.

44 Brooklyn, New York, Brooklyn Army Terminal. *Preparing for War*, a publication of *The Terminal Show.* 1983.

45 Buffalo, New York, Albright-Knox Art Gallery, Hallwalls, and Center for Exploratory and Perceptual Art (CEPA). *Motives.* 1984. Texts by Edit deAk and Duncan Smith.

46 Chicago, Museum of Contemporary Art. *Violence in Recent American Art.* 1968. Text by Robert Glauber.

47 Chicago, The David and Alfred Smart Gallery of the University of Chicago. *Artists View the Law in the 20th Century.* 1977. Text by Katherine Lee Keefe.

48 Cleveland, The Art Gallery, Cleveland State University. *American Policy.* 1987. Texts by Don Harvey and the artists.

49 Columbus, The Ohio State University Gallery of Fine Art. *Rape.* 1985. Texts by Stephanie Blackwood, Susan Caringella-McDonald, et al.

50 Davis, Richard Nelson Gallery, University of California at Davis. *Confluences of Tradition and Change: 24 American Indian Artists.* 1981.

51 Dayton, Ohio, University Gallery, Wright State University. *Art of Conscience: The Last Decade.* 1980. Text by Donald Kuspit.

52 *Disarming Images: Art for Nuclear Disarmament.* New York: Adama Books, A Bread and Roses Book, 1984. Text by Nina Felshin.

53 Greenvale, New York, Hillwood Art Gallery, Long Island University, C. W. Post Campus. *Perverted by Language.* 1987. Texts by Robert Nickas and the artists.

54 *Images of Labor.* New York: The Pilgrim Press, A Bread and Roses Book, 1981. Texts by Irving Howe, Joan Mondale, and the artists.

55 Lewisburg, Pennsylvania, The Center Gallery of Bucknell University. *Contemporary Perspectives 1984.* 1984. Texts by Barry Blinderman, Thomas Lawson, et al.

56 London, Institute of Contemporary Arts. *Issue: Social Strategies by Women Artists.* 1980. Text by Lucy R. Lippard.

57 Long Beach, California, Long Beach Museum of Art. *At Home.* 1983. Text by Arlene Raven.

58 Long Island City and New York, New York, The Institute for Art and Urban Resources, Inc., at P.S.1 and Public Art Fund, Inc. *Out of the Studio: Art with Community.* 1987. Texts by Tom Finkelpearl, Lucy R. Lippard, et al.

59 Los Angeles, L.A. Artists for Survival. *Fallout Fashion.* 1983.

60 Los Angeles, Los Angeles Contemporary Exhibitions (LACE). *Surveillance.* 1987. Texts by Deborah Irmas, Gary T. Marx, et al.

61 Los Angeles, Los Angeles Institute of Contemporary Art. *Secular Attitudes.* 1985. Text by Robert Smith.

62 Los Angeles, Los Angeles Institute of Contemporary Art. *Social Works.* 1979. Texts by Nancy Buchanan and the artists.

63 Los Angeles, The Woman's Building. *From History to Action: An Exhibition in Celebration of the Tenth Anniversary of the Woman's Building.* 1984. Texts by Lucy R. Lippard and Terry Wolverton.

64 New York, A.I.R. Gallery. *Overview 1972–1977: An Exhibition in Two Parts.* 1978. Text by Corinne Robins.

65 New York, Alternative Museum. *Contra Media.* 1983. Texts by Terry Berkowitz, Kenneth S. Friedman, and the artists.

66 New York, Alternative Museum. *Disinformation: The Manufacture of Consent.* 1985. Texts by Noam Chomsky and Edward S. Herman.

67 New York, Alternative Museum. *Liberty and Justice.* 1986. Texts by Alexander Cockburn, Jayne Cortez, et al.

68 New York, Alternative Museum. *Visual Politics.* 1982. Text by Robert H. Browning.

69 New York, Artists Space. *The Fairy Tale: Politics, Desire, and Everyday Life.* 1986. Texts by Jean Fisher, Fredric Jameson, et al.

70 New York, Grace Borgenicht Gallery. *Natural History.* 1982. Text by Scott Cook.

71 New York, The Clocktower. *Guerrilla Girls: The Banana Report.* 1987. Text by the Guerrilla Girls.

72 New York, Ronald Feldman Fine Arts, Inc., and The Village Voice. *The 1984 Show.* 1984. Texts by Carrie Rickey and the artists.

73 New York, Franklin Furnace. *Illegal America.* 1982. Texts by Jeanette Ingberman and the artists.

74 New York, Franklin Furnace. *Vigilance: An Exhibition of Artists' Books Exploring Strategies for Social Concern.* 1980. Texts by Mike Glier and Lucy R. Lippard.

75 New York, Henry Street Settlement. *Beyond Aesthetics: Art of Necessity by Artists of Conscience.* 1982. Texts by Juan Sánchez and the artists.

76 New York, Hunter College Art Gallery, Hunter College of the City University of New York. *Race and Representation.* 1987. Texts by Maurice Berger, Johnetta B. Cole, et al.

77 New York, Kenkeleba House Gallery. *Ritual & Rhythm: Visual Forces for Survival.* 1982. Texts by Juan Sánchez and the artists.

78 New York, The Museum of Modern Art. *The Artist as Adversary.* 1971. Texts by Betsy Jones and the artists.

79 New York, The New Museum of Contemporary Art. *Art & Ideology*. 1984. Texts by Benjamin H. D. Buchloh, Donald Kuspit, et al.

80 New York, The New Museum of Contemporary Art. *The Art of Memory, The Loss of History*. 1985. Texts by David Deitcher, William Olander, et al.

81 New York, The New Museum of Contemporary Art. *The End of the World: Contemporary Visions of the Apocalypse*. 1983. Texts by Lynn Gumpert and the artists.

82 New York, The New Museum of Contemporary Art. *Events: En Foco, Heresies Collective*. 1983.

83 New York, The New Museum of Contemporary Art. *Events: Fashion Moda, Taller Boricua, Artists Invite Artists*. 1980. Texts by Lynn Gumpert, Ed Jones, and the artists.

84 New York, The New School Art Center. *My God! We're Losing a Great Country*. 1970.

85 New York, Pratt Graphics Center Gallery. *The Black Experience in Prints*. 1972. Texts by Romare Bearden and Ben Goldstein.

86 New York, Pratt Graphics Center Gallery. *Contemporary Graphic Art on Contemporary Law and Justice*. 1970. Texts by Franklin Feldman, Una E. Johnson, et. al.

87 New York, Protetch-McNeil Gallery. *The Revolutionary Power of Women's Laughter*. 1983. Text by Jo-Anna Isaak.

88 New York, The Studio Museum in Harlem. *Tradition and Conflict: Images of a Turbulent Decade 1963–1973*. 1985. Texts by Benny Andrews, Lerone Bennett, Jr., et al.

89 New York, Whitney Museum of American Art, Downtown Branch. *Metamanhattan*. 1984. Texts by Geoffrey Batchen, Ingrid Schaffner, et al.

90 New York, Whitney Museum of American Art, Downtown Branch. *The Prison Show: Realities and Representations*. 1981. Texts by Micki McGee, Lisa Phillips, et al.

91 Norfolk, Virginia, The Chrysler Museum. *Crimes of Compassion*. 1981. Text by Thomas W. Styron.

92 Oberlin, Ohio, Allen Memorial Art Museum, Oberlin College. *Art & Social Change, U.S.A.* 1983. Texts by David Deitcher, Jerry Kearns, et al.

93 Old Westbury, New York Institute of Technology. *Art and the Suburban Experience*. 1984. Texts by Anthony Clementi and Alix Sandra Schnee.

94 Old Westbury, Amelie A. Wallace Gallery, State University of New York, College at Old Westbury. *The Power to Provoke*. 1984. Texts by Tamie Jackson, Cal Lom, et al.

95 Old Westbury, Amelie A. Wallace Gallery, State University of New York, College at Old Westbury. *We Are Always Turning Around on Purpose*. 1986. Texts by Jimmie Durham, Jean Fisher, and the artists.

96 Philadelphia and New York, The Balch Institute for Ethnic Studies and Independent Curators Inc. *The American Experience: Contemporary Immigrant Artists*. 1985. Texts by Cynthia Jaffee McCabe, Yi-Fu Tuan, et al.

97 Philadelphia, Muse Foundation for the Visual Arts. *Her Own Space*. 1983. Texts by Norma Broude, Mary D. Garrard, et al.

98 Reading, Pennsylvania, Freedman Gallery, Albright College. *Messages: Words and Images*. 1981. Text by Marilyn A. Zeitlin.

99 Saint Paul, Minnesota Museum of Art. *West '80: Art and the Law*. 1980. Text by Jack Levine.

100 San Francisco, New Langton Arts. *Image/Word: The Art of Reading*. 1985. Text by Barrett Watten.

101 San Francisco, San Francisco Art Institute. *Other Sources: An American Essay*. 1976. Texts by Rupert Garcia, Allan M. Gordon, et al.

102 San Francisco, San Francisco Art Institute, Mission Cultural Center, and Stephen Wirtz Gallery. *Artists Call Against U.S. Intervention in Central America: San Francisco*. 1984. Texts by Peter Selz, Marcia Smith, et al.

103 San Francisco, San Francisco Camerawork. *Products and Promotion: Art, Advertising and the American Dream*. 1986. Texts by Donna Stein and Lynn Zelevansky.

104 San Francisco, San Francisco Museum of Modern Art. *The Human Condition: SFMMA Biennial III*. 1984. Texts by Wolfgang Max Faust, Henry T. Hopkins, et al.

105 Santa Clara, California, de Saisset Museum, Santa Clara University. *Speak, You Have the Tools: Social Serigraphy in the Bay Area, 1966–1986*. 1987. Text by Michael Rossman.

106 Santa Clara, California, Triton Museum of Art. *Crime and Punishment: Reflections of Violence in Contemporary Art*. 1984. Text by Jo Farb Hernandez.

107 Seattle, Henry Art Gallery, University of Washington. *No! Contemporary American Dada* (vols. 1 and 2). 1985 and 1986. Texts by Chris Bruce and Illeana B. Leavens.

108 South Hadley and Amherst, Massachusetts, Mount Holyoke College Art Museum and University Gallery, University of Massachusetts. *The Shadow of the Bomb*. 1984. Text by Sally Yard.

109 Stony Brook, The Fine Arts Center Art Gallery, State University of New York at Stony Brook. *Freedom Within*. 1985. Text by Maria Thereza Alves.

110 Stony Brook, The Fine Arts Center Art Gallery, State University of New York at Stony Brook. *The War Show*. 1983. Text by Howardena Pindell.

111 Syracuse, New York, Everson Museum of Art. *From Teapot Dome to Watergate*. 1974. Text by David H. Bennett.

112 Washington, D.C., National Collection of Fine Arts, Smithsonian Institution. *Images of an Era: The American Poster 1945–75*. 1975. Text by Dore Ashton, Margaret Cogswell, et al.

113 Waterville, Maine, Colby College Museum of Art. *Call and Response: Art on Central America*. 1984. Text by Lucy R. Lippard.

114 West Nyack, New York, Rockland Center for the Arts. *Images of Power: Visual Statements by Ten Major Women Artists*. 1987. Text by Joan Giordano.

General: Periodicals

115 *Art & Artists* (New York), vol. 13, no. 4 (January 1984). Special supplement on Artists Call Against U.S. Intervention in Central America.

116 *Art & Artists* (New York), vol. 13, no. 1 (September/October 1984). Special supplement on Art Against Apartheid.

117 "Artists Call: Freedom and the Freedom for Art in Central America: Excerpts from a Conversation, Dore Ashton, Rudolf Baranik, José R. Dominguez, Daniel Flores, Jon Hendricks, Catalina Parra, Guadencio Thiago de Mello." *Arts Magazine* (New York), vol. 58, no. 5 (January 1984).

118 *Artworkers News* (New York), vol. 11, no. 9 (July 1982). Special supplement on artists' participation in the June 12, 1982, antinuclear rally.

119 Cockcroft, Eva. "Heroes and Villains: The Latin American View." *Art in America* (New York), vol. 72, no. 5 (May 1984).

120 *Cultural Correspondence* (New York), no. 4 (Summer 1985). Special issue on the art of demonstration.

121 *Cultural Correspondence* (New York), no. 3 (1984). Directory of arts activism.

122 Durham, Jimmie. "Related Events Practically." *Art & Artists* (New York), vol. 15, no. 1. (January/February 1986). On art and the American Indian Movement.

123 Gambrell, Jamey. "All the News That's Fit for Prints: A Parallel of Social Concerns of the 1930s & 1980s." *The Print Collector's Newsletter* (New York), vol. 18, no. 2 (May/June 1987).

124 Gambrell, Jamey. "Art Against Intervention." *Art in America* (New York), vol. 72, no. 5 (May 1984).

Goldman, Shifra M. "A Public Voice: Fifteen Years of Chicano Posters." *Art Journal* (New York), vol. 44, no. 1 (Spring 1984).

Ikon: Creativity and Change (New York), second series no. 5/6 (Winter/Summer 1986). Special double issue on Art Against Apartheid.

Lippard, Lucy R., ed. "Out of Sight, Out of Mind (II): Asian and Hispanic Artists." *Upfront* (New York), no. 9 (Fall 1984).

Olander, William. "Which Brand Is for You?: Magazines and Activist Arts." *Upfront* (New York), no. 12/13 (Winter 1986/87).

"Out of Sight, Out of Mind (I): Native American, Black and White Artists in Search of Cultural Democracy." *Upfront* (New York), no. 6/7 (Summer 1983).

Powell, Richard J. "I, Too, Am American: Protest and Black Power, Philosophical Continuities in Prints by Black Americans." *Black Art: An International Quarterly* (New York), vol. 2, no. 3 (Spring 1978).

Sánchez, Juan, and Rafael Colon Morales. "Puerto Rican Nationalist Art: A History, a Tradition, a Necessity." *Artworkers News* (New York), vol. 11, no. 9 (May 1982).

Schwartz, Therese. "The Politicalization of the Avant-Garde, I–IV." *Art in America* (New York). Section I: vol. 59, no. 6 (November/December 1971); section II: vol. 60, no. 2 (March/April 1972); section III: vol. 61, no. 2 (March/April 1973); section IV: vol. 62, no. 1 (January/February 1974).

Stasik, Andrew. "Artists' Protest." *Print Review, A Publication of Pratt Graphics Center* (New York), no. 17 (1983).

Upfront (New York), no. 10 (Fall 1985). Special section on Political Art Documentation/Distribution's *State of Mind/State of the Union* "counterinaugural series" of exhibitions and events.

Upfront (New York), no. 12/13 (Winter 1986/87). Special supplement on Polit-

ical Art Documentation/Distribution's exhibition *Concrete Crisis: Urban Images of the '80s.*

136 *The Village Voice* (New York), vol. 27, no. 24 (June 15, 1982). Special issue on nuclear disarmament, in conjunction with Ronald Feldman Fine Arts, Inc., New York.

137 *The Village Voice* (New York), vol. 28, no. 5 (February 1, 1983). "Special Issue: A Preview of 1984 and Beyond," in conjunction with Ronald Feldman Fine Arts, Inc., New York.

Index of Artists

Numbers in italics refer to notes on the artists.

Photograph Credits

Credits are keyed to illustration num